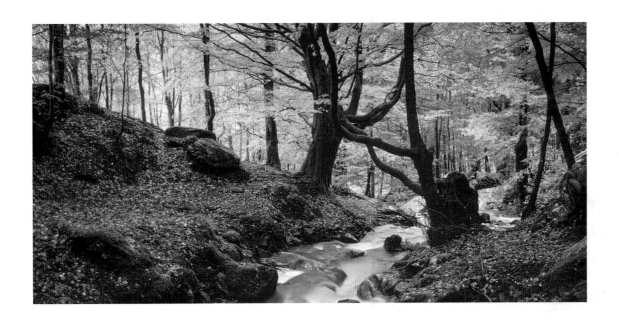

SEASONS
of Landscape

SEASONS
of Landscape

An inspirational and
instructive guide
in photography

PETER WATSON

photographers'
pip
institute press

First published 2010 by **Photographers' Institute Press**

An imprint of **Guild of Master Craftsman Publications Ltd**
Castle Place, 166 High Street, Lewes, East Sussex BN7 1XU

ISBN 978-1-86108-800-0

Associate Publisher Jonathan Bailey

Production Manager Jim Bulley

Managing Editor Gerrie Purcell

Project Editor Gill Paris

Managing Art Editor Gilda Pacitti

Designer Rob Janes

Set in Syntax and Eurostile

Colour origination by GMC Reprographics
Printed and bound in China by Hing Yip Printing Co. Ltd

Half-title page
**Mamore Forest, Kinlochleven,
The Scottish Highlands**

Title page
**Delamere Forest, Cheshire,
England**

This page (see also page 19)
**Near Burtersett, North Yorkshire,
England**

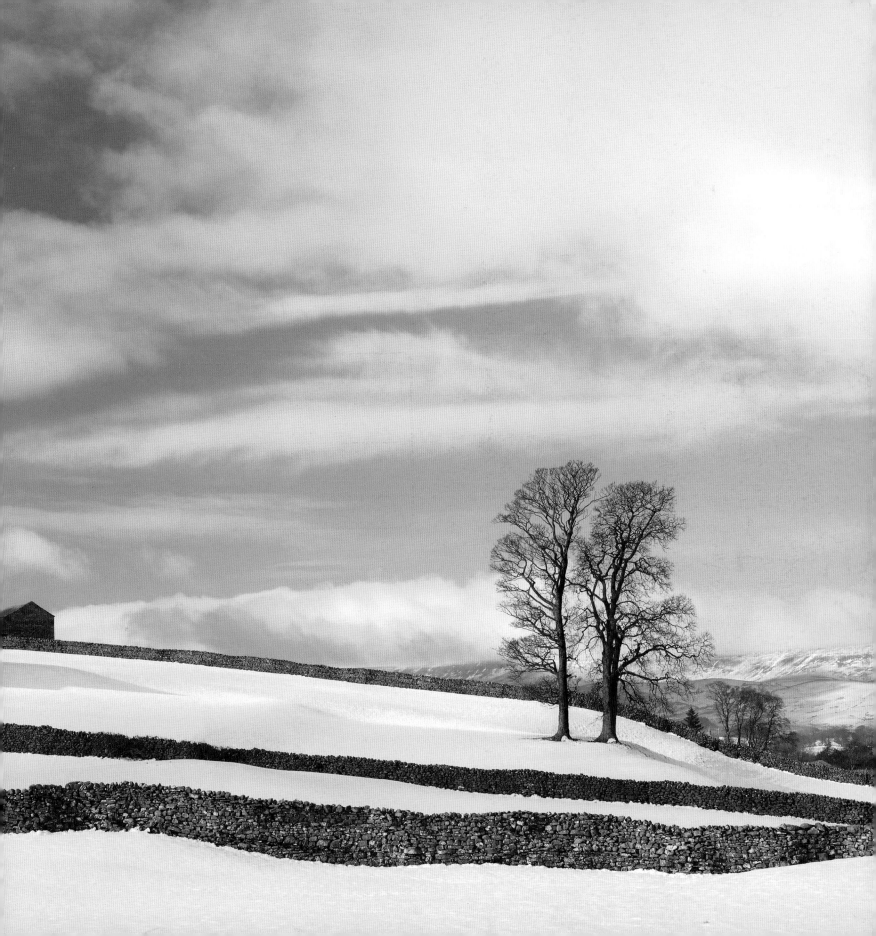

Contents

Introduction 8

Adopting the Right Approach 10

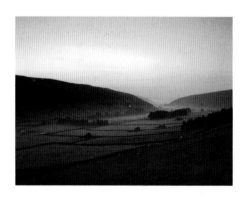

Chapter One

▶ **January** 17

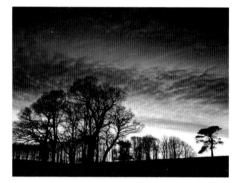

Chapter Two

▶ **February** 31

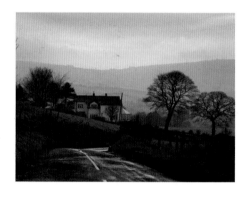

Chapter Three

▶ **March** 45

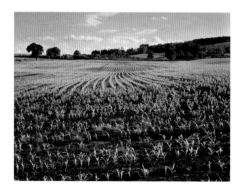

Chapter Four

▶ **April** 59

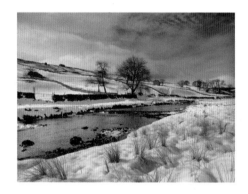

Chapter Five

▶ **May** 75

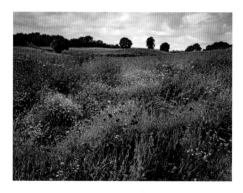

Chapter Six

▶ **June** 87

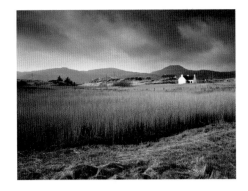

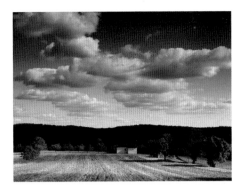

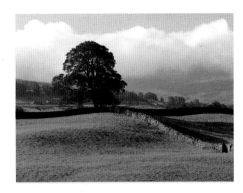

Chapter Seven

▶ **July** 99

Chapter Eight

▶ **August** 109

Chapter Nine

▶ **September** 121

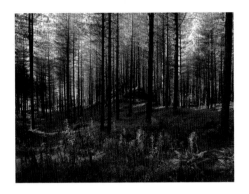

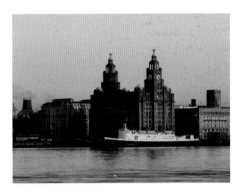

Chapter Ten

▶ **October** 139

Chapter Eleven

▶ **November** 155

Chapter Twelve

▶ **December** 171

Image index 182

Glossary 187

About the author 189

Equipment used 189

Index 190

Introduction

Ask a landscape photographer what his or her favourite season is and the answer is likely to be autumn, followed by winter, spring and finally summer. This would also be my answer but I have to say that the time of year is not, personally speaking, of absolute paramount importance. This is because opportunities arise throughout the year and, whatever the date on the calendar, distinctive images are always there for the taking. What is important, though, is that you become familiar with the changing appearance of the landscape and gain an understanding of how different types of terrain are affected, not only by light, but also by atmospheric conditions, climate and rainfall (or lack of it).

Weather patterns seem to be becoming more unpredictable and the seasonal calendar is no longer set in stone. Nature can put on a good show at any time of year and, perhaps more than ever before, there are, photographically speaking, no longer any fallow periods. It is for this reason that I have always remained active throughout the year, perhaps a little less intensively in the summer months (well, it is summer!), but I never completely switch off.

There is a good reason for this – variety. Ignoring a particular season or time of year inevitably means that a wealth of material such as short-lived flora, crops and many other transient features will never be photographed, and a wide variety of potential images will be lost. And, in addition to this, there is the varying quality of light. Because of the ever changing arc of the sun the time of year is just as important as the time of day when photographing many subjects. Indeed, there are many landscapes that can only be photographed at specific times of year, and this is often during the summer months when the sun's arc is at its longest. Atmospheric conditions also affect the light and this can vary greatly as the climate changes throughout the year.

It can also be fascinating, and very rewarding, to visit the same location at different times of year because seasonal changes can have a surprising – and often dramatic – effect on the landscape. Consider, for example, the photographs on these two pages: same place, same viewpoint, same time of day, but taken during different seasons – and what a difference those seasons make! Both pictures are a graphic example of one location being capable of yielding more than one image. Let nature do the work and then reap the benefits – what more could a photographer ask for?

So, day in, day out, throughout the year, there are images to be taken and opportunities to be grabbed. With awareness, observation and perseverance you can make the most of nature's offerings and I sincerely hope that the pages that follow will help and inspire you to capture the many varied guises of our seasonal landscape.

Peter Watson

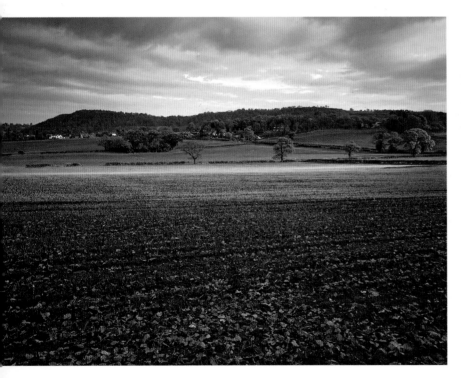

Near Harthill, Cheshire, England

Camera: Tachihara 5x4in
Lens: Super Angulon 90mm (Wide Angle)
Filter: 0.6ND grad
Film: Fuji Provia 100
Exposure: 1/2sec at f/32
Waiting for the light: 1 hour

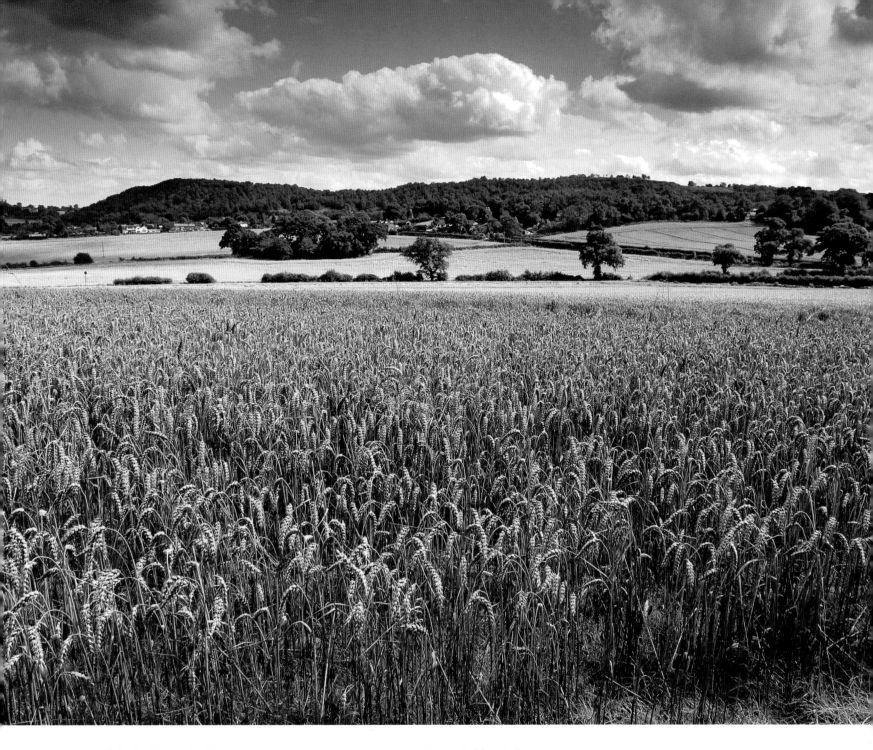

Near Harthill, Cheshire, England

Camera: Tachihara 5x4in

Lens: Super Angulon 90mm (Wide Angle)

Filter: 0.45ND grad

Film: Fuji Provia 100

Exposure: 1/4sec at f/32

Waiting for the light: 30 minutes

Adopting the Right Approach

Choosing the right equipment

The first and most important question I am frequently asked is always the same: should I use film or digital? I have, as many of you might know, always been a dedicated follower of film photography and, until recently, my advice was to continue shooting on film. I felt that the quality of digital images was still inferior to that of film. The new medium certainly offered advantages, such as speed and convenience, but for landscape work these aren't the priority. What matters above anything else is the quality of the final image and in my opinion film still had the edge.

Well, time moves on and the past few years have seen a huge leap in the quality of digital imaging, which has been concurrent with a significant fall in prices of high megapixel cameras. No longer is digital the poor relation of the photographic family. It is now a credible alternative to film and I can foresee a time in the not-too-distant future when digital imaging overtakes film in terms of quality. This is, I believe, inevitable. Consider for a moment how much research and development is being invested in digital sensor technology compared with traditional silver-halide-based film. There is, to say the least, a sizeable gap and this can, I suspect, only widen.

So, has film had its day? No, absolutely not. It is a beautiful medium and I still use film for a lot of my work and will, for the foreseeable future, continue to do so. My love of film is shared by many other established photographers and, worldwide, there are legions of devoted followers who have no plans to give up using the medium. There are practical considerations, however, and there are some occasions when digital is the better choice. Based on my own experience and other photographers' comments, my view, for what it's worth, is that film and digital photography will co-exist for many years to come. My advice, therefore, is as follows: if you already have a good-quality film camera and are happy to continue using it, there is no reason why you shouldn't do so. You should not feel compelled to join the burgeoning digital masses. If at some time in the future you feel like changing, then do so because it will be even less expensive, in relative terms, than it is today. The longer you leave it the more you will get for your money.

If, on the other hand, you are at the moment considering buying new equipment, then I would have no hesitation in recommending that you choose the digital option. Although the current trend of falling prices and rising quality/specification will continue, this is already a good time to make the investment. A good-quality camera and lens can now be bought for a few hundred pounds and, having made the purchase, you no longer, of course, have the expense of buying film and processing.

So, if you decide, in principle, to follow the digital route, what type of camera is most suitable for the landscape environment?

Pixel count

I prefer to think of a digital camera not as a miniature box of cutting-edge technology but as a traditional camera with pre-loaded digital film. When choosing a model I would therefore look for features which are present on film cameras. The lack of viewfinder on compact cameras therefore excludes them from my shortlist and a DSLR (digital single lens reflex) camera would be my choice. The next consideration is the megapixel count. There is some confusion that the number of pixels is linked to image quality. It is, but only as far as print size is concerned.

As the dimensions of the print increase a proportionate increase in the number of pixels is required in order to maintain the resolution of the image, but if you are producing, for example, a 12 x 10in (30 x 25.5cm) print then a 12mp camera is just as good as, say, a 15 or 20mp camera. Unless you wish to produce very large prints, the number of megapixels is not, therefore, the major consideration.

Furnace Falls, Near Machynlleth, Wales

Camera: Tachihara 5x4in

Lens: Super Angulon 150mm (Standard)

Filter: 81C

Film: Fuji Provia 100

Exposure: 1/2sec at f/22

Waiting for the light: Immediate

This photograph was taken on an overcast day. This can create a blue bias and to compensate for this a warm 81C filter was used.

Sensor size

This should be carefully considered. There are now a number of options ranging from the very small (equivalent to half-frame 35mm) to medium format and larger. Generally speaking, the larger the sensor, the higher the image quality (but, of course, prices rise as the size of the sensor grows). I use a medium-format sensor; this was an easy choice to make because I exchanged my old Mamiya film camera for the digital equivalent. This isn't a budget option, however, because even though the price of Mamiya digital equipment compares favourably with other medium-format manufacturers, it is still more expensive than the smaller formats.

Full frame (i.e. 35mm equivalent) cameras produced by Canon, Nikon and a small number of other manufacturers would be a good choice for landscape work but again they are more expensive than their smaller counterparts. The APS-C sensor has proved to be a popular format and this size of camera is produced by most manufacturers in a range of prices. Having compared the various options, my advice would be to buy a full-frame 35mm (or larger) size camera if it is within your budget, if not opt for an APS-C camera. The image quality is still very good (I speak from recent experience because I have just tested a Pentax K20 and was impressed by its level of performance) and these cameras are an excellent introduction to the world of digital imaging.

The choice of lens

This is another important consideration. There is a discernable correlation between lens optical quality and image quality and a sharp, high-resolution lens will prove to be a good investment. I have always preferred to use fixed focal length lenses but the latest zooms are now almost as sharp. For a full-frame 35mm camera a zoom range of 24–70mm will cover most landscape requirements (the approximate equivalent for APS-C size cameras is 17–50mm). This size of lens, or similar, is often supplied as part of a kit, i.e. you buy camera and lens together, but kit lenses are a budget option. Although they are reasonably good value for the price, they are not usually of the highest optical quality. I would suggest that instead you consider, replacing it with a higher-specification lens from the camera manufacturer or Sigma, Tamron, or Tokina. These latter companies are independent manufacturers who produce their lenses in a range of fittings and they are therefore compatible with the majority of DSLRs.

Memory cards

To complete your digital camera you will need a memory card; these are available in various capacities. 4gb cards are a popular choice but I would suggest that, as an alternative, you use two 2gb cards. That way you won't be left high and dry if, heaven forbid, a card fails (this is unlikely, particularly with well-established brands, but it is not unknown). I use SanDisk Extreme 1V cards and have always found them to be 100% reliable.

Other equipment

Having just rummaged through my camera case for the first time in a while (a useful exercise, every so often!), I will detail below those items which I carry and, more importantly, use consistently. You might be pleased to know that this isn't a particularly long shopping list. You can add accessories and equipment as you go along, based on your own requirements and experiences. The following are, however, what I consider to be essential items.

Tripod

A strong, sturdy and adaptable tripod is a must. It should be stable enough to not only prevent camera shake but also protect your camera. The outdoor environment can be challenging and a tripod which can be adjusted to accommodate different types of terrain would be the best choice. The Uni-Loc and Benbo ranges are designed for landscape use and, in my opinion, are the most suitable for this type of photography. The benefit of using both a strong and adaptable tripod can be seen in the image on the facing page. Close-up photography requires great versatility in movement and positioning as well as rock-solid support. This type of photograph would not be possible with flimsy apparatus.

Near Young Harris, Georgia, USA

Camera: Tachihara 5x4in
Lens: Super Angulon 150mm (Standard)
Filter: None
Film: Fuji Provia 100
Exposure: 1sec at f/32
Waiting for the light: Immediate

Capturing this image required precision positioning of the camera. This was only possible using the support of a sturdy and adaptable tripod.

Filters

There are a small number of filters which can greatly improve landscape images. These are discussed throughout the book but are listed here for convenience.

A neutral-density graduated filter (or ND grad, also known as a grey grad) will help to prevent the sky from being overexposed. They are available in a range of strengths; I find the most useful to be one and two stops, i.e. they will absorb the equivalent of one and two stops of light. The photograph taken near Thirlemere, on the opposite page, shows the benefit of using this type of filter. It has darkened the sky and brought its light value down to the level of the landscape. Without this darkening effect the sky would have been horribly overexposed and the image would have been a failure.

A polarizer is a very useful filter because it can be used to increase colour saturation, darken a blue sky and improve the transparency of water. It also absorbs approximately two stops of light, which isn't always an advantage, but can be useful when a slower shutter speed is required.

I also suggest you consider adding a warming filter to your collection, either an 81B or 81C. These filters are used to compensate for a blue cast which is sometimes present in daylight. They also improve the colour of sand and autumn foliage (as can be seen in the photograph on page 11). If you are using a digital camera then this type of filter is unnecessary, because the colour balance can be corrected after exposure.

These are really the only filters you need. Although there is a vast range available I wouldn't recommend that you carry any more than these few. Many are unsuitable for landscape photography and are designed to create special effects, so if you haven't got them you won't be tempted to use them!

Exposure meter

If you are using a film camera then a handheld exposure meter is useful, particularly one with a spot-reading capability. As well as calculating exposure a spot meter will enable you to take readings from specific parts of the landscape and sky and allow you to determine the level of contrast in a scene.

Cable release

This is an important accessory and the benefits of using one shouldn't be underestimated. It will greatly reduce the possibility of camera shake.

Spirit level

Mounted on the camera's accessory shoe, these are very useful when photographing buildings and coastal landscapes when it is important to keep the horizon perfectly straight.

Maps

Large-scale maps that show contour lines are a tremendous help when researching locations. In the UK I find the Ordnance Survey *Landranger* maps, scale 1:50,000, particularly useful. In addition to land contours they also show small rivers and streams, waterfalls, footpaths and types of forest. They are a very important aid when exploring a landscape and I cannot recommend them too highly.

Case

Having assembled your range of equipment it is important to ensure that it can be conveniently – and safely – carried. A backpack designed for photography is, in my experience, the most practical option, particularly when trekking across any type of terrain. It is important to choose one which is the right size; the contents should fit securely yet be easily accessible. There are many times when you have to work fast – sometimes very fast if you are not to miss the fleeting moment – and seconds lost searching through your bag for a particular item can cost you dearly. It is important, therefore, to know exactly where everything is and be able to put your hand on any accessory immediately.

Adequate clothing

Finally, you need to protect yourself as well as your equipment. Outdoor conditions can be demanding and a cold, wet, uncomfortable photographer is unlikely to be at his or her best. Warm, waterproof clothing, walking boots and rubber boots are essential if you are to cope with what the landscape and weather can throw at you. Be prepared for changeable weather and the unexpected and you won't be taken by surprise.

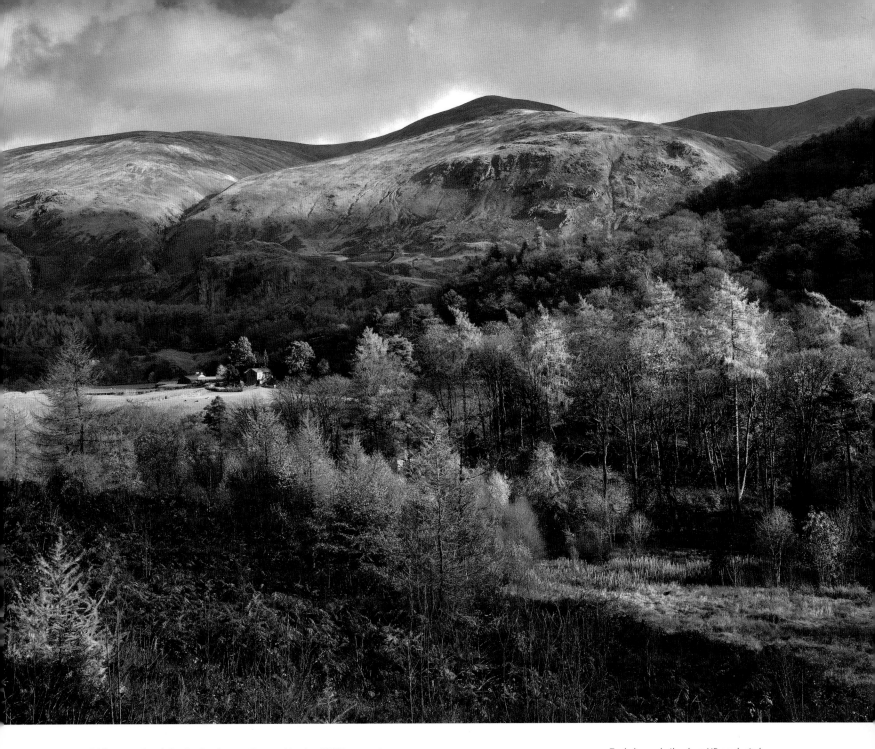

Near Thirlemere, Cumbria, England

Camera: Mamiya 645ZD
Lens: Mamiya 80mm (Standard)
Film: Dalsa CCD sensor ISO 100
Filter: 0.6ND grad
Exposure: 1/2sec at f/22
Waiting for the light: 1½ hours

To darken only the sky a ND graduated filter was used. This has prevented the sky from being overexposed and has enabled the detail and depth of the cloud structure to be revealed.

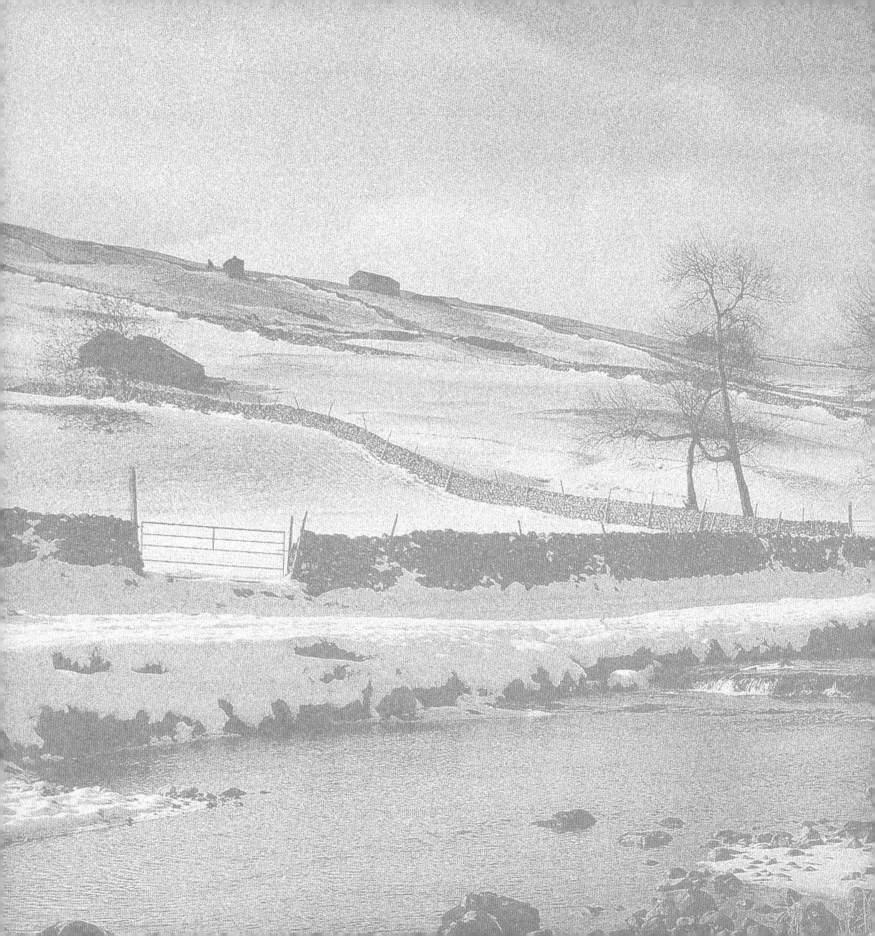

Chapter One

▶ January

Daylight is a precious commodity this month, averaging just eight hours a day – so make those short hours count! What the light lacks in quantity will, with any luck, be more than compensated for in quality.

The low arc of the sun, together with the soft intensity of the sunlight, produces a subdued, discriminating light which is perfect for revealing hidden undulations in the landscape. Use it to bring depth and a three-dimensional quality to distant views and vistas. Winter landscapes often exude a mood and drama which is lacking at other times of year and light can be used to intensify that drama.

▶ A Little Warmer?

Photographing snow scenes can be a challenge. Exposure readings (from both built-in and handheld meters) are likely to produce underexposed images and, to avoid the snow being recorded as a rather unattractive pale grey, you will need to increase exposure by approximately one stop. The aim is to record detail on the surface of the snow without under- or overexposing it. There is virtually no margin for error so, for safety, bracket your exposure in steps of ⅓ or ½ stop. A polarizer can often improve the texture and appearance of a snow-covered landscape, but beware when photographing a predominantly blue sky, because polarization can over-darken the blue areas. This is because there is likely to be little, or no, difference in the light values of the landscape and sky. I would suggest, therefore, that half, not full, polarization is used.

Snow scenes often display a bluish cast when photographed, particularly in shaded areas. If you are using film you can add an 81B warm filter to compensate for this. There is no need to use this filter when shooting digitally, because the colour balance can be corrected later. Care should be taken, however, when using photo-editing software. A delicate touch should be applied to the slider controls, because over-compensation can look manipulated.

In both these images a circular polarizer has been added to improve colour saturation and texture but, in order to avoid over-darkening the sky, I viewed the scene through the filter (before attaching it to the camera), rotating it as I did so. This enabled the extent of the required polarization to be determined and I decided to use only half, which required partial, not full, rotation of the filter.

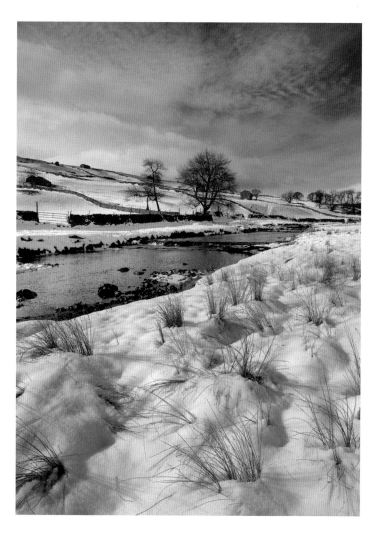

Langstrothdale, North Yorkshire, England

Camera: Tachihara 5x4in
Lens: Super Angulon 90mm (Wide Angle)
Filter: Polarizer (half polarized), 81B
Film: Fuji Provia 100
Exposure: 1/2sec at f/32
Waiting for the light: 15 minutes

TIP: Take care when walking across a snow-covered landscape. Unwittingly you may leave footprints where you least want them, i.e. in the middle of your photograph. Try to assess the scene, initially from a stationary position, before embarking on a carefully planned route to search for a viewpoint.

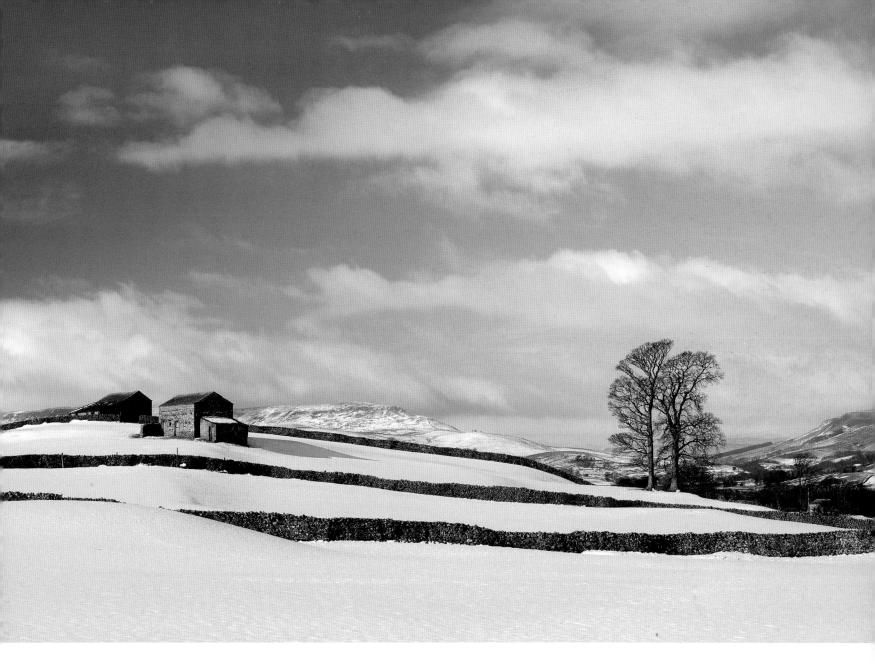

Near Burtersett, North Yorkshire, England

Camera: Tachihara 5x4in

Lens: Super Angulon 90mm (Wide Angle)

Filter: Polarizer (half polarized), 81B

Film: Fuji Provia 100

Exposure: 1/2sec at f/32

Waiting for the light: 30 minutes

► A Balanced Arrangement

Derwent Water is a location I like to visit as often as possible. It seems to encapsulate the spirit and character of the Lake District and whatever the time of year, whatever the season, it always has something to offer. The picture on the facing page was taken on a cold and misty January morning. The surrounding landscape appeared to be in hibernation but the still waters of Derwent provided a focal point, an atmospheric oasis upon which a photograph could be built.

Readers of my earlier books will know that I have a penchant for symmetry (some might call it an obsession!) and whenever possible I like to incorporate balance and equilibrium in a composition. It was apparent that the distant groups of trees and the two posts, together with their reflections, provided the basis for such an arrangement. To reinforce the theme, complementary foreground elements were needed, and with a little searching along the water's edge the picture began to take shape.

Normally those two rocks in the foreground would be completely submerged but there had been little rain in the preceding two weeks and it was fortunate that the water level was low. Without the rocks the image would have been incomplete, because their presence maintains the balanced arrangement across both the width and length of the photograph.

The picture isn't solely about symmetry, however. The moody atmosphere is also an essential element and the mist-enshrouded horizon adds an extra dimension to the image. The cool blue cast enhances the mood and the wintry appearance and on this occasion, unlike the pictures on the previous pages, it required no warming. The only thing that needed warming on that bitterly cold morning was the freezing photographer but, picture taken, a flask of coffee was soon keeping hypothermia at bay!

The picture on the left was taken early one autumnal morning several years earlier, during a quiet spell. There is less of a wintry feel to the image, the raw, stark quality of the main photograph being replaced here by a serene, pastoral atmosphere.

Derwent Water, The Lake District, England

Camera: Tachihara 5x4in
Lens: Super Angulon 150mm (Standard)
Filter: 0.6ND, 81C
Film: Fuji Velvia 50
Exposure: 1/2sec at f/22.5
Waiting for the light: Immediate

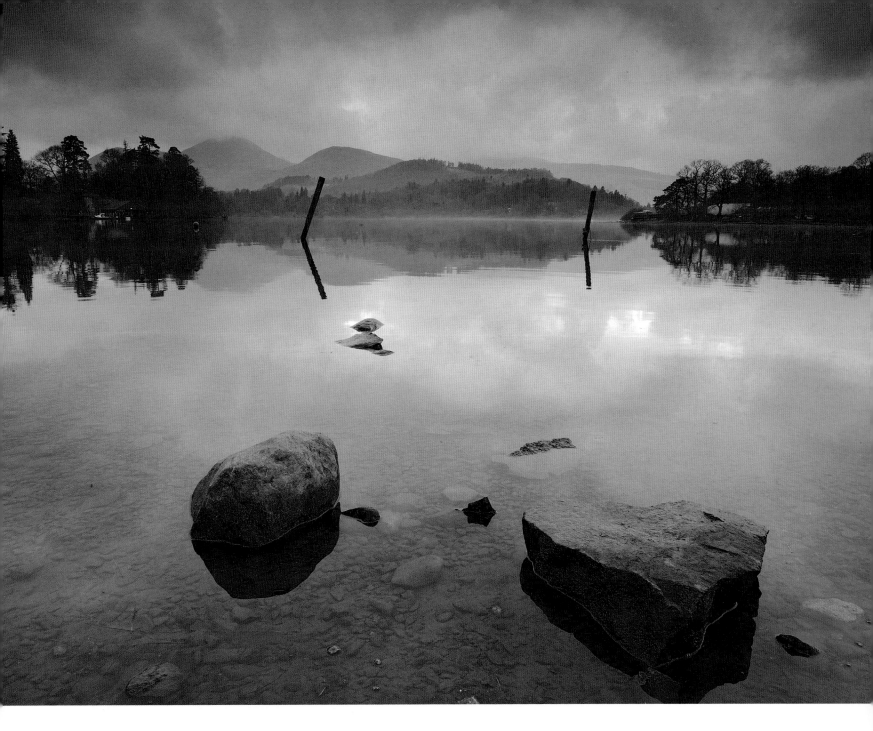

Derwent Water, The Lake District, England

Camera: Mamiya 645ZD
Lens: Mamiya 35mmm (Wide Angle)
Filter: 0.6ND grad
Film: Dalsa CCD sensor ISO 100
Exposure: 1/2sec at f/22
Waiting for the light: Immediate

▶ No Margin for Error

The timing of the photograph below was important, not only for the time of year, but also the time of day. The aim was to emphasize the weathered, rugged texture of the barn's stone wall and low winter sun from the side – almost at an angle of 90 degrees – was required. Unfortunately, as you can see from the image, I failed to achieve my objective. I was there at the right time of year but not, sadly, at the right time of day. My calculations were wrong and the optimum moment had been missed by a matter of minutes. I arrived as the last of the sunlight was grazing the front of the barn – you can see it clipping some of the protruding edges – and it was most frustrating to see the precious light ebbing away, but I only had myself to blame.

The only option was to take the photograph in flat light and the result is not, in fact, a total disappointment. Directional sunlight would have been preferable but the rich colours of the stone wall and door have saved the image from complete failure. Indeed, the more I look at it the more the picture grows on me and I would like to return one day to retake the barn in more direct sunlight and compare the results. It would be an interesting comparison.

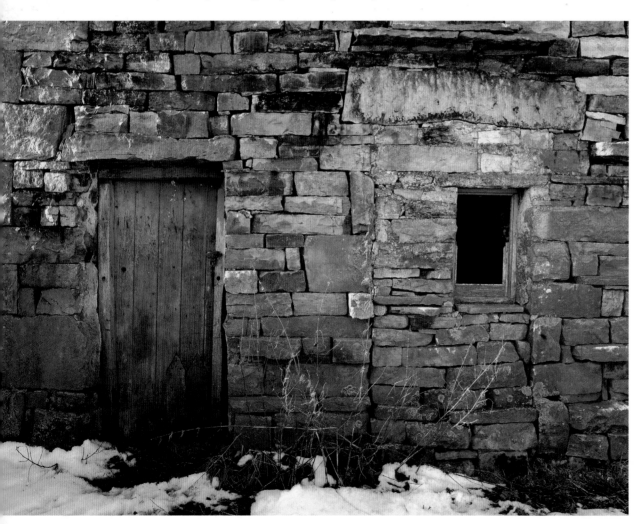

Near Bainbridge, North Yorkshire, England

Camera: Mamiya 645ZD
Lens: Mamiya 35mm (Wide Angle)
Filter: Polarizer (half polarized), 81B
Film: Dalsa CCD sensor ISO 100
Exposure: 1/4sec at f/16
Waiting for the light: Immediate!

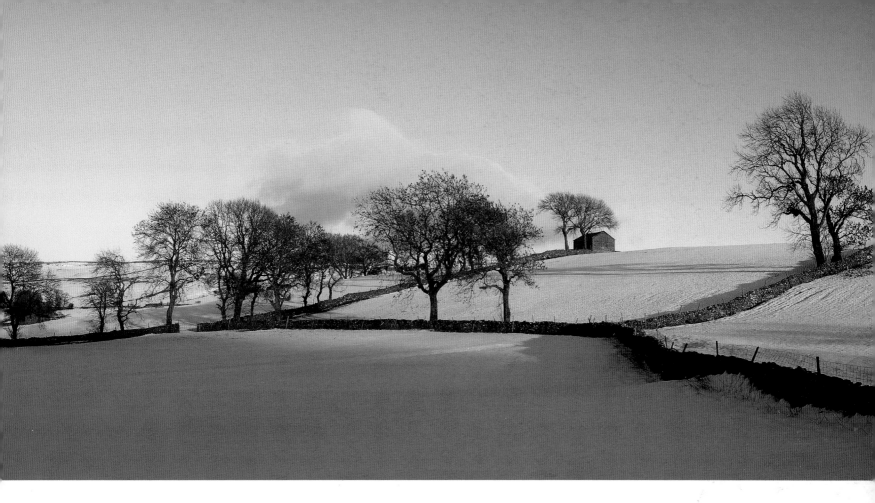

Near Countersett, North Yorkshire, England

Camera: Tachihara 5x4in (12x6cm format back)
Lens: Super Angulon 90mm (Wide Angle)
Filter: Polarizer (fully polarized)
Film: Fuji Provia 100
Exposure: 1/4sec at f/16.5
Waiting for the light: 30 minutes

Unlike the images on pages 18 and 19, no warm filters were used in the making of the photograph above and you can see why they were unnecessary. The contrast between the cool, blue shadows and the warm, late afternoon sunlight complement each other perfectly. On this occasion, warming the shaded areas (and also the sunlit trees and snow) would have been a mistake. Any adjustments would have disrupted the delicate balance between the colours and would not have brought any improvement.

TIP: When timing is critical allow yourself plenty of time. Minutes can make a big difference, so allow for a margin of error in your calculations.

▶ The Perfect Weather

The north-west of Scotland is somewhat remote but the quality of its landscape, both coastal and inland, justifies the long journey. I have travelled to the area several times and have never returned empty handed. But I take nothing for granted because, although the landscape provides a rich source of images, the weather in this exposed, highland region is changeable and difficult to predict. Rain, grey skies, more rain, more grey skies followed by, on a good day, a burst of sunlight are not untypical conditions along this exposed coastline. However, this is, of course, the perfect weather for capturing the spectacular beauty of the Scottish Highlands.

Looking at this picture of Clachtoll Bay you might think that my visit coincided with a spell of fine weather, but that wasn't the case. I waited for three hours for the rain to subside and the sky to clear. It was fortunate that it was only three hours, much longer and the glorious foreground would have been lost to the incoming tide. A mere three hours of weather watching – I'm not complaining!

This image is dominated by foreground. This type of composition can give a picture impact but care must be taken to ensure that the horizon is not relegated to a subordinate role. There must be something in the distance to draw the eye across the foreground and through the picture to the skyline. Buildings are useful in this respect. Imagine this photograph without the small group of cottages, it would suddenly lose depth and balance and would become a study of rocks instead of a picture of the bay.

TIP: Taking a visual trek across the landscape engages the eye, involves the viewer, and gives a picture depth and a three-dimensional appearance. Balance a strong foreground with eye-catching objects in the distance and you will have the makings of a fine photograph.

Clachtoll Bay, Sutherland, Scotland

Camera: Tachihara 5x4in
Lens: Super Angulon 90mm (Wide Angle)
Filter: 0.3ND grad
Film: Fuji Provia 100
Exposure: 1/2sec at f/32
Waiting for the light: 3 hours

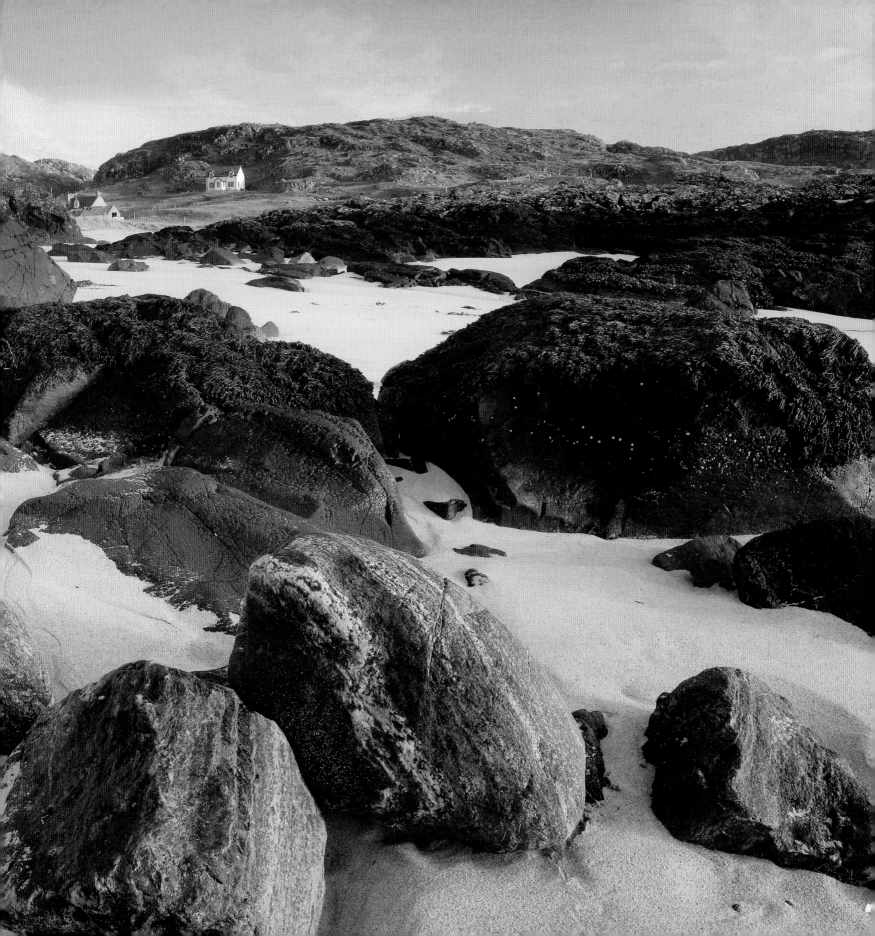

▶ Soft, Winter Light

Having previously photographed this isolated barn, I had no plans to return to the location. I felt that I had already witnessed and – more importantly – captured the building and surrounding moorland at one of its more memorable moments. However, I was curious. Unlike the earlier occasions, when heavy, oppressive skies had prevailed, the weather was now less threatening and a soft, winter light was gently caressing the rural landscape. I wanted to see the barn in a different light and, being just a short distance away, took the opportunity to make a return journey.

The scene certainly looked quite different. The light was much warmer and, in the picture on the facing page, you can see the effect it has had on the long grass. When compared with the smaller image below it is noticeably richer in tone, the yellow tinge in the original picture being replaced by a deep red/orange. This is due solely to the temperature of the light and illustrates the benefit of visiting locations in a variety of lighting and weather conditions.

The other notable aspect of the most recent photograph is the much greener grass in the near foreground. This is a result of the shadow and also, perhaps, the heavy rainfall which had fallen for several weeks prior to my visit. So, a combination of different light and a wetter climate has had a fundamental effect on the appearance of this moorland landscape. It was certainly worth making the repeat visit but, having said that, I still marginally prefer the original version below.

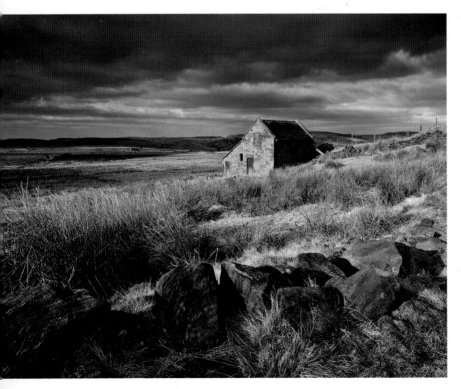

TIP: When retaking a previously photographed subject, consider changing the format, i.e. from landscape to portrait or vice versa. This, together with a change in the light and sky and perhaps a variation in viewpoint, can create a totally new image, quite different to your earlier version.

Brund Hill, Staffordshire, England

Camera: Tachihara 5x4in
Lens: Super Angulon 90mm (Wide Angle)
Filter: 0.6ND grad, 81C
Film: Fuji Provia 100
Exposure: 1sec at f/32
Waiting for the light: 5 days

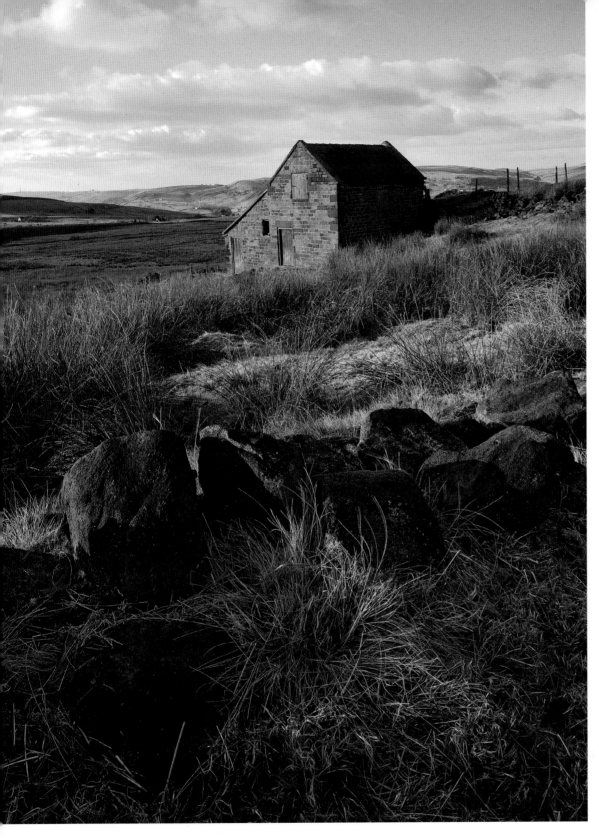

Brund Hill, Staffordshire, England

Camera: Tachihara 5x4in
Lens: Super Angulon 90mm (Wide Angle)
Filter: 0.6ND grad
Film: Fuji Provia 100
Exposure: 1⁄2sec at f/32
Waiting for the light: 30 minutes

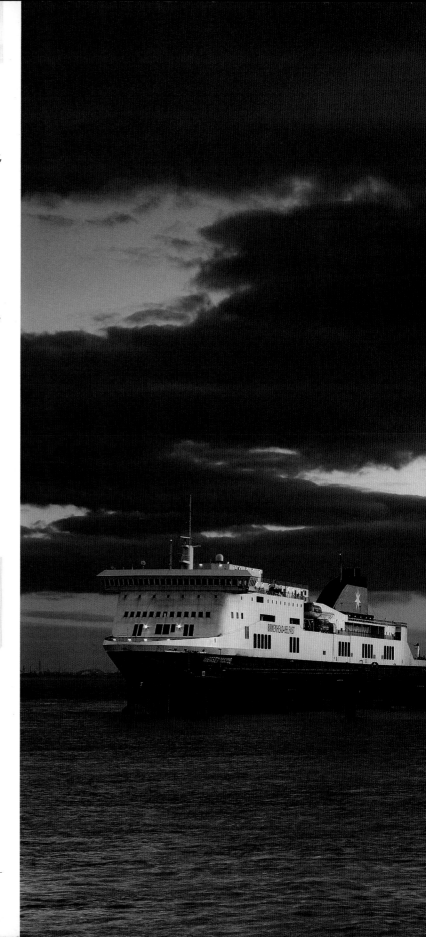

▶ Ebbing Tide, Ebbing Sky

Industrial landscapes are not, as a rule, my subject of choice. However, if an opportunity falls squarely into my lap – as it did one cold and blustery January evening – I will gladly make the most of it. At the time I was searching for a picture along the shoreline but nothing did justice to the sky which appeared to be building to an unmissable climax. I hate to let a good sky go to waste, so my attention was drawn towards the normally uninspiring docks and harbour.

The low sun was throwing a spotlight on the berthed ship, causing it to glow radiantly against the darkening evening sky. Not a second was lost in positioning my camera up against the steel perimeter fence and thankfully it was possible to squeeze the lens through a narrow gap. It was a tight fit and there was no room for manoeuvring but fortunately that was unnecessary. Having checked that the horizon and vertical lines were straight and perpendicular it was simply a matter of adding a grey graduated filter and waiting just a few minutes for the optimum moment. Photograph taken, I watched as the sunlight faded and the colour in the clouds gradually ebbed away. There was to be no afterglow and no sudden reawakening of the darkening sky (this can happen, so it is always worth waiting for complete darkness) and I set off on the journey home, happy in the knowledge that my meagre collection of industrial images had just been considerably augmented. Every picture counts!

TIP: When trying to recreate a twilight scene you might need to reduce exposure by half or one stop. Automatic metering will tend to produce a daylight effect and the image will therefore look too light. Reducing exposure will subdue tones and give the photograph an accurate 'last light of the day' appearance.

Birkenhead Docks, The Wirral Peninsula, Merseyside, England

Camera: Mamiya 645ZD
Lens: Mamiya 35mm (Wide Angle)
Filter: 0.3ND grad
Film: Dalsa CCD sensor ISO 100
Exposure: 1/2sec at f/22
Waiting for the light: 30 minutes

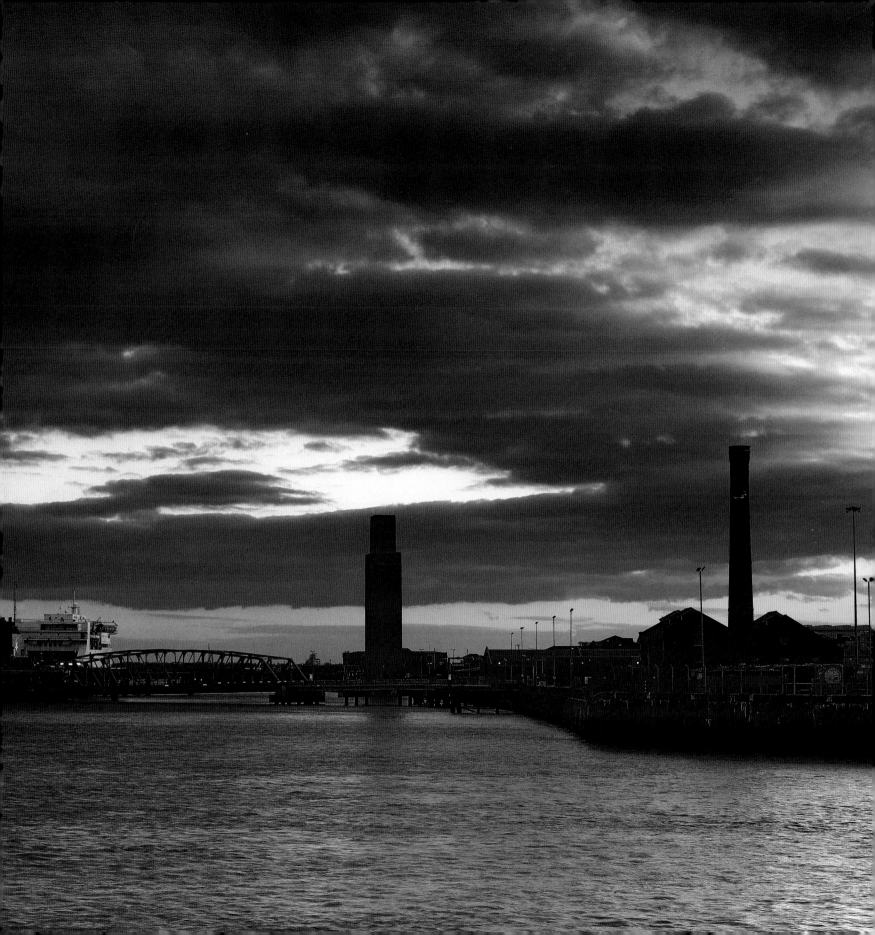

Chapter Two

▶ February

Spring isn't far away but winter can be reluctant to release its icy grip. Days are, though, becoming longer and early morning visits to lakes and streams can lead to the discovery of ice patterns on the water's surface. They photograph well as do frost-covered rocks, frozen reeds and leaves.

In milder weather the landscape can begin to show signs of emerging from its period of hibernation. Winter crops and flora can brighten the landscape and impart a graphic quality. Low sunlight will emphasize patterns and repetitive lines which can be found on arable farmland.

▶ A Useful Option

Grey skies and dismal weather don't always mean that your camera has to remain hidden away in its case. There are many subjects that suit flat, shadowless light and coastal areas, in particular, abound with image-making opportunities. The west coast of Cornwall is a particularly rich source of colourful, ocean-smoothed stone and if the striking colours and textures are to be captured in all their resplendent glory, then bright sunlight should be avoided. Soft light is all that's required and an overcast day is therefore the perfect weather.

This particular photograph suited a panoramic composition. It's a useful option to have and when choosing to employ it I sometimes use a Fuji GX617 film camera, which has an aspect ration of 3:1. This is relatively wide and sometimes a shorter, slightly squarer image is more appropriate. This is provided by a 12 x 6cm roll film back, which can be attached to a large-format view camera. It gives an aspect ratio of 2:1, which suits many panoramic arrangements. The other method (and possibly the easiest) is to simply crop the image after processing and this is common practice when working digitally.

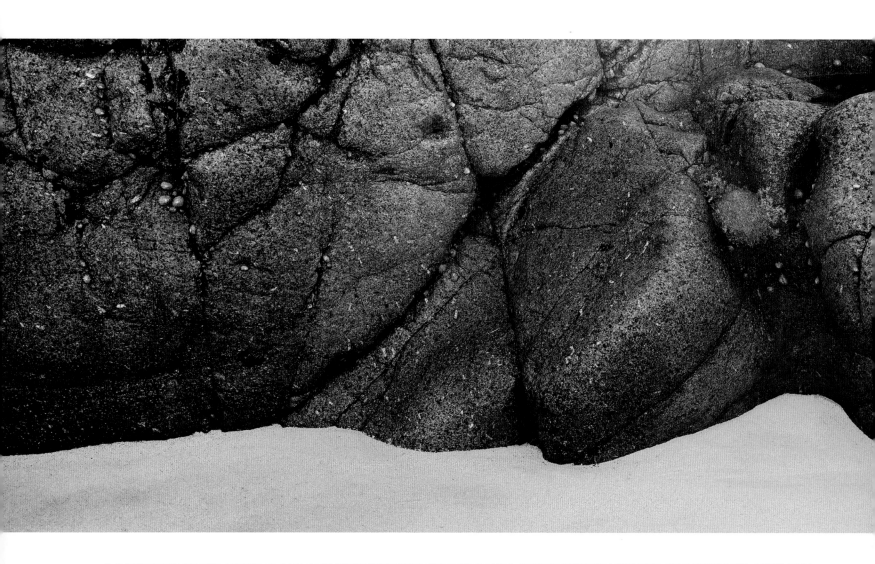

For both film and digital photography, cropping can be a useful option and it is something to be considered when looking at a subject and deciding on a composition. You might be about to dismiss a photograph, but do remember to examine all alternatives before you do so, including the possibility of a panoramic arrangement.

TIP: Bold colours can be further strengthened by using a fully polarized filter. When shooting film on an overcast day, a warm filter might also improve colour balance.

Near St Just, Cornwall, England

Camera: Fuji GX617
Lens: Fujinon 105mm (Standard)
Filter: Polarizer (fully polarized), 81C
Film: Fuji Provia 100
Exposure: 1sec at f/16.5
Waiting for the light: Immediate

▶ Achieving the Right Balance

Curves and flowing lines are a main theme in this still-life study of raised boulders along the small beach at Porth Nanven. The soft, rounded shapes give the picture repetition and this, together with the position and diminishing size of the boulders, help to create depth. The narrow colour range and pastel tones are also an important feature because they allow the eye, free of distraction, to perceive the repetitive shapes and composition. When bold colours are present they tend to become dominant and can eclipse other elements. Therefore, unless colour is the theme of your picture, brightly coloured objects should, if possible, be excluded from your composition.

The smaller photograph, below left, is a variation of the theme but, compared to the main image on the facing page, it is weak. There is too much empty space and it fails to engage the viewer. I do like simplicity in a picture but, like everything, it can be overdone. A good photograph has a certain balance; there must be sufficient information to communicate a theme and meaning, but too much can be confusing while too little will lack visual impact. Getting the balance right is the key to success, but when you are presented with a number of options, finding the right arrangement is not always straightforward. I do not suggest that you simply take picture after picture and hope for the best, that is no way to pursue success and is a recipe for mediocrity, but there are occasions when it can be useful to take a number of different images. Comparing the results afterwards is a powerful learning tool: it will help you to gain experience and get a feeling for the type of composition that will work most successfully in a given situation.

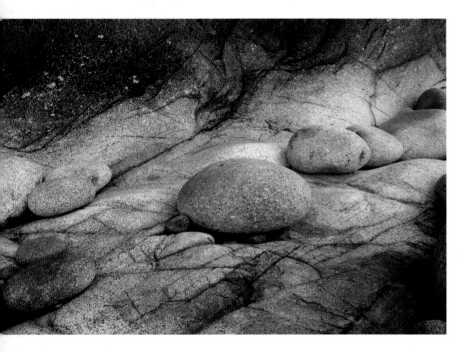

Porth Nanven, Cornwall, England

Camera: Tachihara 5x4in

Lens: Super Angulon 90mm (Wide Angle)

Filter: None

Film: Fuji Provia 100

Exposure: 1/2sec at f32

Waiting for the light: 30 minutes

Porth Nanven, Cornwall, England

Camera: Tachihara 5x4in

Lens: Super Angulon 90mm (Wide Angle)

Filter: None

Film: Fuji Provia 100

Exposure: 1sec at f/32

Waiting for the light: Immediate

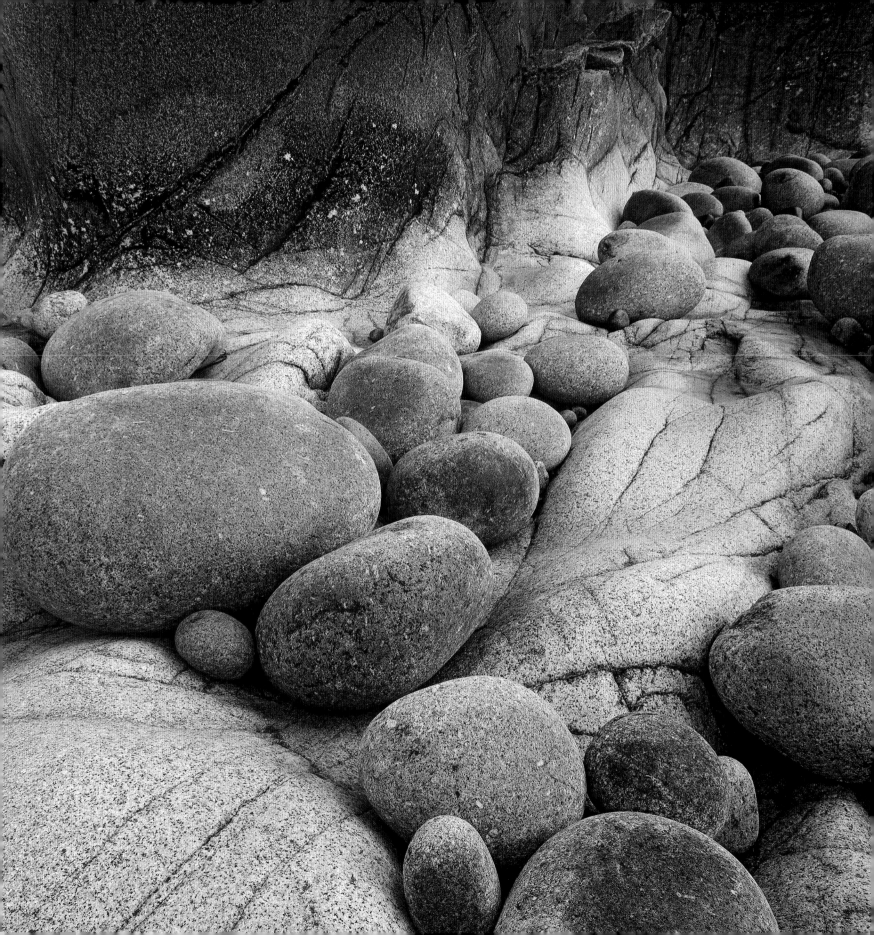

▶ A Whisper of Colour

Colour is, once again, a subdued feature of this North Yorkshire snow scene. There is very little of it, in fact the photograph is almost monochrome, but the presence of a hint of colour is, nevertheless, very important. Those cool, wintry hues are essential to the picture's mood and atmosphere and the interesting thing about colour is that it doesn't have to shout at the viewer in order to make itself heard. Sometimes a faint, seductive whisper can be more effective than a bellowing, thunderous roar.

When photographing a snow-coloured landscape my inclination would normally be to warm the scene by adding an 81B, or the slightly stronger 81C filter. But there are occasions – and this was one of them – when the winter blues should be left just as they are. There can be no strict rule about this. It depends on what you want your picture to convey and you can only make a judgement at the time of capturing the image.

It is not just the colour of the sky that's a key element in this image, its tonal range is also important. Quite often this type of cloud can be a featureless, bland expanse of milky white monotony that doesn't photograph well. This had to be avoided and it took an hour of sky-watching before I was satisfied with its appearance, but it was worth the wait. A weak sky would have made no contribution to the image and would, in fact, have caused it to fail.

Near Thornton Rust,
North Yorkshire, England

Camera: Tachihara 5x4in
Lens: Super Angulon 150mm (Standard)
Filter: 0.3ND grad
Film: Fuji Provia 100
Exposure: 1/8sec at f/16.5
Waiting for the light: 1 hour

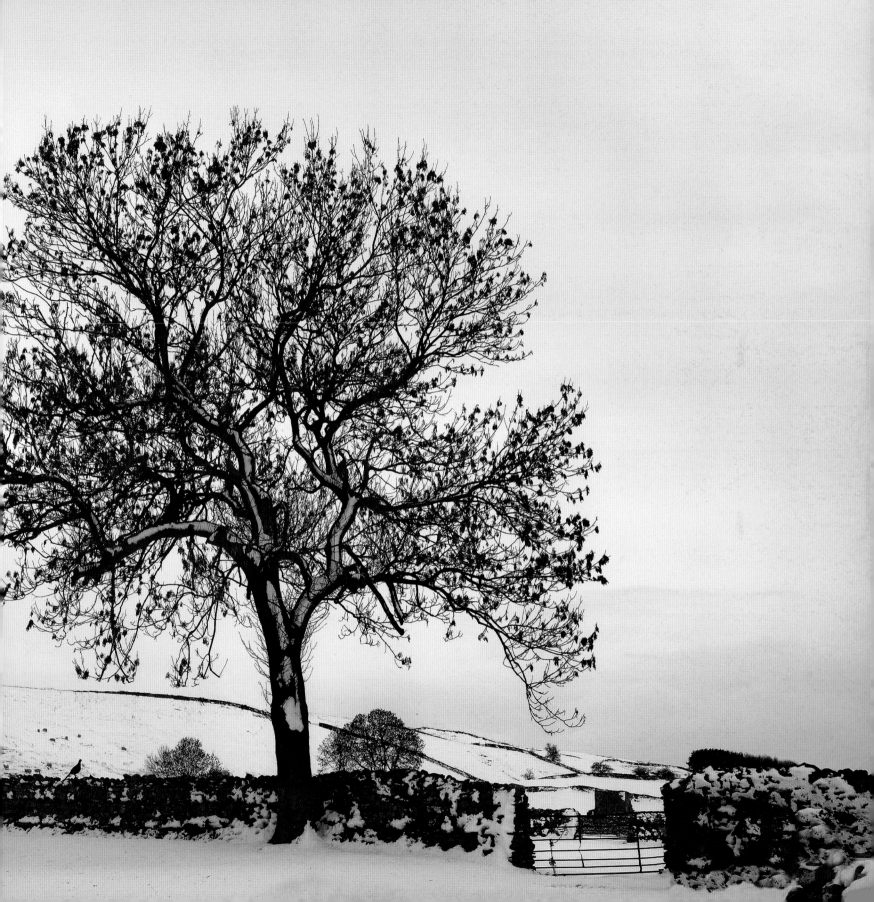

▶ Reflecting Characteristics

Every country has, within it, its own regional characteristics. These can vary greatly from area to area, even in a country the size of Britain, and they can have a marked impact on the appearance of the landscape. These localized traits can say a lot about the history and culture of a community and they can also be a real aid to the photographer. This is why, when searching for pictures, I like to incorporate, or build my image around, objects which reflect the true nature of the local environment.

The photographs here and on the opposite page were both taken in Snowdonia. Although completely different they do, I feel, reflect both the character and geography of this striking part of Wales. It is both a mountainous and a working farm area where grazing and pasture land nestles seamlessly between the hills and valleys;

it also has a long history as an important slate-mining area. Dry-stone walls are a common, and very attractive, feature and they are, of course, marvellous to photograph, both as a close-up and as an adornment of the landscape.

I was following a wall along a narrow road, looking for a viewpoint, and eventually arrived at a position that provided a view across the Nant Ffrancon valley. All the elements were there: foreground grasses, farm gates, dry-stone wall, slate, a distant, isolated farm and all set against a towering, skyscraping backdrop. The search was over, there was a photograph here, waiting to be captured.

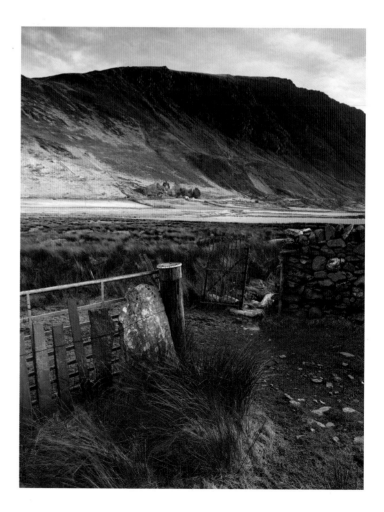

Nant Ffrancon, Snowdonia, North Wales

Camera: Mamiya 645ZD
Lens: Mamiya 35mm (Wide Angle)
Filter: 0.6ND grad
Film: Dalsa CCD sensor ISO 100
Exposure: 1/2sec at f/22
Waiting for the light: 30 minutes

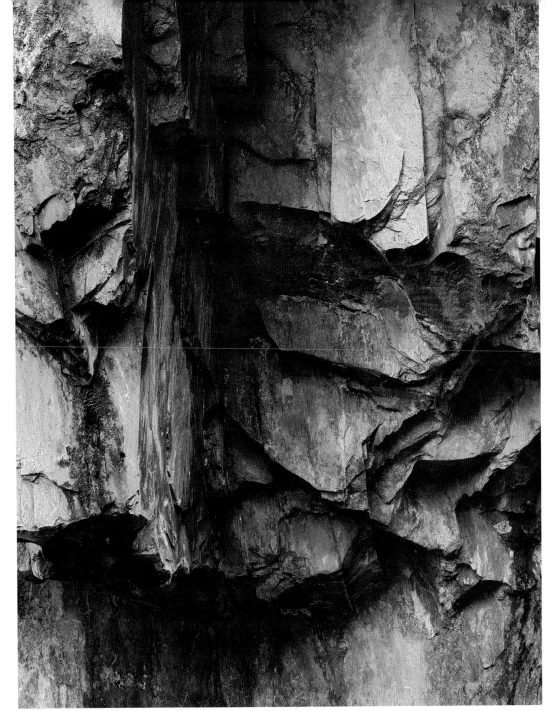

Nant Ffrancon, Snowdonia, North Wales

Camera: Mamiya 645ZD
Lens: Mamiya 80mm (Standard)
Filter: None
Film: Dalsa CCD sensor ISO 100
Exposure: 1/2sec at f/16
Waiting for the light: Immediate

Although the picture on the facing page adequately depicts the character of Snowdonia, I am not completely happy with it. The problem is the farm, which is too small and insignificant. I was aware of this at the time and tried to compensate for it by capturing the farm in a splash of sunlight, but it hasn't succeeded. The image is a little unbalanced and suffers from a lack of visual interest beyond the foreground. Because of this I prefer the photograph above, of the rock detail. Although obviously a completely different type of picture, which doesn't portray the open landscape, I think it is a stronger image. And, of course, any photographic essay of a place should contain a number of small-scale, close-up pictures of intricate detail. These are just as important as the wider views and should not be overlooked.

▶ Leafless Wonders

Many subjects can only be photographed during the winter months and seasonal favourites of mine are leafless trees. This annual feature of the hibernating landscape can be rewarding to photograph and should not be considered an 'autumn only' subject. Clothed in leaves, trees often conceal intricate shapes and patterns but, during their dormant period, deciduous trees can, in every sense, be a revelation. They photograph particularly well as a silhouette against a sunset/sunrise sky and can bring an extra dimension to many 'skyscapes'.

TIP: Unless they are of an intricate and interesting shape, large expanses of pure black are usually best avoided. Here the use of a one-stop ND grad filter has prevented the foreground field from being depicted as a total silhouette.

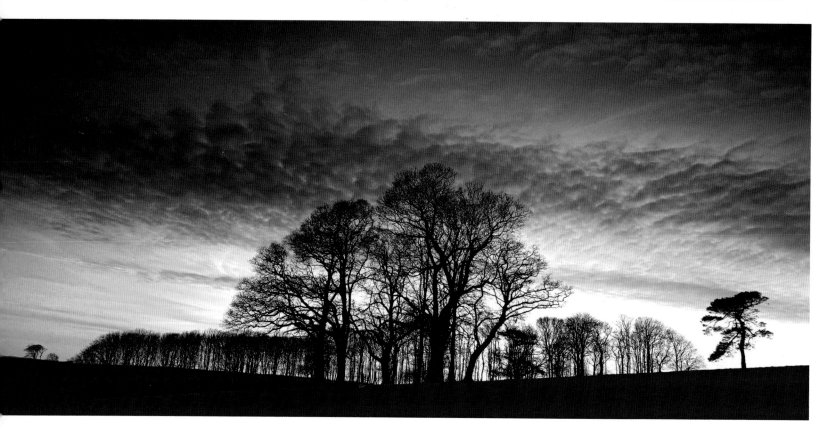

Near East Allington, Devon, England

Camera: Fuji GX617
Lens: Fujinon 105mm (Standard)
Filter: 0.3ND grad
Film: Fuji Provia 100
Exposure: 1/4sec at f/16.5
Waiting for the light: 45 minutes

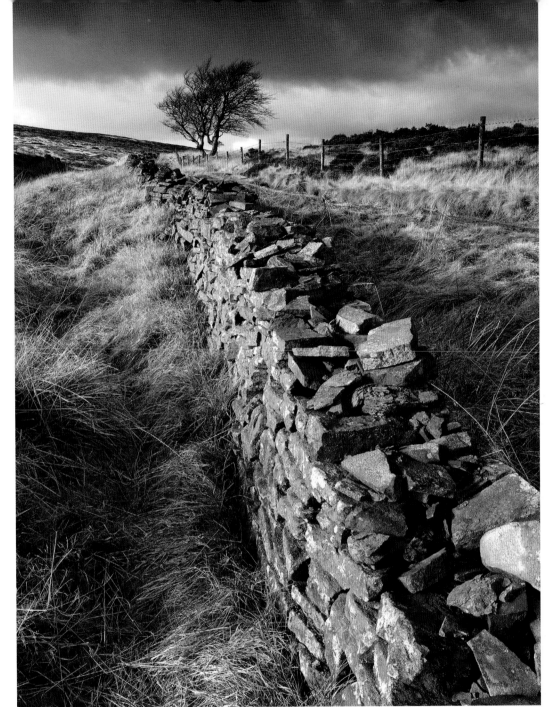

The Goyt Valley, The Peak District, England

Camera: Tachihara 5x4in
Lens: Super Angulon 90mm (Wide Angle)
Filter: 0.6ND grad
Film: Fuji Provia 100
Exposure: 1/2sec at f22
Waiting for the light: 1 hour

There was to be no sunset on this stormy February day but the leafless tree still makes its presence felt against the brooding, heavy sky. The tree is not diminished by its lack of leaves. Indeed this, perhaps, adds to the stark bleakness of the scene and reinforces the raw, winter-day theme. A bright splash of green foliage would have made no beneficial contribution to the image and would, perhaps, have weakened the drama.

▶ A Winter Wonderland

Winter can still bare its teeth, even as late as the end of February. On the day these photographs were captured temperatures hovered around freezing point, as they had done for the previous week. The snow, frost and ice were deep and plentiful and much of the landscape resembled a winter wonderland. To my delight this provided an opportunity to create a number of images of what can only be described as a traditional, old-fashioned winter.

Snow-covered surfaces are very efficient light reflectors and bright highlights can form, resulting in overexposure and a loss of detail. A neutral-density graduated filter can sometimes prevent this and one was used in the making of the picture of West Burton waterfall (below).

It was positioned over the lower half of the photograph only, in order to reduce the brightness of the foreground rocks without affecting the darker parts of the picture. This has enabled the entire image to be accurately exposed with detail retained in both the highlights and shadows.

TIP: ND graduated filters aren't just for skies. Use them to reduce highlights and contrast in other parts of the picture.

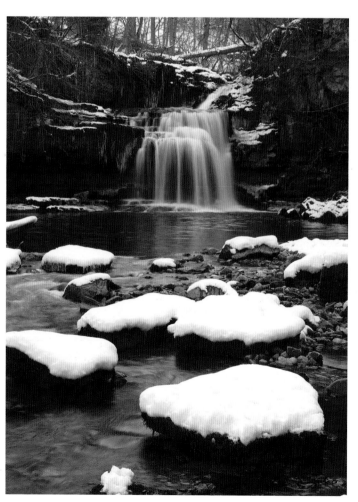

West Burton, North Yorkshire, England

Camera: Mamiya 645ZD
Lens: Mamiya 80mm (Standard)
Filter: 0.45 ND grad
Film: Dalsa CCD sensor ISO 100
Exposure: 1/2sec at f/20
Waiting for the light: Immediate

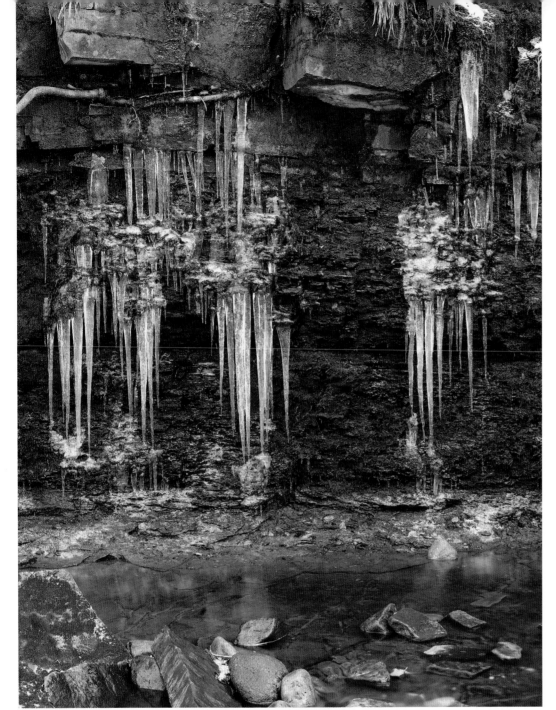

Fossdale Gill, North Yorkshire, England

Camera: Mamiya 645ZD
Lens: Mamiya 80mm (Standard)
Filter: None
Film: Dalsa CCD sensor ISO 100
Exposure: 1sec at f/16
Waiting for the light: Immediate

Icicles resembling stalactites are relatively rare in Britain but this memorable sight is what greeted me as I approached a trickling stream at Fossdale Gill. The ground was covered in solid, packed ice and it was with some trepidation that I began to set up my tripod.

Eventually, with everything securely in position, it was a relatively simple task to capture the scene. So, picture taken, one frozen – but very happy – photographer made the tortuous trek back to civilization to reflect on a gruelling, but very satisfying, morning's work.

Chapter Three

▶ March

March can be a surprisingly productive month. It is

an unpredictable time of year and the whole spectrum

of weather conditions – from dry and sunny to gales

and blizzards – can be experienced, and often is.

This can create many unexpected opportunities so, when

planning excursions, a certain amount of flexibility can

be of benefit. Choose locations that hold a number of

options. Woodland and forests, for example, can yield

images of rivers and waterfalls and provide a degree

of protection from inclement weather. Coastal areas,

too, have real potential during late winter and early

spring. Dawn and dusk occur at convenient times and

changeable conditions can create striking skies.

▶ Choosing a Format

The day was ending on a high note as I visited an open stretch of beach along the Dee Estuary and it was possible to make a number of images in both portrait and landscape formats. The choice of format – vertical or horizontal – is an important decision because it will have a fundamental effect on your composition and, ultimately, the success or failure of a photograph can hinge on which one you elect to use. Sometimes the choice can be difficult to make and if you are at all uncertain – as I was on this occasion – then the answer is to take both formats. There is nothing wrong with this, it doesn't mean you're being indecisive; if you are uncertain it's probably because your subject suits both formats so, if you have time to shoot both, why sacrifice one for the sake of making a choice? There can also be a benefit to this because you can often make two quite different, but equally successful, images of the same subject.

Of the two photographs here my preference has wavered – I have, at one time or another, favoured on or the other – at the moment I prefer the portrait version on the facing page, but that could well change the next time I compare them. So, I couldn't make a decision at the time of taking them and I can't really decide now. I'm happy with that, however, because, of course, I now have two images, not just one.

TIP: An 81B or 81C filter will improve the colour of sand even in warm sunlight.

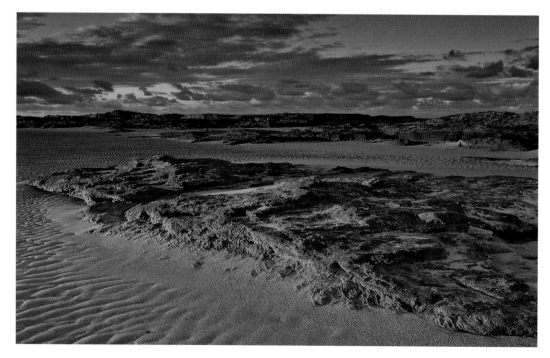

Hoylake, Wirral, Merseyside, England

Camera: Tachihara 5x4in
Lens: Super Angulon 90mm (Wide Angle)
Filter: 0.6ND grad, 81B
Film: Fuji Provia 100
Exposure: 1/2sec at f/22
Waiting for the light: 20 minutes

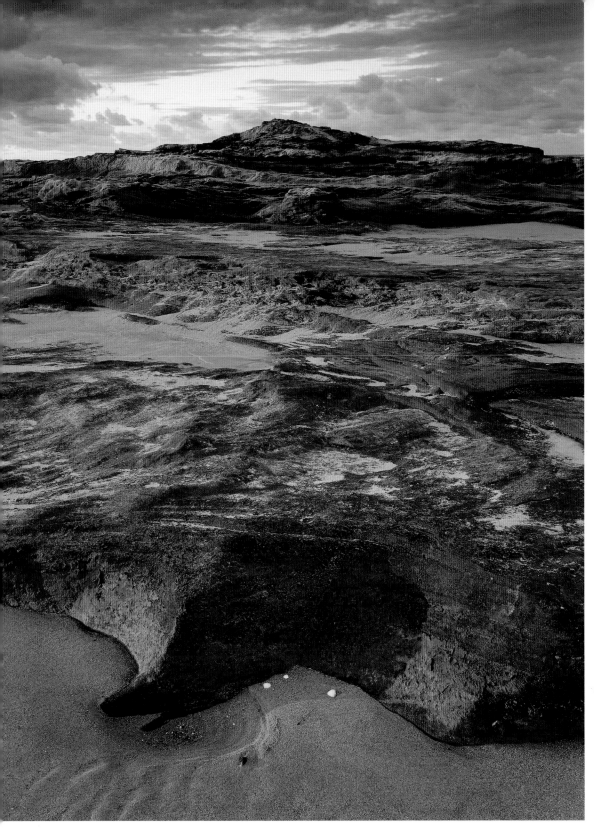

Hoylake, Wirral, Merseyside, England

Camera: Tachihara 5x4in
Lens: Super Angulon 90mm (Wide Angle)
Filter: 0.6ND grad, 81B
Film: Fuji Provia 100
Exposure: 1/2sec at f/22
Waiting for the light: 20 minutes

▶ The Annual Display

Here is another example of trees coming into their own during their dormant period. Draped in a blanket of leaves those glorious, twisting and weaving branches would be lost to the world and there would be nothing to photograph. Thankfully the seasonal cycle guarantees an annual display and what a display it can be.

To my mind, there is often a slightly sinister element in the appearance of leafless trees. I'm not sure why this is, the effect must be subliminal. It's possibly because leafless trees seem to suggest winter, dark nights, stormy weather and an inhospitable, forbidding landscape. It is certainly a fact that any drama in an image will be intensified if leafless trees are present. They reinforce mood and atmosphere and are a tremendous aid to the photographer. They are also an excellent subject on their own. Capture them in the right light, with a strong sky, and you should have the makings of a distinctive photograph.

TIP: The backlighting is an important feature in this picture. In addition to adding drama to the scene it gives shape and modelling to the steeply sloping hillside. Softer, non-directional light would have flattened the image and as a result greatly diminished it.

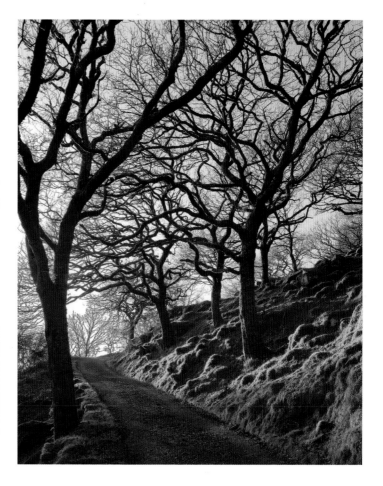

Near Cwm Bychan, Snowdonia, Wales

Camera: Mamiya 645ZD
Lens: Mamiya 35mm (Wide Angle)
Filter: 0.3ND grad
Film: Dalsa CCD sensor ISO 100
Exposure: 1sec at f/22
Waiting for the light: Immediate

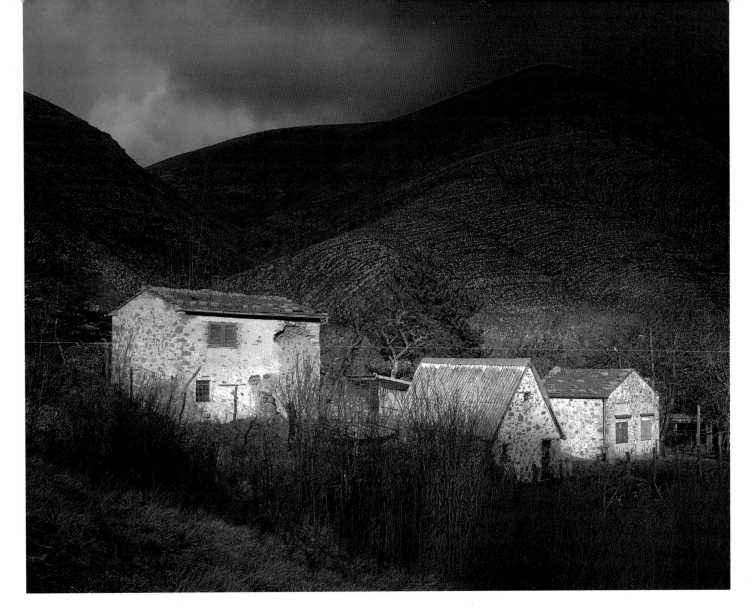

Montefegatesi, Tuscany, Italy

The drama continues in the hills of Tuscany. This time it is, of course, light which sets the tone. The surrounding landscape is so dark that the splash of sunlight – the last ray of light for the day – could easily be mistaken for moonlight. Using spotlighting in this way can be very effective. In stormy weather look for breaks in the cloud and watch as shafts of sunlight play across the terrain, illuminating specific features. This can be particularly useful if the landscape is a little mundane, because you can use shadow to subdue the less interesting parts and wait for the spotlight to fall on the features you want to highlight. It will usually require a fair degree of patience but this approach can transform an inferior location into something spectacular.

Camera: Tachihara 5x4in
Lens: Super Angulon 90mm (Wide Angle)
Filter: 0.3ND grad
Film: Fuji Provia 100
Exposure: 1sec at f/22.5
Waiting for the light: 40 minutes

TIP: Grey skies are often brighter than they appear. A 0.3 or 0.6ND graduated filter will help to retain detail and strengthen their appearance.

▶ Balanced Foreground

Frustration is a word I have come to loathe. Like most, if not all, outdoor photographers it is a feeling with which I have become very familiar. This is, unfortunately, an occupational hazard because we are, of course, operating in an environment over which we have absolutely no control. Too little light, too much light, light in the wrong place, wind, rain, landscape disfigurements and a myriad of obstacles of one description or another – they are all part of a photographer's day and it's hardly surprising that frustration can occasionally rise to the surface.

I am not complaining, though, because without the disappointments there would be no sense of achievement and it is the successes – often against adverse conditions – which make it all worthwhile. Having said that, any success with this photograph of the Snowdonia landscape (if, indeed, it was a success) is mitigated by my failure to capture the image in perfect light.

There should have been splashes of light from front to back, with the centrally placed tree and the distant groups of trees brightly lit against a subdued landscape but, despite waiting for more than two hours, the beams of sunlight – and there were many – would not fall where they were needed. The photograph is therefore a compromise (another word I dislike) and a slight disappointment. The image isn't a complete failure because the marvellous dry-stone wall is an important feature and because of this the quality of the landscape, rather than the quality of light, still shines through. There is no doubt, though, that the photograph could have been better.

TIP: If composing a picture around a large, dominant foreground, make sure it doesn't become too dominant. If very brightly lit, it is likely to become the main feature and there will be no foreground/background balance. Use shadow or weak sunlight to subdue foreground elements and divert attention to more distant objects.

Near Beddgelert, Snowdonia, Wales

Camera: Mamiya RB67
Lens: Mamiya 50mm (Wide Angle)
Filter: 0.6ND grad
Film: Dalsa image sensor ISO 100
Exposure: 1/2sec at f/22
Waiting for the light: 2½ hours

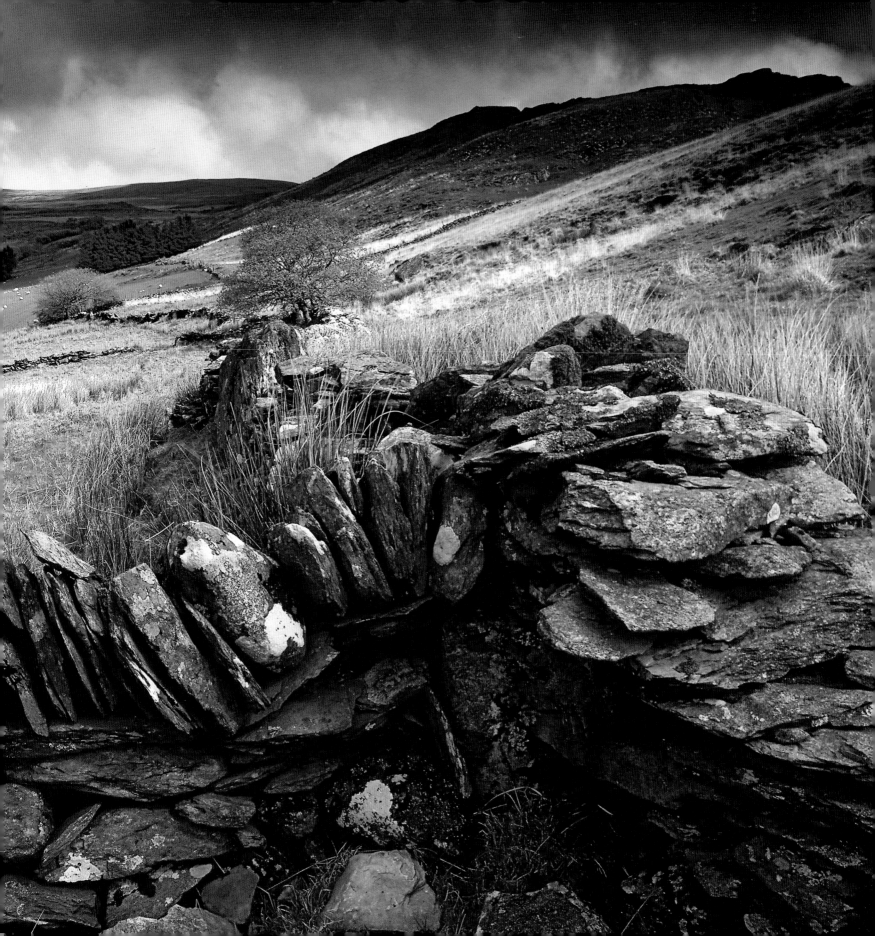

▶ Creating Atmosphere

Mist and fog can still be prevalent during late winter and early spring, particularly at dawn and dusk. Days can draw to a hazy, atmospheric close, as can be seen from these images, both of which were taken as the sun was setting. Mist is a little more predictable than sunsets, which is fortunate because timing is critical: choose your moment carefully, because the density of the haze or fog is the critical element.

There should be sufficient to create atmosphere, but with enough visibility to allow landscape features to be discernable. As a rule I don't warm a misty scene because a blue haze is appropriate for the wintry mood. There are, of course, exceptions and if you are lucky enough to have warm sunlight, an 81B or 81C filter will enhance the golden hues, particularly if the scene is backlit.

Higher Sutton, Cheshire, England

Camera: Tachihara 5x4in (12x6cm roll film back)
Lens: Super Angulon 150mm (Standard)
Filter: 0.6ND grad
Film: Fuji Provia 100
Exposure: 1sec at f/22
Waiting for the light: 30 minutes

TIP: Take care with your exposure. A predominantly misty landscape can be underexposed by automatic metering. For safety bracket your exposures and, if you are using a digital camera, check your histogram.

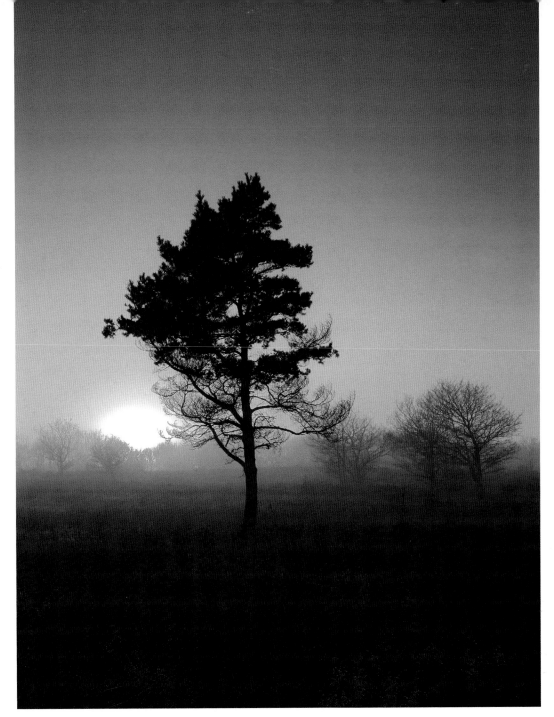

Royden Park Nature Reserve, Wirral, England

Camera: Tachihara 5x4in

Lens: Super Angulon 150mm (Standard)

Filter: 0.45ND grad

Film: Fuji Provia 100

Exposure: 2sec at f/32

Waiting for the light: 45 minutes

TIP: Check your lens regularly when photographing in foggy conditions. Mist can form on its surface and should be carefully removed with a lens cloth.

▶ Dilapidated Glory

The stories behind the making of both this, and the photograph opposite, are similar: at first glance there was nothing of interest but a closer look revealed otherwise. And this is the problem with many places; first impressions can be misleading and sometimes you need to search and scrutinize everything very, very carefully.

The coastal defence wall along much of the Dee estuary is virtually redundant. Because of the silting and the change in the river's course over the years, its main purpose now is to keep the sand in place, rather than the tide at bay. As a result of its relatively stress-free existence it has not been considered necessary to replace or maintain the wall. It is being allowed to age gracefully and you can guarantee that where human intervention is minimal, the natural weathering process of this type of structure will always yield interesting images. It was with this in mind that I embarked on a detailed inspection of every inch of the rust-covered rampart.

It was time well spent and I was truly excited by the find. Here in all its rich, dilapidated glory was a piece of coastline which bore the hallmarks of decades of exposure to the elements. Years of history were etched on the wall's craggy surface, a distillation of the effect of time, and it was there ready and waiting to be captured and preserved. It was a most satisfying discovery and, on this occasion, a two-hour trawl of the estuary had borne fruit. This is not always the case, of course, because success can never be guaranteed but that uncertainty makes the find all the more memorable, and this was an occasion I will always recall with satisfaction and gratitude.

Decaying wood (opposite page) is nature's canvas upon which it produces often breathtaking displays of rich, variegated colour and texture. Once discovered they are relatively straightforward to photograph and provide endless opportunity for distinctive image making.

The Dee Estuary, Wirral, England

Camera: Tachihara 5x4in
Lens: Super Angulon 150mm (Standard)
Filter: Polarizer (fully polarized)
Film: Fuji Provia 100
Exposure: 1/4sec at f/22
Waiting for the light: Immediate
(having found it!)

Sloan Gorge, New York State, USA

Camera: Mamiya 645ZD
Lens: Mamiya 80mm (Standard)
Filter: None
Film: Dalsa image sensor ISO 100
Exposure: 1sec at f/18
Waiting for the light: Immediate

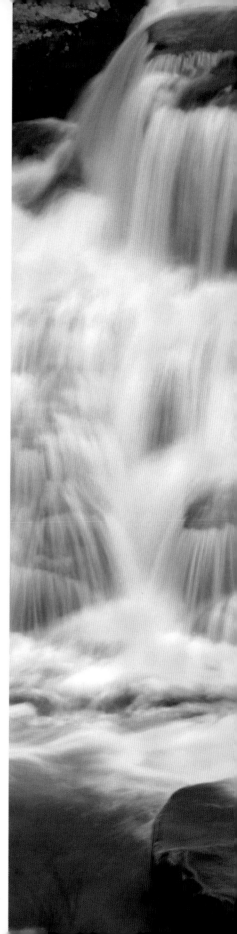

▶ More Rain Please

My arrival in the Catskill Mountains, in New York State, had been preceded by a month of heavy and persistent rain. As a photographer, I reaped the benefits of the torrential downpours because the forests were alive with crashing and cascading rivers and waterfalls. The normal water levels in this region are rather low, particularly during summer and autumn, so the timing of my trip was, by sheer good luck, somewhat fortunate.

There were images everywhere, pictures crying out to be taken. The only obstacle was bright sunlight. Strong, directional light and water are not a good combination because highlights and shadows are usually best avoided. In mountainous areas the solution is to photograph early or late in the day, when the sun is hidden by the surrounding peaks.

The other consideration is the length of your exposure. When water is flowing very fiercely a shutter speed of 1sec might sometimes be too long, as it might cause the water to lose texture and definition. An exposure of 1/2sec might be preferable, particularly when using a telephoto lens, although this is not always possible in low levels of light. The only solution, as discussed on page 118, is to either increase the ISO rating of your image sensor or uprate (push) the speed of your film.

Plattekill Creek, New York State, USA

Camera: Mamiya 645ZD
Lens: Mamiya 150mm (Telephoto)
Filter: None
Film: Dalsa image sensor ISO 200
Exposure: 1/2sec at f/22
Waiting for the light: Immediate

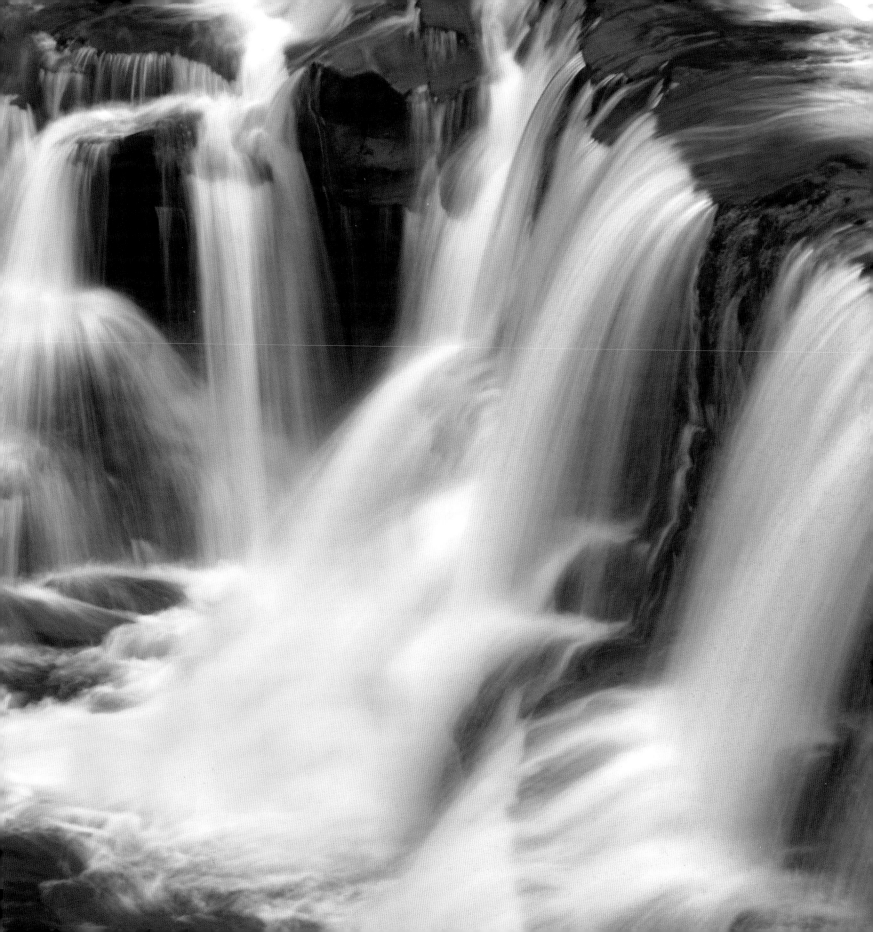

Chapter Four

▶ April

This is the month when the landscape bursts into colour. The start of the growing season means that appearances can change quickly at this time of year. Farmland is a fertile landscape in more ways than one and can yield as many images as it does crops, so keep a close eye on arable fields. They can be a hive of activity and images can emerge and disappear on a daily basis. Trees, too, now show signs of life and often display bright, vivid greens which gradually fade as summer approaches. But it's not all about the bountiful landscape because clear nights can cause mist to linger in valleys and give dawn an added dimension. If the forecast looks promising, rise early to catch what is often the best moment of the day.

▶ A Rich Source of Images

Llyn Dinas is a mountain lake in the heart of Snowdonia, Wales. It is a place I visit often because, as with most lakes, its appearance is always changing. Constant variations in light, sky, water levels and the seasons ensure there is always something new to contemplate. Also worthy of regular attention is the Afon Goch, a river which follows a steep course down a mountainous slope to flow into the lake. The speed and depth of its water changes dramatically according to the rainfall, and the surrounding leafy bushes and trees always seem to display a variety of colourful hues. The river is so steep that it is virtually a series of mini – and at times not so mini – waterfalls. There is a lot to observe and despite my many visits I have yet to examine every part of it. It can be very wet and treacherous but one day I'll make it all the way up to its lofty summit. Such a climb is by no means essential, though, because there is ample to satisfy those who prefer a more cautious approach along the river's lower levels.

This image was made at one of its more accessible points and I like to think it captures the essence of both the river and the surrounding landscape. Although I elected to use a landscape format, there were, as you might imagine, a number of possible alternatives. One option would have been to move in closer and concentrate on the smaller details or, perhaps, photograph the river in a portrait format. The choices were numerous – and all from just one part of the river. My intention was in fact to take a number of different pictures, but the onset of rain brought proceedings to an unexpected close for the remainder of the day. It wasn't too disappointing, however, because it had been possible to capture the image I wanted. There will always be another time, and this is one of the great attractions of finding a steep, fast-flowing river: there will always be new, alternative photographs waiting to be teased out of the rocks and tumbling waters. Find yourself such a river and you will have discovered a rich source of striking images.

**Afon Goch, Llyn Dinas,
Snowdonia, Wales**
Camera: Mamiya 645ZD
Lens: Mamiya 35mm (Wide Angle)
Filter: None
Film: Dalsa sensor ISO 100
Exposure: 1sec at f/16.5
Waiting for the light: Immediate

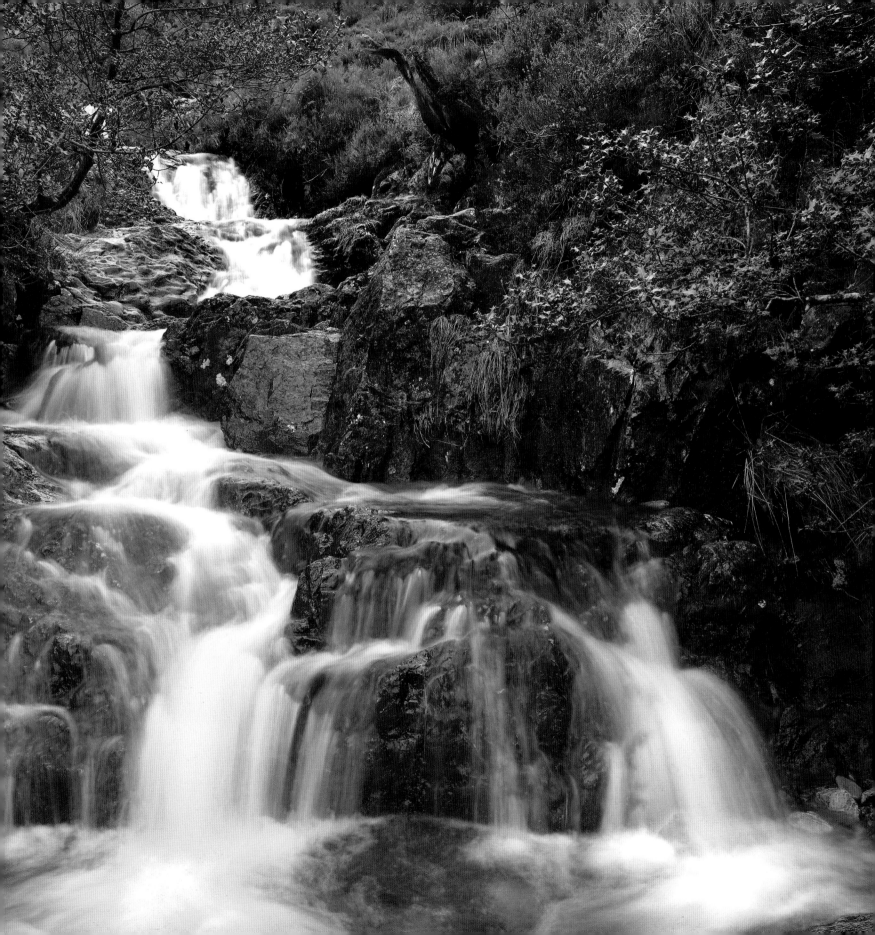

Essential Elements

Freshly tilled land radiates with graphic lines and eye-catching, repetitive patterns. Even in this image of a colourful evening sky, the small strip of land below the twilight display still draws the eye. Despite its diminutive size, the contribution the farmed field makes is immense. Without it the picture would have been greatly diminished – probably to the point of failure. I was therefore fortunate to stumble upon the field because I had no idea it was there. I could see the sky developing and was searching frantically for a viewpoint, looking for a piece of landscape or a group of trees, or in fact anything that would act as a focal point and complete the picture. And suddenly, turning a corner, my heart leapt as soon as it came into view; those glorious flowing lines were just what were needed. An arable field and a sunset sky are not, it should be said, conventional partners, but nevertheless it proved, on this occasion, to be, in my view, a successful pairing.

TIP: The use of a two-stop (0.6) ND filter has reduced the light value of the sky and has enabled detail to be retained in both sky and landscape – which is essential for this type of photograph.

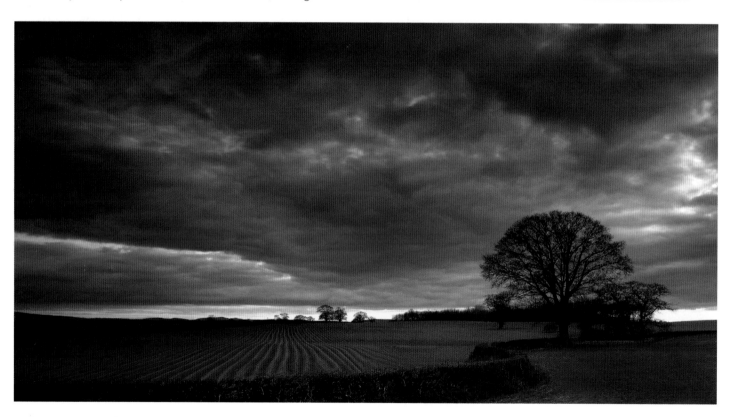

Near Ruabon, Clwyd, Wales

Camera: Tachihara 5x4in
Lens: Super Angulon 90mm (Wide Angle)
Filter: 0.6ND
Film: Fuji Provia 100
Exposure: 1/2sec at f/16.5
Waiting for the light: Immediate

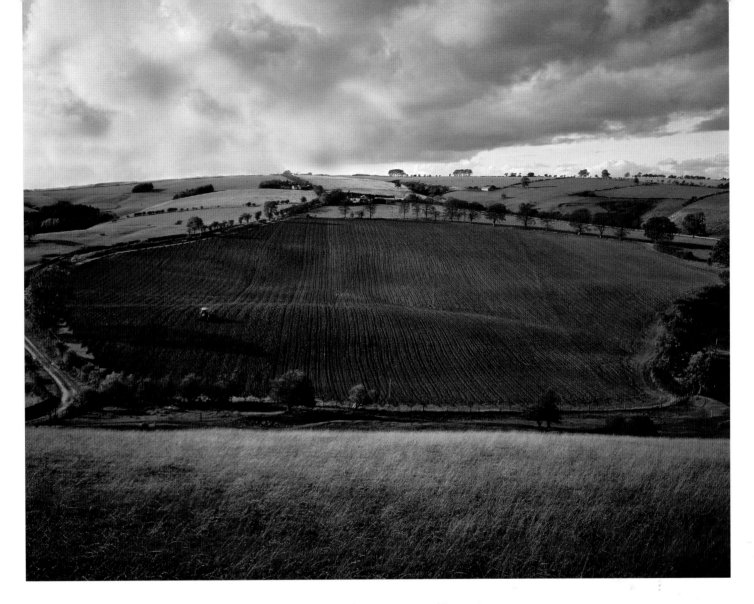

South of Shrewsbury, Shropshire, England

Camera: Tachihara 5x4in
Lens: Super Angulon 90mm (Wide Angle)
Filter: 0.3ND
Film: Fuji Provia 100
Exposure: 1sec at f/32
Waiting for the light: 50 minutes

Generally speaking I prefer not to have people or any signs of activity in my photographs. I like the landscape to have a certain purity, and a timeless quality. Unrelated elements can be a distraction because they draw the eye and obscure more subtle features in the image. There are exceptions, of course, one of them being the occasion this photograph of rolling farmland was captured in the heart of the softly undulating Shropshire hills.

Had the farmer not been ploughing the field I probably wouldn't have taken the image. It is the bright blue tractor – and what a glorious colour it is, a complete contrast to the rich brown soil – which, despite its diminutive size, is the focal point. It commands attention and, together with the surrounding trees, brings a sense of depth and scale to the picture. The other important element is the low sidelighting. The long shadows cast by the sun emphasize the plough lines (which help to create depth) and also highlight the tractor.

▶ Choosing the Strongest Composition

Although lacking in seasonal characteristics, coastal photography has always appealed to me. It's not only the sea views and big, dramatic skies that are attractive, it's also the miniature worlds of colour, texture and patterns which I find so alluring. These tiny microcosms – landscapes within landscapes – are scattered along the coastline and, rich in graphic detail, are a perfect subject for the camera.

Colourful rocks and cliff faces can make interesting images, but careful scrutiny will be necessary if you are to discover the strongest composition. Searching for the right arrangement takes time and experience, but with practice and trial and error successful foraging should be possible. Having found your subject you will at that point sometimes have a fundamental decision to make. Do you isolate a specific part of it and produce an abstract image, or do you use a slightly wider view and depict the subject in its environment to enable it to be viewed in the context of its surroundings?

There is no hard and fast rule to this and a decision should be made on the basis of the merits of both types of approach. If the subject has strong graphic qualities which can be emphasized by concentrating on small details, then a close-up, abstract image might be the better choice. If, on the other hand, you feel that a slightly wider view would be more appropriate then look for a composition which includes background information, but not so much that it detracts from the main subject. Sometimes it is worth making both wide and close-up images because with many subjects quite different photographs can result and both approaches can be successful.

TIP: When photographing wet rocks a polarizing filter will help to reduce surface reflections and this will, in turn, increase colour saturation slightly.

Carbis Bay, Cornwall, England

Camera: Fuji GX617
Lens: Fujinon 105mm (Standard)
Filter: Polarizer (fully polarized)
Film: Fuji Provia 100
Exposure: 1/2sec at f/22
Waiting for the light: Immediate

▶ A Rare Opportunity

Perfection in a landscape is a rare commodity. Blemishes and disfigurements, both man-made and natural, are all too common and are a frequent source of frustration to the photographer. These unwanted elements are widespread and are not confined to dry land; rivers and streams are rarely perfectly arranged and photographing them successfully always requires meticulous composition and a very careful selection of viewpoint.

You can imagine my delight, therefore, as I discovered this heaven-sent opportunity – a morsel of nature in perfect equilibrium. Everything is exactly how I would have organized it. Nothing is missing, out of place or wanting in any way. From the texture of the flowing waters to the shape and colour of the central rocks, there is nothing that could be improved. Every part of the image makes a contribution to the whole and each individual element sits in harmony with its neighbour. All I had to do was set up the camera and make an exposure.

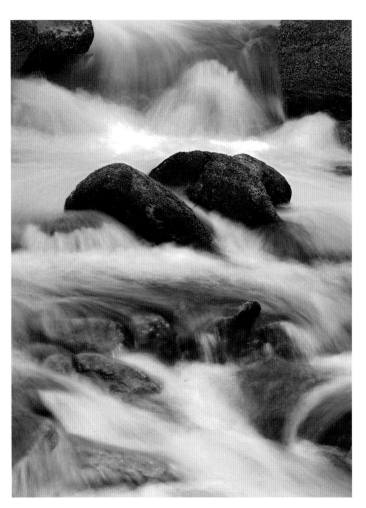

Warner Creek, New York State, USA

Camera: Mamiya 645ZD
Lens: Mamiya 35mm (Wide Angle)
Filter: None
Film: Dalsa image sensor ISO 100
Exposure: 1/2sec at f/22
Waiting for the light: Immediate

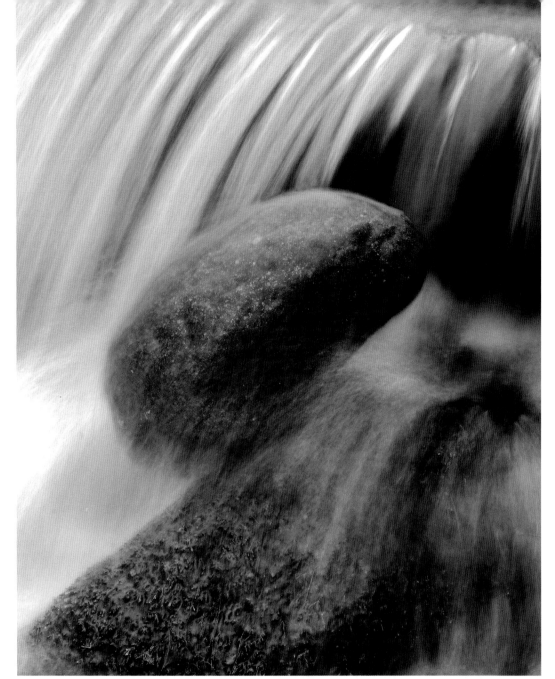

Panther Kill, New York State, USA

Camera: Mamiya 645ZD
Lens: Mamiya 80mm (Standard)
Filter: None
Film: Dalsa CCD sensor ISO 100
Exposure: 1sec at f/22
Waiting for the light: Immediate

It was hardly the height of creativity, but of course the contribution that the photographer makes in these circumstances is the finding of the picture in the first place. These miniscule oases of perfection can lie buried in a desert of mediocrity and, sadly, they often remain undiscovered. Nature can provide the opportunity but after that you're on your own. I have said it many times before but it is a message worth repeating: intensive scrutiny and razor sharp observation are absolutely fundamental to successful image making. Dispense with this approach and you might just as well dispense with your camera.

TIP: Keen observation was required in the making of the image above. The key to success lies in isolating specific parts of the bigger picture. Visually dissect a flowing stream as your eyes roam over it and strip it down to its bare essentials. Seek to capture the essence, not the entirety.

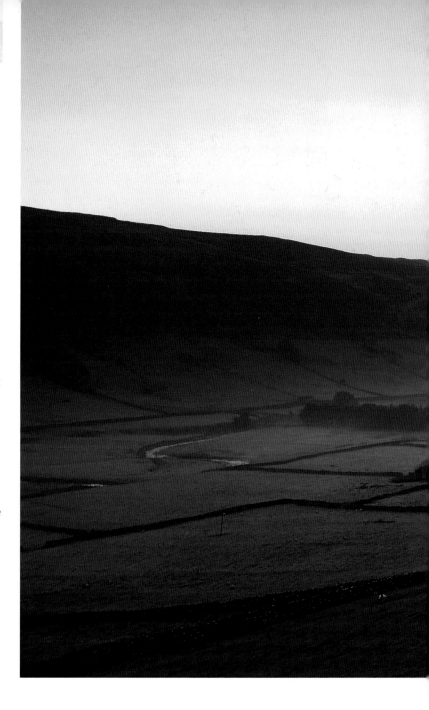

▶ An Entrancing Moment

Dawn is considered by most photographers to be the best time
of day, followed closely by sunset. Dawn has the edge because
there is often an ethereal tranquility, a mist-laden stillness which
is not as common at dusk. This is the attraction, but dawn is
more unpredictable and it can often be a hit-and-miss affair.
The advantage of photographing at the end of the day is that
you are working under a falling, i.e. improving, light whereas at
dawn the light can quickly deteriorate. This doesn't matter of
course if you have captured the optimum moment, but there is often
no time for contemplation and the event can sometimes be rushed.
During the summer months, unless you have great stamina and
energy, you will have to make a choice: do you rise at dawn or wait
for sunset? The rewards are likely to be higher at dawn but so are
the risks. So, do you opt for the higher-risk strategy or play safe and
wait for the end of the day? This can only be a personal decision but
one solution is to restrict your photography to shorter days when
you can observe both sunrise and sunset.

Depending on the prevailing weather conditions, this is the approach
I adopt during the winter months. By April, daylight extends to
more than twelve hours and it is then that I choose between the
two times of day. And how very fortunate it was that, for some
reason, I decided to rise early on the day I captured this image of the
Littondale valley. Its aspect is tailor-made for dawn; standing there,
breathing in the morning air and watching the sky brighten as soft
light and mist permeated the landscape was an entrancing moment
and an occasion to be savoured. This is the beauty of dawn; higher
risk perhaps, but certainly higher rewards.

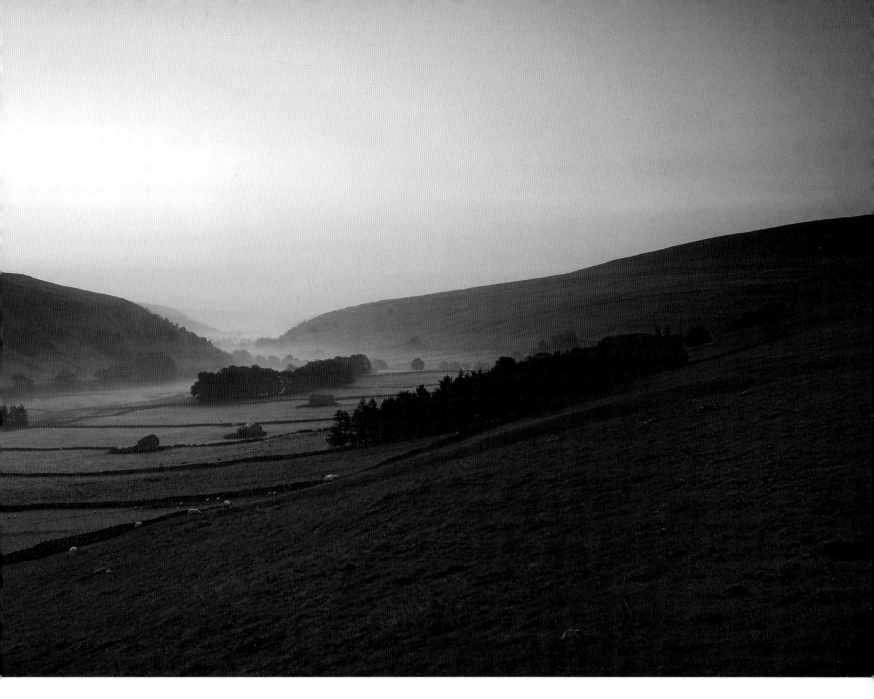

Littondale, North Yorkshire, England

Camera: Tachihara 5x4in (12x6cm roll film back)
Lens: Super Angulon 90mm (Wide Angle)
Filter: 0.6ND grad
Film: Fuji Provia 100
Exposure: 1sec at f/22
Waiting for the light: 40 minutes

▶ Springtime Opportunities

I made a trip to the Catskill Mountains during March and April. This wasn't by choice, autumn would have been my preference, but a combination of deadlines and scheduled commitments prevented this. So, it was to be a spring visit. Although not the peak of the photographic calendar this time of year has its attractions and my trip to the mountainous region of upstate New York was to prove highly rewarding.

Capturing the fleeting beauty of delicate blossom is a springtime-only opportunity and its colourful display is often the equal of even the most striking autumn foliage. It is, however, a more demanding subject to photograph.

The quality of light has to be just right. Not too soft and not too harsh, neither should it be too warm nor too cool (I refer of course to the temperature of the light, not the climate). There is little margin for error. Sunlight softened by hazy cloud usually produces the best results, but consider also the quality of the sky; hazy cloud rarely photographs well so a degree of patience will be required in order to capture the right combination of light and sky.

Near Barrytown, New York State, USA

Camera: Mamiya 645ZD
Lens: Mamiya 80mm (Standard)
Filters: Polarizer (fully polarized), 0.3ND grad
Film: Dalsa image sensor ISO 100
Exposure: 1/4sec at f/18
Waiting for the light: 2 hours

The River Hudson, New York State, USA

Camera: Mamiya 645ZD
Lens: Mamiya 35mm (Wide Angle)
Filter: Polarizer (fully polarized), 0.3ND grad
Film: Dalsa image sensor ISO 100
Exposure: 1/2sec at f/22
Waiting for the light: 1 day

The first flush of spring can be seen along the green, tree-lined banks of the gently flowing Hudson River. It was also possible to repeat the colourful theme in the foreground because, despite it stretching more than 300 miles (500km) inland, the river is tidal and this helps to give colour to the rocks and stones along its shoreline. Repeating a theme across different parts of an image strengthens impact and improves its aesthetic appeal.

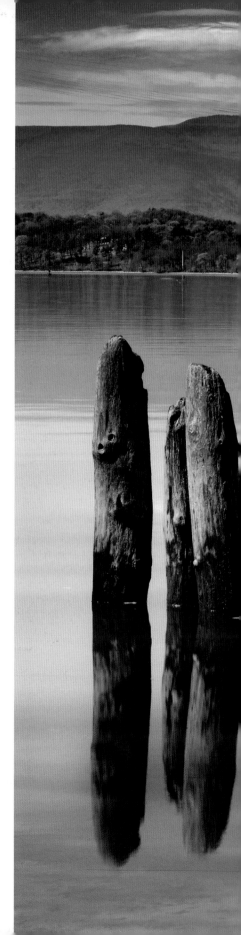

The Missing Piece

During the early stages of the spring season there is a brief period when newly leafing trees display an autumn-like quality. The colours are of a more subtle tone, they don't have the exuberance of the later season, but they can display a warm freshness which, for a short spell, brings an added dimension to the landscape. The tree-adorned banks of the River Hudson were bursting into life and formed an attractive backdrop against the gently flowing waters. The challenge was to construct a photograph because there was a dearth of attractive foreground, and without balancing elements throughout the image, the picture would have been incomplete. My trawl of the river began.

Frustratingly much of the river is inaccessible, long stretches of the banks being in private ownership, and it is in situations like this when large-scale maps become an essential aid. You can leave no stone unturned when searching for foreground elements because all it takes is a tiny area – often just a few square feet – and if it is of the right quality then you have the missing piece to the jigsaw. My map showed an open, public area which looked across the river from the town of Hudson, it also indicated the presence of a lighthouse on the opposite bank – the lighthouses along the Hudson are architectural gems and are, themselves, fine subjects for the camera – and my hopes of making an image suddenly leapt.

Despite the river being tidal, the water was calm and glorious reflections were radiating from its surface. Soon everything fell marvellously into place: foreground elements, colourful reflections, a distant focal point, a mountainous backdrop and, of course, the right quality of light. The River Hudson had, in my star-struck eyes, never looked better and it was with profound pleasure that I photographed it.

The Hudson River, New York State, USA

Camera: Mamiya 645ZD
Lens: Mamiya 150mm (Telephoto)
Filters: Polarizer (fully polarized). 0.3ND grad
Film: Dalsa image sensor ISO 100
Exposure: 1sec at f/32
Waiting for the light: 1 hour

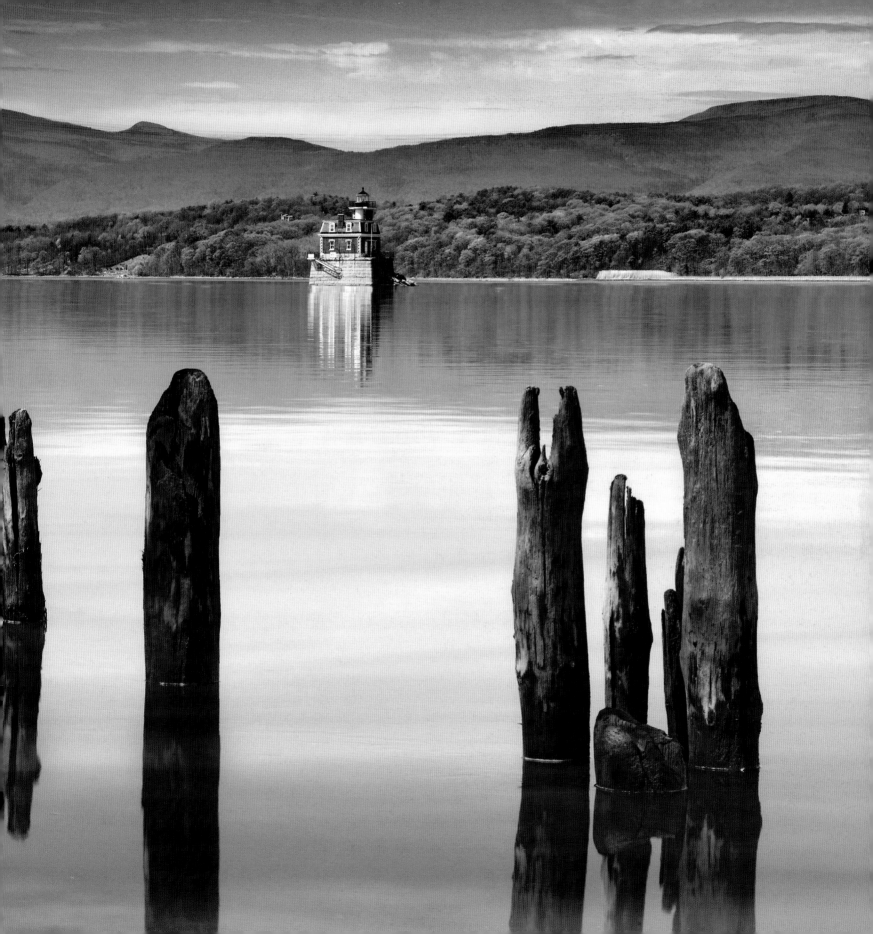

Chapter Five

▶ May

Days are becoming noticeably longer and the flowering

of the landscape continues apace. This is the month

to take woodland walks, to search for wild flowers

and other flora. Prolific growth can result from a

combination of mild weather, sunshine and showers,

so keep a close eye, too, on arable land. Misty,

atmospheric mornings continue throughout May,

particularly after calm, clear nights. Rise early to

catch the best moments and visit sheltered lakes.

The combination of mist hovering above the water's

surface, mirror-like reflections and early morning

sunlight can be a recipe for exceptional image making.

▶ The Effect of Colour

Cloudless blue skies make little contribution to a landscape image and, lacking visual interest, are generally best avoided. There are, however, exceptions to this, one of them being when colour is the theme of the photograph. In order to express this theme simple, bold blocks of colour should be used. A small number of solid segments are therefore preferable to a scattered kaleidoscope of hues because, however appealing they might look at the time of photographing them, a myriad of small, colourful splashes rarely photographs well. The chances are that, when seen as a picture, they will be perceived as little more than a confusing eyesore. Keep the arrangement simple. Include only a small number of colours in clearly defined, easily discernable shapes or patterns.

Which colours you use depends on the mood you wish to convey. Warm tones – those at the red, orange, yellow end of the spectrum – evoke feelings of warmth and comfort while those in the blue area have a calm, tranquil quality. Harmonious hues are also a gentle combination, while contrasting colours are more vibrant and dynamic. Dark, sombre colours will, not surprisingly, produce sombre, atmospheric images while lighter tones will create an airy, more relaxing mood. Another useful quality is the ability of certain colours to create depth. Warm hues give the impression of advancing forward, while cool tones appear to recede. A landscape image with a warm foreground and cool background will therefore have a strong three-dimensional quality.

TIP: Take care when polarizing a clear blue sky. The polarization can lead to uneven darkening, particularly in the corner of sky furthest from the sun. Using only half polarization might be the better option. Check the effect of the filter by viewing the sky through it as you slowly rotate it.

Near Church Stretton, Shropshire, England

Camera: Tachihara 5x4in
Lens: Rodenstock 120mm
(Semi-Wide Angle)
Filter: Polarizer (half polarized)
Film: Fuji Provia 100
Exposure: 1/2sec at f/32
Waiting for the light: Immediate

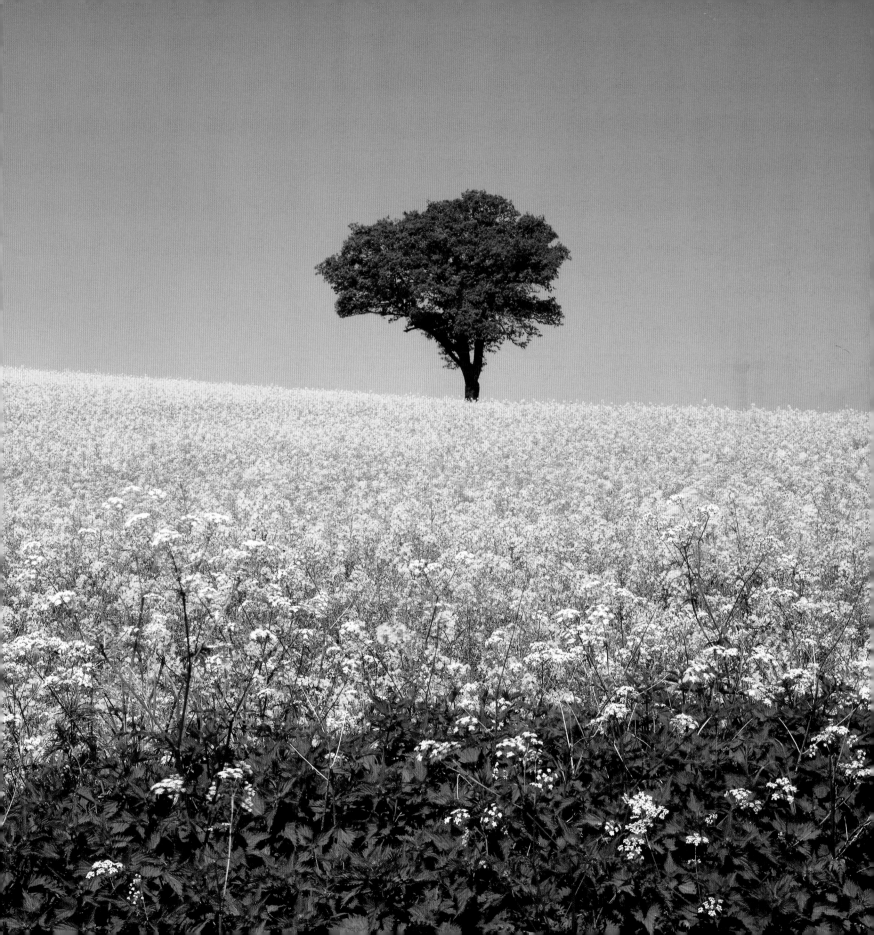

▶ An Essential Ingredient

In any landscape image there is one ingredient which, whatever the season, you must use with infinite care and judgement. That ingredient is, of course, light. Infinitely variable and constantly changing, this is the photographer's precious raw material and, like paint to canvas, it must be applied with the skill and creativity of an Old Master. I cannot emphasize too strongly how important it is; quality light lies at the heart of every quality image and it is no exaggeration to say that your photography will stand or fall by the way the way you use it.

Cors y Llyn, Gwynedd, Wales

Camera: Mamiya 645ZD
Lens: Mamiya 645ZD
Filter: 0.3ND grad
Film: Dalsa image sensor ISO 100
Exposure: 1/4sec at f/18
Waiting for the light: 45 minutes

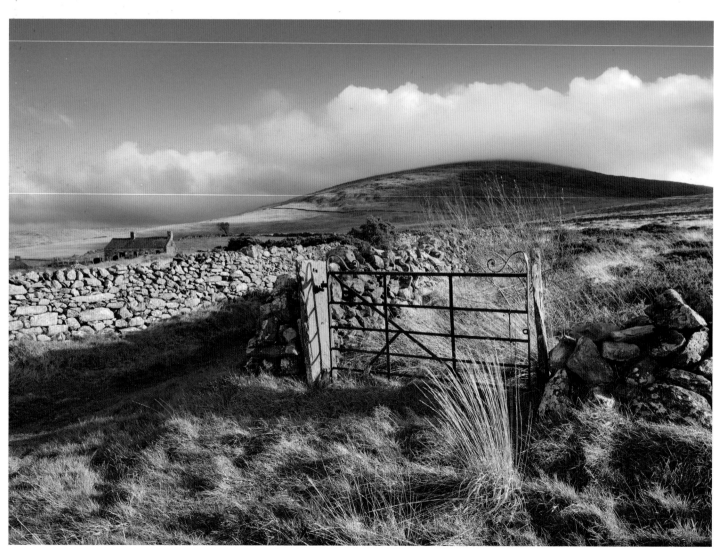

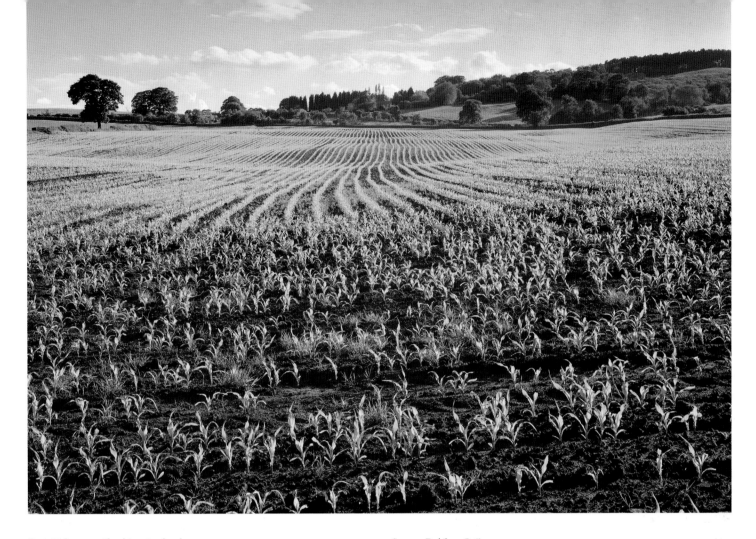

Near Delamere, Cheshire, England

Camera: Tachihara 5x4in
Lens: Super Angulon 90mm (Wide Angle)
Filter: 0.6ND grad
Film: Fuji Provia 100
Exposure: 1/2sec at f/32
Waiting for the light: 50 minutes

Light was the key factor in the creation of the pictures on these two pages. Both images are slightly backlit and it is the quality and direction of the light which gives the photographs depth and impact. Landscapes lit from the rear become enriched and exude a vibrancy which emphasizes depth and texture. This can be seen in the foreground grass in the Cors y Llyn image. It is a pleasant, but unremarkable, landscape which has been elevated by the quality of light. It's not only the grass but also the dry-stone walls which have benefited from the backlighting, because it is the intricate juxtaposition of light and shade which penetrates every crevice and every tiny undulation of the hand-built walls.

Without the forensic searching of the low, angled sunlight the landscape would have been reduced to mediocrity and there would have then been no photograph.

Similarly, had it been frontally lit, the field of sprouting crops would have looked flat and uninteresting. The semi-backlighting has given the delicate shoots and leaves a translucent quality and has accentuated the pattern and graphic quality of the field. The burgeoning crops have been woven into a single, flawless garment – not by nature, but by the glorious evening sunlight.

► Flowing Opportunities

Waterfalls are a rewarding subject at any time of year because it is, of course, rainfall, rather than seasonal considerations, that affects their appearance. Photographically speaking, rivers and streams are uncharted waters and catching a waterfall at its best is largely a matter of luck. There is no right or wrong time to photograph them because they are all different, each one a unique combination of water, rocks and motion and it is the balance between these elements that determines a waterfall's visual appeal.

On the occasion I made this photograph of the delightfully named Sour Milk Ghyll my visit to Cumbria coincided with a spell of unseasonably wet weather. The ghyll was a raging torrent and, while too much water can be as undesirable as too little, fast-flowing streams can be brimming with creative opportunities. From a distance, the water might appear to be a blanket of white foam but look closely and you should, with luck, discover areas of subtle variations in tone and texture. If you can then combine these with a scattering of half-submerged rocks – again there should be some colour in them, avoid black or dark grey because they will look featureless – you will have the basic elements of a successful image.

TIP: If you wish to capture movement in the water you will need to blur the flowing motion and this will require a shutter speed of between ½ and 4secs. The precise length of exposure depends on the speed and direction of the water, but in most cases 1sec will produce good results.

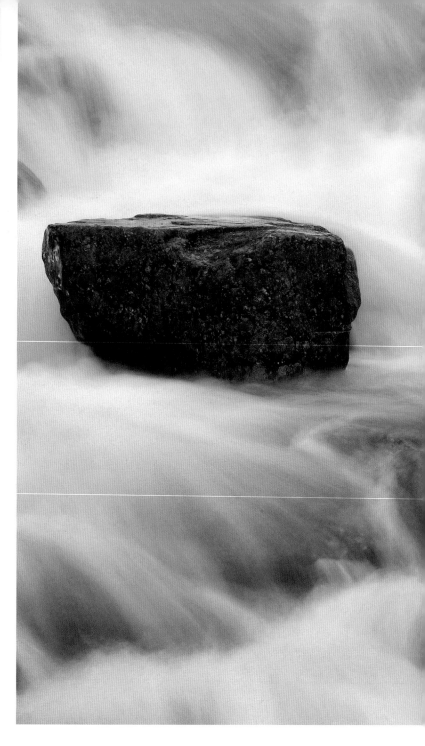

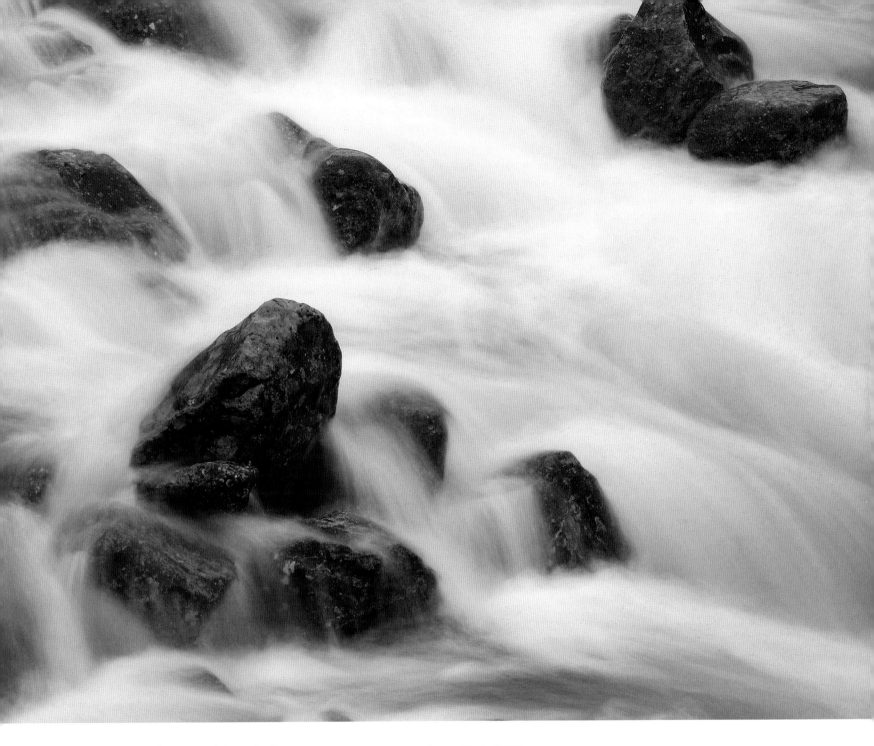

Sour Milk Ghyll, Seathwaite, Cumbria, England

Camera: Mamiya 645ZD
Lens: Mamiya 80mm (Standard)
Filter: None
Film: Dalsa image sensor ISO 100
Exposure: 1sec at f/18
Waiting for the light: Immediate

▶ A Silver Lining

The day didn't look promising but at least it was dry. The prospect of photographing an open landscape seemed remote but Snowdonia has more, much more, than big views. The area has more than its fair share of rain but rain clouds always have a silver lining and you can see them trickling through the forests and down the mountain sides. This is where you will find waterfalls and rock-covered streams that abound with images waiting to be teased out from the flowing waters. They're a perfect subject on overcast days because soft, shadowless light is all that's needed. I was therefore soon scrambling and wading through the streams and rivers in the Nant Ffrancon valley, in the heart of Snowdonia, searching for the right combination of water, rocks, motion and colour.

I eventually settled on the arrangement you see here. It required a central position i.e. standing in the middle of the stream, but the combination of a sturdy tripod and a foolhardy photographer soon had the picture taken. Precarious as it was, I chose the viewpoint because there is great depth in the image. The positions and diminishing size of the rocks, together with the narrowing width of the stream, create an avenue along which the eye can travel and it is very three dimensional. It was certainly worth the effort (and the soaking!).

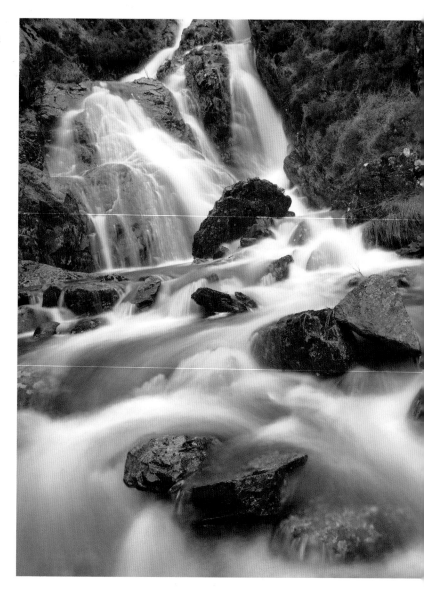

Y Garn Mountain,
Snowdonia, Wales

Camera: Tachihara 5x4in

Lens: Super Angulon 90mm (Wide Angle)

Filter: None

Film: Fuji Provia 100

Exposure: 1sec at f/22.5

Waiting for the light: Immediate

Near Rhyd-Ddu, Snowdonia, Wales

Camera: Tachihara 5x4in
Lens: Fujinon 300mm (Telephoto)
Filter: None
Film: Fuji Provia 100
Exposure: 3sec at f/45
Waiting for the light: Immediate

Many other features, for example dry-stone walls and buildings, can be photographed in subdued light, but if the sky is a monotonous grey it is best excluded from your composition. To reduce the need for highlights and shadows look for specific parts of the landscape which have a varied tonal range and, if appropriate to the nature of your subject, small areas of bright colour. Exclude the sky and extraneous detail by using a telephoto lens to isolate subjects and compress distance. Here the telephoto lens has tightened the composition. It has compressed distance, bringing the foreground wall and background mountain much closer together than they are in reality. This links all the elements together, which emphasizes their tonal and textural difference and this obviates the need for highlights and shadows.

▶ When Storm Clouds Gather

Far from being a deterrent, unpredictable, changeable weather should be considered a challenge and a positive encouragement. As clouds roll in they bring with them opportunities and a day spent out on the landscape sky-watching is rarely a day wasted. Storm clouds can be particularly productive and in Britain they can develop at any time of year – and when they do, they suddenly bring a new dimension to the landscape.

It was therefore with some relief that I saw the clouds gathering on the horizon to bring a promise of enrichment to a rather featureless blue sky. It took time, but eventually a bank of heavy, but colourful, cloud loomed above. The subject and viewpoint were already planned; it was an image I had previously attempted (but with a notable lack of success). I was therefore poised and prepared for the moment, ready to release the shutter the very second the light, sky and landscape combined to dramatic effect.

Unfortunately, although the sky was strong, the sun was determinedly uncooperative and after three hours of waiting I was on the verge of giving up for the day. It was approaching sunset and there seemed little prospect of improvement when suddenly a bright beam of sunlight burst through the thunderous cloud to illuminate my landscape. The light faded as quickly as it arrived but it had been possible to make two exposures – just two, why on earth was I still shooting on cumbersome large-format sheet film – but it had been enough. The picture had finally been taken, which was fortunate because as I drove home the rain – which had been threatening for several hours – finally arrived. It was a deluge but it wasn't unwelcome as it augured well for the following day. And in any case, there's nothing like a storm to brighten up a summer's day!

**Near Leyburn, North Yorkshire,
England**

Camera: Tachihara 5x4in
Lens: Super Angulon 90mm (Wide Angle)
Filter: 0.6ND grad
Film: Fuji Provia 100
Exposure: 1/2sec at f/22
Waiting for the light: 3 hours

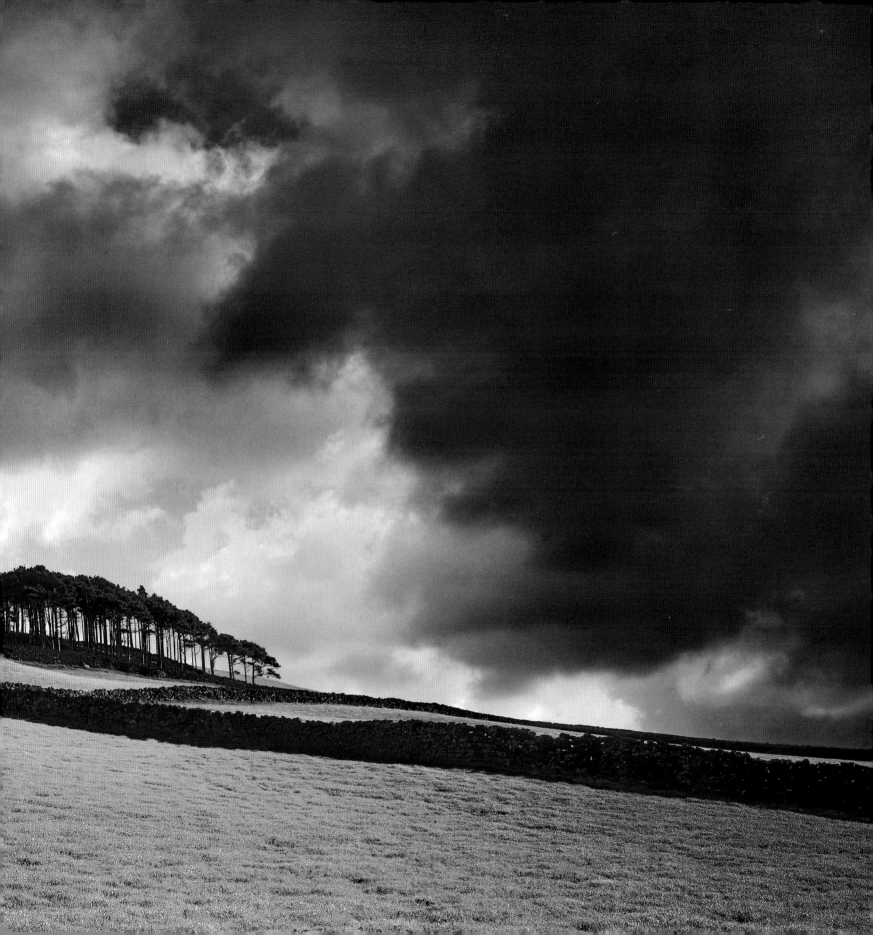

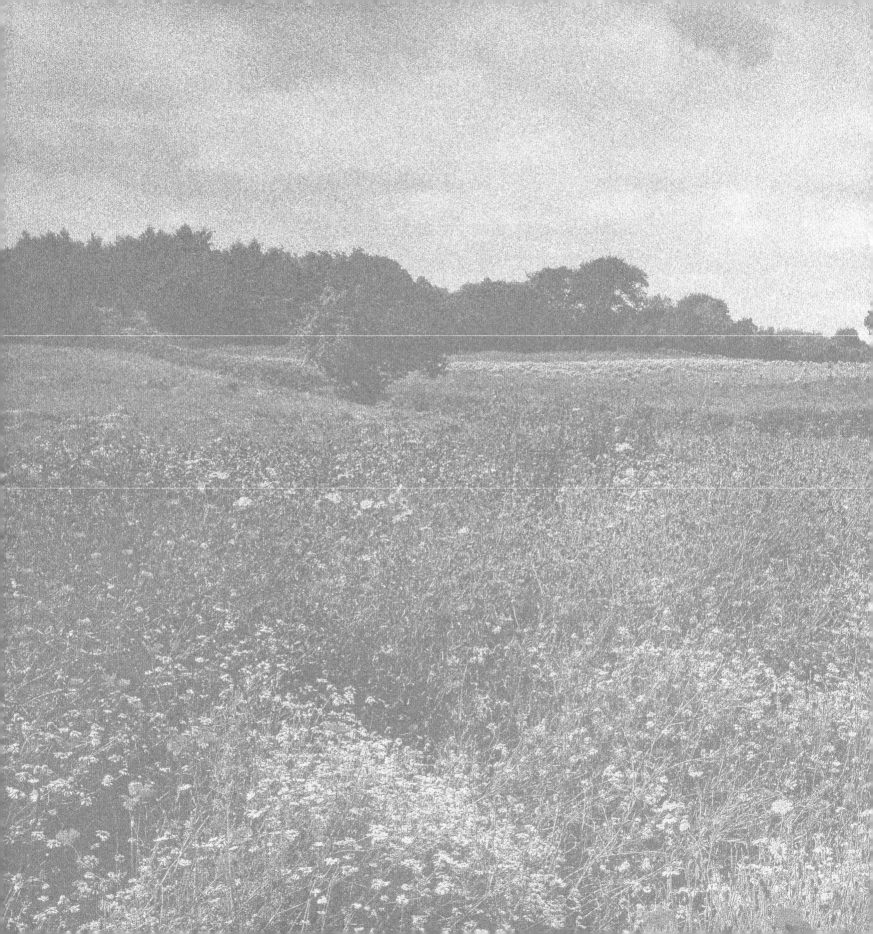

Chapter Six

▶ June

Make the most of the long days by photographing early morning and late evening. The landscape looks full and fresh at this time of year and the long slanting rays and shadows just after sunrise and before sunset will search out and reveal every detail. Wild flowers and hay meadows will also be looking their best. Use softer lighting – hazy sunlight or scattered, broken cloud are ideal – to capture the colourful spectacle. Avoid windy days, if possible. Tall stems are vulnerable to the lightest of breezes and waiting for perfect stillness is likely to test your patience to its limit.

▶ Capturing the Elusive Moment

A number of failed attempts and a frustrating period of waiting preceded the making of this image. But it wasn't the light that was elusive; it was the constant wind which forced me to weather-watch for seven consecutive days. An expansive wild-flower meadow, beautiful though it is to behold, can be infuriating to photograph and, believe me, its beauty can begin to fade after several hours of intensely watching every flowerhead and stem, waiting for that frustratingly elusive moment when absolute stillness finally – at last – descends.

There is no simple solution, no shortcut to success. Invariably a wide depth of field will be required if you are to have perfect sharpness from the near foreground all the way back to the horizon. This will necessitate a small aperture which, in turn, will require a long exposure. A shutter speed longer than 1/8sec will reveal the swaying of all but the most imperceptible of movements. A film or image sensor with a speed of ISO 100 is likely to need an exposure of 1/2sec or longer and having to wait for a lull in the breeze is therefore to be expected with this type of image. One option is to use a higher ISO speed but delicate, finely detailed subjects are generally best depicted in the highest resolution possible and an ISO speed of no more than 200 is preferable. Therefore, if quality is not to be sacrificed, patience, perseverance and, when the moment occurs, lightning quick reactions are the recipe for success.

Strong sunlight should be avoided when capturing delicate colours. If the light is too harsh it will create shadows (in a flower field they might be small and barely detectable but they are there nonetheless). The result will be an increase in contrast and this will tend to obscure the subtle colour palette and range of hues which you are attempting to capture. If anything, this photograph suffers from a little too much contrast in places. Perhaps slightly softer light would have been preferable.

TIP: Beware when photographing a large expanse of colour. It can lose its appeal when seen as a small, two-dimensional image. There needs to be a degree of repetition and uniformity, or a quiet, understated pattern which the eye can roam over and absorb, without being bombarded by a colour overload.

Alvanley, Cheshire, England

Camera: Tachihara 5x4in
Lens: Super Angulon 90mm (Wide Angle)
Filter: 0.6ND grad
Film: Fuji Provia 100
Exposure: 1sec at f/32
Waiting for the light: 30 minutes

▶ Preserving Beauty

These photographs remind me that, however enticing a subject might be, there is no guarantee that its beauty, in its entirety, will transfer to a photograph. A hay meadow in full bloom should, in theory, be an easy subject to capture. In practice, however, making a photograph of anything which takes your breath away is always going to be a challenge. This is because a picture is a single sensory medium. It can capture the visual aspects of a subject but in reality we experience a range of sensory stimuli way beyond this when we stand in front of, and absorb, a sweeping, majestic view. Gaze across a wild-flower field and we not only see it, we smell the flowers, feel the breeze and the sunlight, hear the birdsong; in short, we are living and breathing the outdoor experience. Little wonder that back home, when we look at a photographic reproduction of the scene, it sometimes doesn't quite live up to the memory. When I compare the picture of the Alvanley hay meadow below with the image on the previous page it suffers by comparison. It doesn't quite have the same appeal or impact. The question is, why? I think it has a lot to do with colour. Here the warmer tones are more agricultural, they suggest crops rather than wild flowers and as a result the image doesn't captivate the viewer.

Alvanley, Cheshire, England

Camera: Tachihara 5x4in

Lens: Super Angulon 90mm (Wide Angle)

Filter: 0.6ND grad

Film: Fuji Provia 100

Exposure: 1/2sec at f/32

Waiting for the light: 45 minutes

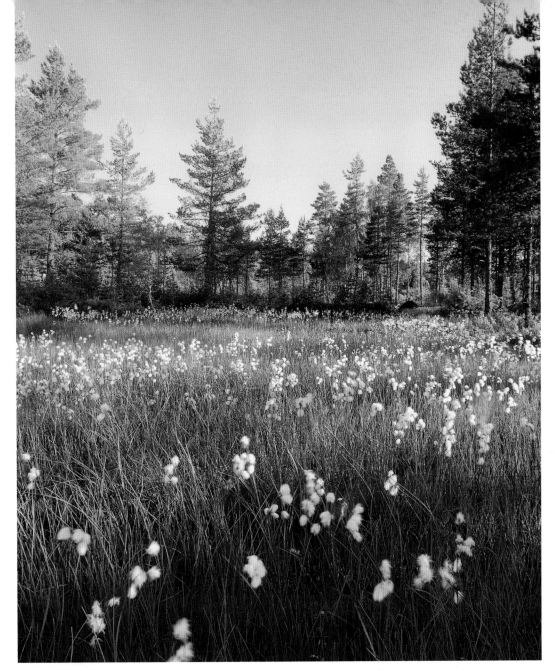

Near Aseral, Norway

Camera: Tachihara 5x4in

Lens: Super Angulon 90mm (Wide Angle)

Filter: Polarizer (fully polarized)

Film: Fuji Provia 100

Exposure: 1/4sec at f/22.5

Waiting for the light: 30 minutes

The same can be said of this photograph of the cotton-grass field in southern Norway. This time it's the trees and sky that fail to impress. I was forced to cut into the trees at both sides of the image, which is never desirable, and the bland, featureless sky draws attention to this flaw. The lesson I learn from these photographs is that beauty is not something to be taken for granted. In order for it not to be lost when it is reproduced as an image it must be moulded, nurtured and packaged with the utmost care and attention to detail. The objective is to achieve a timeless preservation of beauty, a holy grail perhaps, but one which is within reach of every photographer.

▶ The Choice of Lens

Establishing the correct balance of foreground, middle ground and background lies at the core of every successful scenic landscape image. But there is no strict rule that can be applied, sometimes a photograph can be built around a large, dominant foreground and still look balanced. There are, though, situations where too much foreground can swamp an image and obscure other important features. Getting it right is largely a matter of experience and learning through trial and error. You can experiment by photographing from different viewpoints using lenses of different focal lengths. A long lens will compress depth and perspective while a short, wide-angle lens will emphasize foreground and have the effect of accentuating depth and distance. Using the latter might sound like the simple solution when photographing any large, open view but there are times when a longer focal length might be more suitable.

My initial reaction, as I gazed across the rolling, tree-covered hills of Nordbo, was to reach for the wide-angle lens but, studying the view more closely, I had second thoughts. I was concerned that the foreground flowers, attractive as they were, would, if given too much emphasis, become too dominant. They would have taken up more than half the picture and the trees in the middle distance – which are an attractive, well-ordered, depth-enhancing group, and an important feature – would have been squeezed to the point of being lost. But a standard lens would have been too long, it would have compressed the landscape too severely so the answer was to use a semi-wide-angle lens.

This lens is, as its name implies, midway between wide and standard and on this occasion it proved to be the most appropriate choice. A zoom lens would have also been suitable because you can choose a specific focal length, but beware of falling in the trap of letting your lens do all the work for you. You must consider the camera position as well as the focal length. Relying solely on the zooming capability of a lens might not produce the best composition, so use your legs as well as your lens and check out a number of different viewpoints.

Nordbo, Norway

Camera: Tachihara 5x4in
Lens: Rodenstock 120mm
(Semi-Wide Angle)
Filter: 0.45ND grad
Film: Fuji Provia 100
Exposure: 1sec at f/32
Waiting for the light: 1 hour

▶ Maximizing Depth of Field

As I wandered across the windswept sands of Freshwater West there was no doubt in my mind which lens would be most suitable for capturing the character of the boulder-strewn beach. The scattered array of colourful rocks and pebbles left only one choice: it had to be wide angle – as wide as possible – with the camera positioned very close to the foreground.

When photographing an expansive landscape, which extends from infinity to within touching distance of your camera, maximum depth of field will be required in order to ensure that you have everything in focus – from the nearest foreground to as far as the eye can see. To achieve this you will need to use the smallest possible aperture and, of course, precision focusing.

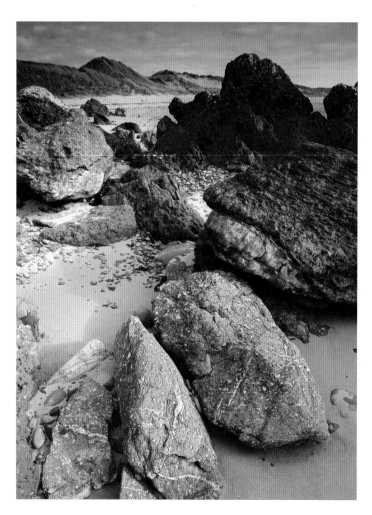

Freshwater West, Pembrokeshire, Wales

Camera: Mamiya 645ZD
Lens: Mamiya 35mm (Wide Angle)
Filter: Polarizer (fully polarized), 0.3ND grad
Film: Dalsa CCD sensor ISO 100
Exposure: 1sec at f/32
Waiting for the light: 1 hour

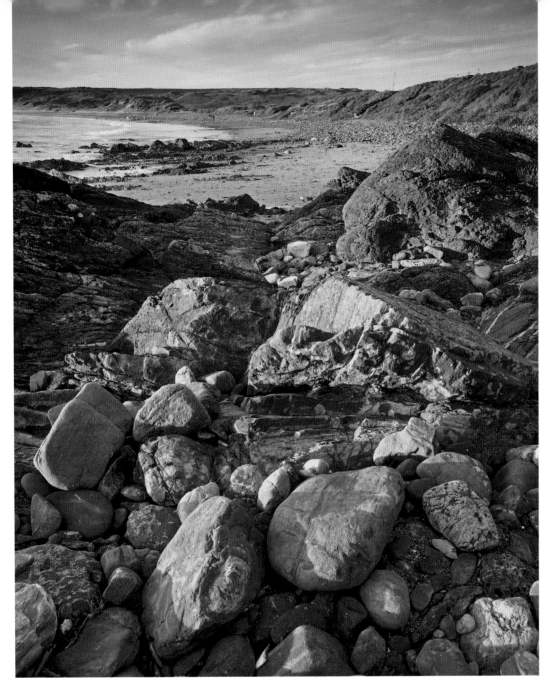

Freshwater West, Pembrokeshire, Wales

Camera: Mamiya 645ZD
Lens: Mamiya 35mm (Wide Angle)
Filter: Polarizer (fully polarized), 0.3ND grad
Film: Dalsa CCD sensor ISO 100
Exposure: 1sec at f/32
Waiting for the light: 30 minutes

Maximum depth of field is achieved by focusing on the hyperfocal distance, because this is the closest distance on which a lens can be focused while retaining sharpness all the way to infinity. When using a small aperture and a short focal length lens this is surprisingly close to the camera. For example, the hyperfocal distance for a 35mm camera fitted with a 28mm lens set at f/22 is 1.4m and this produces a depth of field from 1.1m from the camera to infinity. If your camera has one you can use the depth of field preview button to check the extent of sharp focus.

Using a very small aperture will require a long shutter speed and a solid, robust tripod is, therefore, a necessity if you are to avoid the risk of camera shake. A ball-and-socket head, whilst not absolutely essential, would also be an advantage. They greatly assist camera movement and are particularly useful when taking close-up images because small adjustments in camera position can have a noticeable effect on the composition, and therefore appearance, of your photograph.

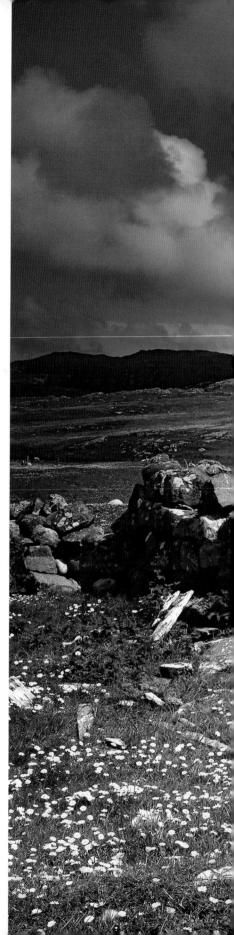

► A Simple Arrangement

Again, the choice of focal length occupied my thoughts as I contemplated the view in front of me. There are few elements in this image: it is a simple arrangement of flower-speckled grass, a crumbling stone wall and, in the distance, a derelict crofter's cottage. Uncomplicated as it is, great care had to be taken with the composition because the simpler the image, the greater the precision required in its arrangement.

I considered using a wide-angle lens because this accentuated the foreground rocks and flowers which have a rustic charm and make a huge contribution to the image. But there was a price to be paid for this approach; the small cottage – which is, of course, an essential feature – was reduced to little more than a speck on the hillside, and once you'd looked beyond the foreground the picture began to lose its appeal.

The solution was to adopt a slightly more distant camera position and use a semi-wide-angle lens. This reduced the apparent distance between foreground and background and increased the effective size of the building. This now acts as a focal point and helps to draw the eye into the picture and across the landscape.

TIP: The sky-filling cloud structure helps to complete the photograph. A quieter sky would have produced a void space which would have drawn attention to the sloping, unbalanced hilltop.

Near Borgh, The Isle of Barra, Scotland

Camera: Tachihara 5x4in
Lens: Rodenstock 120mm (Semi-Wide Angle)
Filter: 0.6ND grad
Film: Fuji Provia 100
Exposure: 1/2sec at f/32
Waiting for the light: 1 hour

Chapter Seven

▶ July

Strong, midsummer sunlight does not flatter the landscape but broken cloud can give some modelling to the land. Watch and wait for moments when the interplay of light and shadow reveals undulations and contours. Early morning and late evening continue to be productive times to photograph open landscapes and sweeping vistas. If early morning dew lingers, use a polarizer to suppress reflections and increase visual impact.

This is the month when Britain's moorlands become adorned with swathes of pink, red and purple heather. Use soft light to capture their colourful blooms and, again, a polarizer to boost colour.

▶ Connected Elements

Sunny days and blue skies may not be conducive to creativity but there are always opportunities to be discovered. Bold, graphic images can be made in these conditions because they are not dependent upon depth or the intricacies of light and shadow. Simple shapes and blocks of colour can make interesting images and I was therefore delighted to chance upon this group of individual, but connected, elements. By using a telephoto lens it was possible to flatten perspective and combine them into a unified and cohesive group.

This image is simplicity itself. There is no depth to it and no subtlety, just colour and form. Four clearly defined, individual elements – grass, wooden fence, a colourful roof and a blue sky – have been brought together to make an equal contribution in the picture. Early afternoon sunlight illuminates the scene but that is the limit of the role it has to play. Midday in midsummer is perhaps not the most creative time for image making but it is not altogether barren.

Hilbre Island, Wirral, England

Camera: Tachihara 5x4in
Lens: Fujinon 300mm (Telephoto)
Filter: Polarizer (fully polarized)
Film: Fuji Provia 100
Exposure: 1/4sec at f/22.5
Waiting for the light: Immediate

Port of Ness, The Isle of Lewis, Scotland

Camera: Tachihara 5x4in
Lens: Super Angulon 90mm (Wide Angle)
Filter: 0.6ND grad, 81B
Film: Fuji Provia 100
Exposure: 1/2sec at f/32
Waiting for the light: 2 days

Although there is once again a simple arrangement to this image, the lighting requirements were much more demanding, so demanding in fact that it took two days of weather-watching before the picture was taken (not an excessively long wait in this exposed part of Scotland). This time the landscape needed to be backlit and you can see why. Successfully depicting the hilly, depth-enhancing terrain required a specific combination of light and shade. Without the alternating sequence of sunlight and shadow the wild moorland would have looked as flat as a pancake and the picture would have been a miserable failure. Unlike the photograph on the previous page, this is an image where light makes an enormous contribution and it is worth noting that such a contribution could still be made during the middle of the 'off-peak' photographic season.

▶ Darkening the Sky

The graduated neutral-density filter (sometimes called a grey graduated filter) is, in my experience, one of two filters which are essential for both film and digital landscape photography. This is because the sky is nearly always brighter than the landscape and, to enable both to be correctly exposed, it is necessary to reduce the light value of the sky by darkening it with a light-absorbing filter. Although it is relatively simple to use, this filter – more than any other – seems to cause confusion and I will therefore attempt to explain its practical application.

As its name implies, a neutral-density graduated filter is neutral in colour (i.e. it will have no effect on the colour balance of your image) and its density is graduated from dark to light. Therefore, by positioning the dark part of the filter over the sky it will absorb excess brightness in the sky but will have no effect on the landscape below. If you then base your exposure on a meter reading of the landscape, not the sky, both should be accurately exposed. This, however, assumes that you have used the correct strength of filter. So, how do we determine what strength to use?

ND filters are available in various strengths (i.e. light-absorbing power) starting from 1/3 stop and increasing to three stops or more. A one-stop filter is denoted as 0.3, one and a half stops as 0.45, two stops as 0.6 and so on. To choose the correct filter you must measure, separately, the brightness of both the sky and landscape and calculate the difference. A spot meter is ideal for this. Once you know both light values you can select the appropriate-strength filter to bring them together. A sky which is two stops brighter than the landscape would therefore require a 0.6ND filter. Two stops is in fact a fairly common differential and this strength of filter is the one I most commonly use. By following this method your images should be correctly exposed, with no loss of detail in the highlights and shadows.

TIP: Here the two-stop (0.6) ND graduated filter has prevented the sky from being overexposed and has allowed detail to be retained in the clouds.

Near Dunvegan, The Isle of Skye, Scotland

Camera: Tachihara 5x4in
Lens: Super Angulon 90mm (Wide Angle)
Filter: 0.6ND grad
Film: Fuji Provia 100
Exposure: 1/2sec at f/32
Waiting for the light: 50 minutes

▶ A Satisfying Pursuit

Fine weather can never be guaranteed, particularly along the north-west coast of Scotland, and it is fortunate that there are many subjects that photograph well in diffused light. Soft, shadowless light is particularly suitable for close-up images of intricate, finely detailed objects and it was with a surge of excitement that I approached a remote stone cottage in the backwaters of the Scottish Highlands. I sensed there was a photograph to be made and, with dark grey clouds sagging heavily overhead, it was a joyous moment to discover a subject which required neither sunlight nor sky. This marvellous cornucopia of intricately patterned colour and form needed no enhancement; the task was simply to set up the camera and make an exposure. The image is by no means a celebration of high summer, but the old building has, nevertheless, an aesthetic quality which deserved to be captured and preserved.

Near Ardroe, Sutherland, Scotland

Camera: Tachihara 5x4in
Lens: Super Angulon 150mm (Standard)
Filter: None
Film: Fuji Provia 100
Exposure: 1/2sec at f/22
Waiting for the light: Immediate

Flat light was the last thing I wanted as I contemplated the heather-clad hills of Commondale. Fortunately the clouds held no threat as broken sunlight drifted lazily across the steeply contoured moorland. The viewpoint, however, faced south-west and, as sidelighting was important, it necessitated a two hour wait for the sun to reach the required position. But this was no hardship; after an hour's stroll through the heather I returned in good time to set everything up and watch as the light gradually changed. It was a moment to savour and one of those times that remind me that landscape photography is an immensely satisfying pursuit – at any time of year.

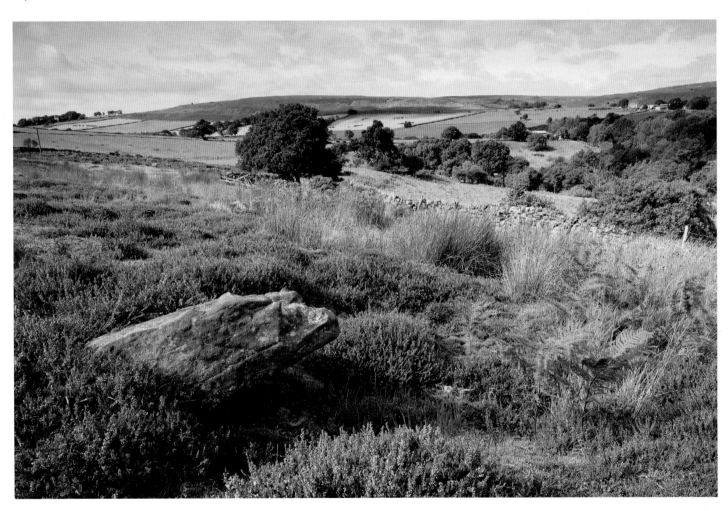

Commondale Moor, North Yorkshire, England

Camera: Tachihara 5x4in

Lens: Super Angulon 90mm (Wide Angle)

Filter: 0.3ND grad, Polarizer (half polarized)

Film: Fuji Provia 100

Exposure: 1sec at f/32

Waiting for the light: 2 hours

A Flourishing Landscape

The mountainous terrain of Snowdonia flourishes in the mild, wet summer months. Showers are frequent and this keeps the hills and valleys looking fresh and vigorous. Its appearance can change according to the prevailing conditions but this creates opportunities because images are a biproduct of a flourishing landscape. Keen observation is required because it is easy to succumb to the surrounding grandeur of a spectacular region and overlook small details. Potential subjects can be short-lived in a thriving landscape so it pays to be vigilant to ensure photographs aren't missed.

I am always attracted by simplicity and was therefore drawn to this modest but, to my eye, charming combination of colour and form. The bright splash of green, framed between long grass and a rugged, mountain background, seemed to encapsulate the diverse beauty of Snowdonia. This is by no means a spectacular image but photographs don't have to be spectacular in order to have aesthetic appeal. Sometimes a glimpse into a forgotten corner can say more about a place than a sweeping, all-embracing vista.

TIP: The scene is backlit and this is essential to the success of the photograph. A frontally lit picture would have looked flat and uninteresting and the radiant green bushes would have lacked sparkle. I waited over an hour for the light but it was a small price to pay. Without the right quality of light even the most breathtaking landscape will look somewhat forlorn.

Near Llanberis, Snowdonia, Wales

Camera: Tachihara 5x4in (12x6cm roll film back)

Lens: Super Angulon 150mm (Standard)

Filter: None

Film: Fuji Provia 100

Exposure: 1/4sec at f/22

Waiting for the light: 1½ hours

Chapter Eight

▶ August

Avoid the crowds and leave resorts and holiday destinations for other times of year. Rural green landscapes can, however, now begin to look a little jaded, their appearance not being helped by strong, overhead summer sun. This is, though, a good month for photographing buildings. They are not dependent upon cloud-based combinations of light and shade because they create their own shadows. Use oblique sunlight to reveal architectural features and give shape to the building.

In spells of fine weather sunrise and sunset can be rewarding times and, if you must visit them, these are also the best hours to photograph busy resorts. Take care, however, when choosing your viewpoint. Parked cars, caravans and campsites can spoil an otherwise idyllic scene.

▶ An Enticing Subject

I welcomed the news of a family wedding in France, particularly as it was to take place in the Dordogne, a renowned region that I had never visited. We were all to stay for a week in a sprawling chateau so, a perfect opportunity for photography, I thought. That was until it was announced that the ceremony was to be held at the beginning of August. August? No, surely not. Why would anybody choose to visit France in August, it didn't make sense. What was wrong with autumn, I asked? A cooler climate, more colour, more atmosphere, better light for the wedding pictures, less traffic, cheaper hotel rates, the reasons were many and surely, I suggested, compelling. It seemed to make perfect sense but sadly my (admittedly, tongue-in-cheek) pleas for the wedding to be moved to October were rejected and I resigned myself to spending a week in midsummer, foraging on a parched landscape while battling against the harsh sunlight. It was going to be a struggle and I would have to formulate a strategy to tip the balance in my favour.

Souillac, The Dordogne, France

Camera: Mamiya 645ZD
Lens: Mamiya 35mm (Wide Angle)
Filter: None
Film: Dalsa CCD sensor ISO 100
Exposure: 1/2sec at f/16
Waiting for the light: Immediate

Souillac, The Dordogne, France

Camera: Mamiya 645ZD
Lens: Mamiya 80mm (Standard)
Filter: None
Film: Dalsa CCD sensor ISO 100
Exposure: 2sec at f/22
Waiting for the light: Immediate

The obvious solution was to photograph in the early morning and late evening which I did as often as social etiquette allowed. Also, the Dordogne is fortunately, like much of France, blessed with many medieval towns and villages and these can be photographed at any time of year. Ancient buildings are rich in character and intimate detail and are an enticing subject. They are, in fact, one of my particular interests and there is nothing I like more than wandering through the narrow streets and alleyways of an old, historic, town absorbing the atmosphere and searching for images. There is always something to photograph, even during the height of summer. Busy French towns become deserted at lunchtime. Photographing during the quieter periods will reduce the chances of passersby inadvertently walking into your shot.

TIP: When photographing buildings it is important to check that vertical and horizontal lines are perfectly square. Use a spirit level to ensure your camera is not tilted in any direction; it must be horizontally straight and parallel with the front of the building.

▶ Compressing Distance

This typically French landscape sums up the character of the Dordogne. I discovered it late one afternoon when the sun was still relatively high and made the photograph a few minutes later. It would have been preferable to have waited for longer shadows but the scene was already becoming backlit and sidelighting was required. This was due to the aspect of the view and, depending on the direction of the outlook, what you perceive as perfect light will sometimes never materialize. This can often happen and a creative approach is sometimes necessary in order to use what light you have effectively.

On this occasion I stepped back from the foreground vines and used a telephoto lens to bring everything closer to the camera. The effect of this is that distance has been compressed and there are now virtually no open spaces in this landscape. Instead the image consists of vertically rising layers, starting from the vines then progressing to the bales of hay, the orchard and then finally the houses at the top of

the hill. Everything is now compacted with the layers of visual interest brought closely together to fill the image. This slightly reduces the need for intricate lighting because the individual elements are all visually strong and they draw the eye into the photograph. Having said that, I did wait for a splash of sunlight to fall across the field of bales. The effect of this is, perhaps, subliminal but the highlights and shadows falling on the bales make an important contribution because they give them shape and help prevent them from being lost in the surrounding leafy greenery.

TIP: Paradoxically, using a telephoto lens to compress distance can, often accentuate the impression of depth. Use this effect to combine individual features and stack up layers of visual interest.

**Near Nadaillac de Rouge,
The Dordogne, France**

Camera: Mamiya 645ZD
Lens: Mamiya 150mm (Telephoto)
Filter: 0.6ND grad
Film: Dalsa CCD sensor ISO 100
Exposure: 1sec at f/32
Waiting for the light: 20 minutes

Near Pinsac, The Dordogne, France

Again the telephoto lens has compressed perspective and accentuated the repetitive and graphic qualities of these tobacco plants. It has also enabled the picture to be tightly framed around a small part of the crop field which helps to reinforce symmetry.

Simplicity in an image equals clarity in an image. Here there are two distinct, contrasting elements and that is all the picture needs. The inclusion of additional information would have weakened the composition and would have been a distraction.

Camera: Mamiya 645ZD
Lens: Mamiya 150mm (Telephoto)
Filter: None
Film: Dalsa CCD sensor ISO 100
Exposure: 1/4sec at f/20
Waiting for the light: Immediate

▶ The Right Permutation

Unlike the photograph on page 112 it was, on this occasion, possible to wait as long as necessary for the light. The aspect of the view was southerly and this meant that low sidelighting – ideal for this landscape – would develop and indeed improve as the evening progressed. This was fortunate because there isn't a great deal to this photograph. Lighting was going to play a major role and it had to be absolutely right. Nothing less than a perfect combination of sunlight and shadow would suffice.

A persistent breeze generated some momentum in the sky which created favourable cloud conditions. After an hour or so the shadows began to lengthen as the dipping sun brought a textured finish to the harvested field and also shape and depth to the surrounding trees. The swiftly moving broken cloud also created swirling stripes of light that danced across the landscape to spotlight specific features which was exactly what was needed. The permutation of light and shadow I was praying for eventually arrived and in a matter of seconds the image was taken. The release of the shutter brought with it a release of emotion because I knew that a fleeting moment of perfection had been captured – a rare, but very memorable, feeling.

It was now getting late and I would have to make my excuses when I returned to the chateau. As a rule I try not to be late for anything but there are occasions when rules have to be broken and this was most definitely one of them. In any case, it wasn't as if I'd missed the actual wedding – well, not all of it.

TIP: When the success of your image hinges on the light, keep patient and wait as long as necessary. Second best is never good enough and the results will be disappointing. The greater the effort you make, the greater will be the reward.

Near Cazoules, The Dordogne, France

Camera: Mamiya 645ZD
Lens: Mamiya 35mm (Wide Angle)
Filter: 0.3ND grad, Polarizer (half polarized)
Film: Dalsa CCD sensor ISO 100
Exposure: 1sec at f/18
Waiting for the light: 1½ hours

▶ A Decade of Change

Revisiting a previously photographed location can be rewarding but it can also be difficult to surpass, or even equal, earlier achievements. This can act as a deterrent to making return trips, particularly when you think you have already captured the perfect moment. This was certainly the case when I returned to the magnificent landscape in the Llantysilio valley. This is the scene of one of my earliest 5x4 images and I have been back a number of times in an attempt to improve on the original version. Sadly my endeavours have largely been a failure.

The smaller image below is the original photograph and this was followed, ten years later, by the main picture on the facing page. The more recent version lacks the impact of the first image because the heather has lost its colour. This has been the case for the past few years so there must have been a permanent change in the local environment which means that the chances of improving on my first picture are virtually nil. What is remarkable, however, is the durability of the old wooden fence. Despite its precarious position and dilapidated condition it has survived a decade of weathering with absolutely no signs of movement or ageing. If only the heather was as hardy!

TIP: Good locations often hold more than one photograph. Changing format from landscape to portrait (or vice versa) can give you a new interpretation of the same subject and a different sky and light will also help to emphasize the change in appearance.

Llantysilio, Clwyd, Wales

Camera: Tachihara 5x4in
Lens: Super Angulon 90mm (Wide Angle)
Filter: 0.6ND grad
Film: Fuji Provia 100
Exposure: 1/2sec at f/45
Waiting for the light: 6 hours

Llantysilio, Clwyd, Wales

Camera: Mamiya 645ZD
Lens: Mamiya 35mm (Wide Angle)
Filter: 0.6ND grad
Film: Dalsa CCD sensor ISO 100
Exposure: 1/4sec at f/32
Waiting for the light: 50 minutes

► Increasing ISO Speed

As I have previously mentioned, my view of digital image making has, to say the least, always been a little circumspect. I have, however, gradually adopted the technology and now my photography is split fairly evenly between digital and film. It doesn't suit all my work, but there is no denying that using a digital camera does add a few strings to your bow. Many of the features are not relevant to landscape photography but one that is particularly useful is the ability to adjust the ISO speed of the image sensor.

In windy conditions there is often a requirement for both a small aperture and a relatively fast shutter speed. With film this presents a predicament; you can't have both so do you sacrifice some depth of field by using a larger aperture, or preserve sharp focus and risk blurred leaves or grass etc. by using a longer exposure? Thanks to digital technology this no longer needs to be a dilemma. By increasing the ISO speed, say from 100 to 200, you can half the exposure time and reduce the risk of a blurred image. For example an exposure of 1/2sec at f/22 ISO 100 would, at an ISO rating of 200, be reduced to 1/4sec at f/22. Half the exposure time = half the risk of blurring and, by leaving the aperture at f/22, depth of field is retained.

As you might expect, however, there is no such thing as a free lunch and an increase in ISO speed brings with it the risk of introducing 'noise' into your image. Digital noise is something which is seen, not heard. It is similar in many ways to the size of grain in film emulsion; the faster the film, the more noticeable the grain. Noise manifests itself as small, random speckles in the image and becomes noticeable at high ISO speeds. It is, however, unlikely to be a problem with a good quality DSLR set at an ISO speed of up to 200, and possibly higher, and is preferable to risking blurred or unsharp images.

TIP: A steady breeze dictated that a short exposure would be necessary and, not wishing to lose any depth of field, I increased the sensor speed to ISO 200. This enabled a shutter speed of 1/8sec to be used, which was fast enough to avoid blurring.

Nevern, Pembrokeshire, Wales

Camera: Mamiya 645ZD
Lens: Mamiya 35mm (Wide Angle)
Filter: 0.6ND grad
Film: Dalsa CCD sensor ISO 200
Exposure: 1/8sec at f/32
Waiting for the light: 30 minutes

Chapter Nine

▶ September

September is an interesting month because this is the time of year when summer and autumn meet to form a mini-season. For a short time there is a 'season within a season' when warmer colours start to make an appearance, not yet full-blown colour, it's more of a nuance, a glimpse of what lies around the corner. Trees still look full and fleshy but subtle hues bring an added quality to woodland scenes.

Nights can be cool and early mornings can have a noticeable autumnal quality, particularly when a hint of mist is present. This is also the month when the landscape's appearance is at its most varied. Look for maturing crops and variegated ferns and grasses.

▶ When Two Seasons Meet

This image seems to sum up the essence of September: the vigour of summer meets the spectacle of autumn. This is the beauty of this special month because at no other time of year do the seasons combine to such magical effect. For a few weeks forests and woodland seem to excel themselves and they can hold many distinctive images. Unfortunately they are not always obvious and will reveal themselves only under close and fastidious scrutiny. Forward planning and research will, however, help you to find favourable locations and make the search that much easier.

Detailed maps such as the Ordnance Survey *Landranger* series (scale 1:50,000) are a tremendous aid when planning trips. They show all the information you need to form a mental picture of a place and enable you to make excursions with specific types of images in mind.

September is a colourful month with vibrant greenery still in abundance. Look for deciduous forests and woodland and monitor their appearance as autumn approaches. This is the time to look for subtle colour combinations. Delicate hues are attractive because they don't bombard the viewer. They allow other features in a photograph to make a contribution and the result can be balanced, harmonious pictures with great aesthetic appeal.

TIP: When photographing inside woodland and forests take care to exclude the sky from your composition. Its presence will weaken your photograph. There should be a density of trees and foliage across all parts of the image with no discernable gaps.

Near Pontsticill, The Brecon Beacons, Wales

Camera: Tachihara 5x4in
Lens: Super Angulon 150mm (Standard)
Filter: None
Film: Fuji Provia 100
Exposure: 1/2sec at f/22
Waiting for the light: Immediate

▶ A Rhythmic Harmony

A whisper of autumn can certainly be seen in both these images. They were taken in September, five years apart, and I had been looking forward to a return visit. I wanted to see if the landscape had changed. Were the trees still there? Had they grown? Would it be possible to change the composition sufficiently to make another image worthwhile?

In the first photograph (below) I chose to emphasize the symmetry of the undulating field. There was a rhythmic harmony in the landscape which was accentuated by the early morning sunlight and also, in no small measure, by the sheep which had obligingly formed themselves into two balanced groups. Nature's helping hand is not so apparent in the main picture (facing page) and symmetry has now been replaced by gently flowing lines and delicate curves. There is still a repetitive theme, though, and this is due mainly to the bank of cloud which fills the sky and mirrors the mass and outline of the rolling hillside.

Is the new image any better than the original? I'm not sure, both hold a certain appeal for me. If I'm being objective I think they are both equal in terms of quality. They do, however, demonstrate that where there is one image, there are often two.

Near Hawes, North Yorkshire, England

Camera: Tachihara 5x4in
Lens: Rodenstock 120mm (Semi-Wide Angle)
Filter: 0.45ND grad
Film: Fuji Provia 100
Exposure: 1/2sec at f/32
Waiting for the light: 45 minutes

TIP: A change in the focal length of the lens has had a fundamental effect on the composition and this alone has created an entirely new image. When looking at a landscape do consider all options. Two images might be possible by simply using two different focal lengths.

Near Hawes, North Yorkshire, England

Camera: Mamiya 645ZD
Lens: Mamiya 150mm (Telephoto)
Filter: 0.3ND grad
Film: Dalsa CCD sensor ISO 100
Exposure: 1/4sec at f/20
Waiting for the light: 1 hour

▶ A Hint of Autumn

Some landscapes should only be photographed at a specific time and this can mean both the time of year and the time of day. The valley at Dyffryn Crawnon is such a place. Its aspect and contours dictate the lighting requirement; the shadows need to be long, therefore the sun needs to be low, and it should be lit from the right in order to give the shadows prominence. This dictates that the image should be made late in the afternoon. Anything other than this specific quality of light would not do this landscape justice. The time of year must also be precise; it should be at the peak of autumn when the tree-adorned valley radiates with colour.

I got the time of day right but, sadly, not the time of year. I knew, of course, that I was two or three weeks early but my schedule didn't allow me to delay my visit. There is still a hint of autumn and the image hasn't been a total failure but it doesn't compare with the colourful peak. Perhaps I will return one year to capture the valley when it is looking its best.

I don't much care for the wire fence and metal gate. Unwanted elements in a landscape are a common problem and often it is, sadly, a question of take it or leave it. My usual response is to leave it but you have to make an objective assessment. If the image, warts and all, still holds appeal, then it might still be worth making. I am not going to advocate the use of digital enhancement but it is now a simple process to remove minor blemishes.

Dyffryn Crawnon, The Brecon Beacons, Wales

Camera: Mamiya 645ZD
Lens: Mamiya 35mm (Wide Angle)
Filter: 0.6ND grad
Film: Dalsa CCD sensor ISO 100
Exposure: 1/8sec at f/18
Waiting for the light: 45 minutes

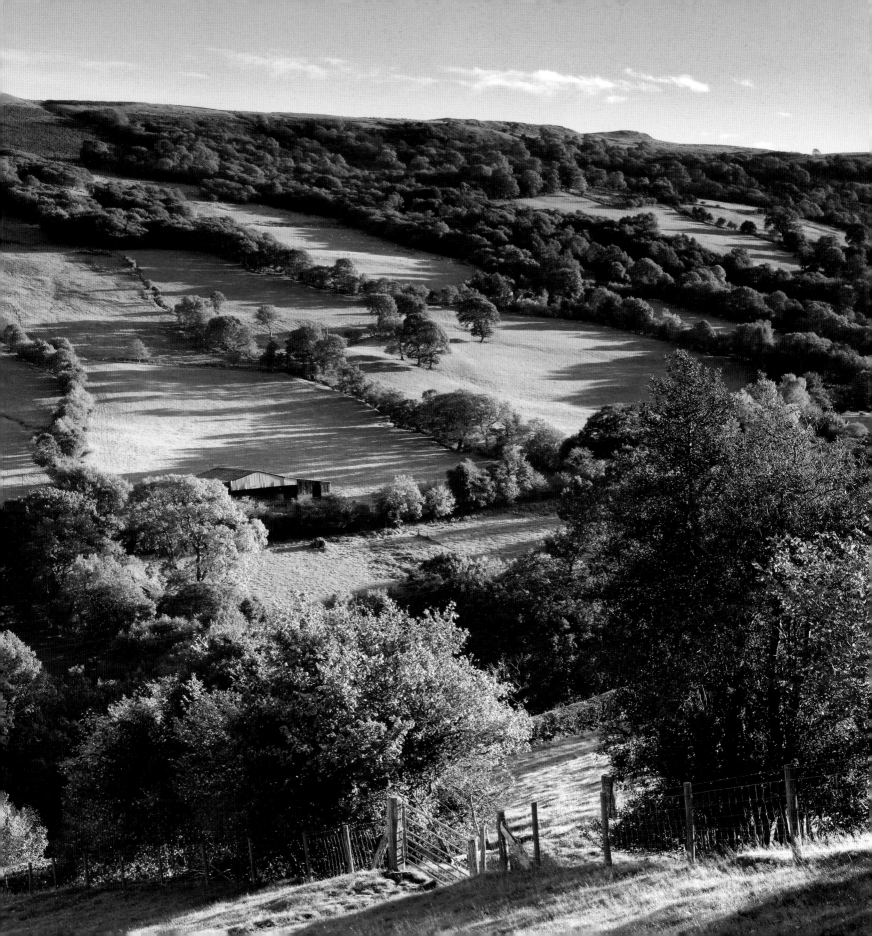

▶ A Lesson Learned

The small picture below of Danby Moor was one of my first images taken on 5x4 film and, being rather inexperienced at the time, and also pleased with the photograph, I failed to thoroughly investigate the surrounding area. I was guilty of the elementary mistake of simply homing in on something which had caught my eye and, having got the picture, it didn't occur to me that there might be other opportunities close by. It was several years later, when revisiting the location, that the error came to light. I had missed part of the moors which were not visible from my viewpoint and hadn't checked the area thoroughly.

It was a careless oversight and the lesson I have learned over the years is: an attractive location can yield many images and, although you might be happy with a photograph you have made, there might still be others awaiting discovery. Don't be easily satisfied, keep searching. A tenacious photographer is often a successful photographer.

TIP: For a hilly landscape to be portrayed as such it essential that light and shadow are used to reveal the undulating contours. Low sunlight and broken cloud will produce the desired effect. Watch and wait for the moment.

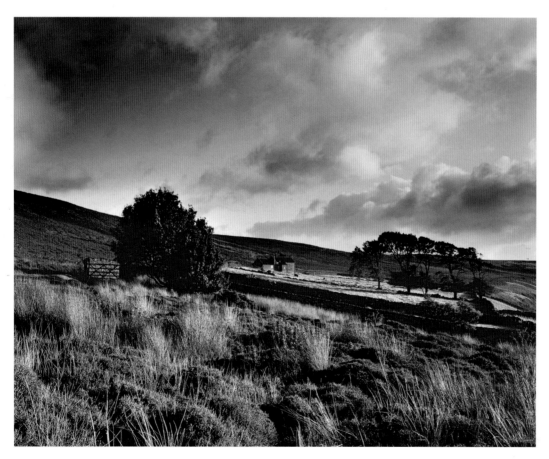

Great Fryup Dale, North Yorkshire, England

Camera: Tachihara 5x4in
Lens: Super Angulon 90mm (Wide Angle)
Filter: 0.6ND grad, 81C
Film: Fuji Provia 100
Exposure: 1/2sec at f/32
Waiting for the light: 1 hour

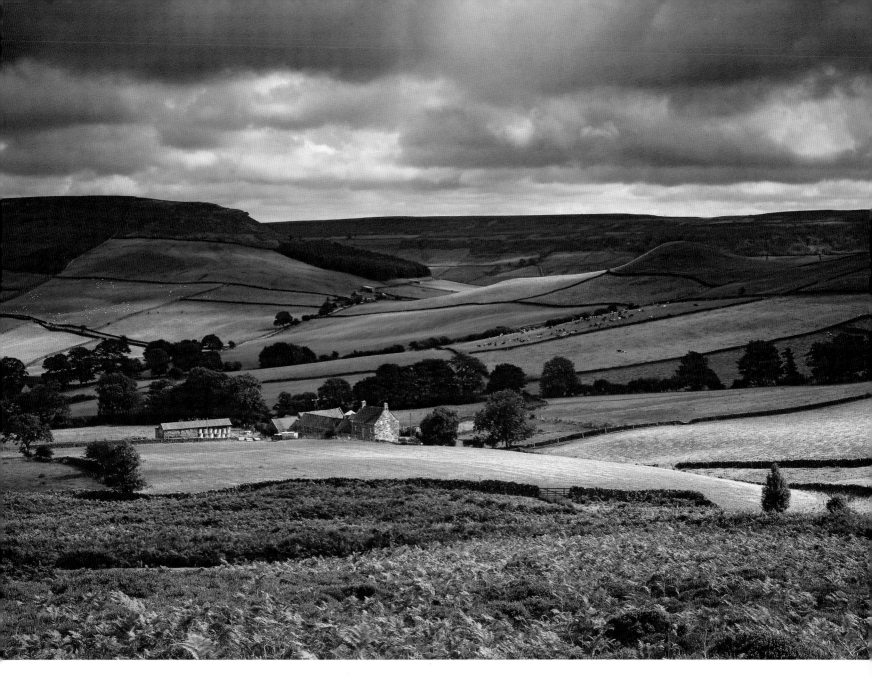

Glaisdale Moor, North Yorkshire, England

Camera: Tachihara 5x4in

Lens: Super Angulon 90mm (Wide Angle)

Filter: 0.6ND grad

Film: Fuji Provia 100

Exposure: 1/8sec at f/22

Waiting for the light: 2 hours

► A Pleasing Combination

This image isn't quite what, at first glance, it appears to be. The trees aren't standing upright; they had been felled and were part of a group of stacked logs lying deep in the middle of a forest. Logged and fallen trees are always worth investigating because they can be a microcosm of fungi and I was soon scrambling around looking for that elusive image.

Interesting fungi was, sadly, scarce, but the search hadn't been fruitless because instead I found a pleasant combination of variegated yellow, red and green against a neutral silver background. Even though the subject is modest, I had to photograph the colourful, turning leaves. This is a New England fall on a small scale and hopefully it demonstrates that an image doesn't have to be spectacular to convey the beauty of a place.

Time seems to move slowly in the remote Western Isles. Traditional farming methods are still widely used and intensive land management is unheard of in these sparsely populated islands. This is reflected in the character of the landscape and contributes to the rich heritage of this unspoilt land. Timeless images abound and there are many opportunities to make photographs which are evocative of times gone by.

The remote village of Lacasaigh lies deep in the heart of the Isle of Lewis. As I approached a group of scattered farmhouses my heart leapt because in front of them stood a field of glorious, hand-built hay bales. There was surely a photograph here if I could find the right viewpoint. I wanted to portray the character of the small community and depict it in its wider environment. To achieve this bales, buildings, mountains and hills would have to be brought together in a unified group.

There were few options. There was less than two hours of daylight remaining and rain was, as usual, threatening. Fortunately this was one of those rare occasions when all the elements fell naturally into place, including the sun which was perfectly positioned to provide sidelighting, which is such an essential ingredient in this picture (facing page). Luckily I was able to find a depth-enhancing composition and take the image without delay. It was lucky because minutes later the rain duly arrived and, as I passed by again the following day, I realized that the bales had vanished!

Near Madison, New Hampshire, USA

Camera: Tachihara 5x4in
Lens: Super Angulon 150mm (Standard)
Filter: None
Film: Fuji Provia 100
Exposure: 1/4sec at f/16
Waiting for the light: Immediate

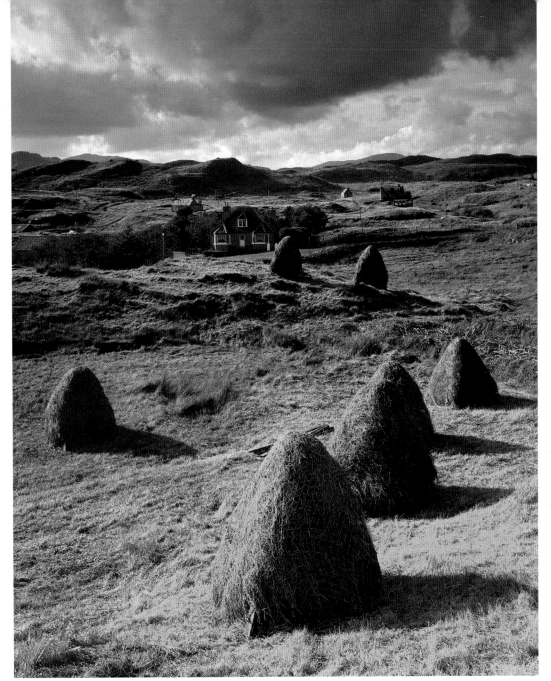

Near Lacasaigh, The Isle of Lewis, Scotland

Camera: Tachihara 5x4in
Lens: Super Angulon 90mm (Wide Angle)
Filter: 0.6ND grad
Film: Fuji Provia 100
Exposure: 1/4sec at f/22
Waiting for the light: Immediate

TIP: Objects of a regular, diminishing size are a powerful presence in an image. Build your composition around them to give your photograph a strong sense of depth and distance.

▶ A Variation on a Theme

This is one of several pictures captured along the flowing waters of the Nantahala River. My visit followed several days of rain and the river was looking resplendent. There was much to photograph, almost too much, in fact, because as the images stacked up the options were becoming fewer and fewer. Having used different permutations of water, rocks and background and a number of compositions it was becoming a variation on a theme, but the variety was becoming increasingly difficult to maintain. I decided to make this the last image.

The river runs through a steep, narrow gorge and there are many places where sunlight doesn't penetrate to river level. That doesn't usually matter when you're photographing a waterfall because flat, shadowless light is preferable. However, the stretch of river where this image was taken is open and golden, hazy sunlight filtered through to bring a warm quality to the photograph. The fallen autumn leaves also benefitted from the warm light and it was these factors that prompted the creation of the image.

TIP: When photographing a fast-flowing river look for a balanced arrangement of water, rocks and colour. Too much water can look monotonous while too little can cause an image to look static and flat. Splashes of colour, particularly fallen foliage, can be effective because they will bring an added dimension to your picture.

Nantahala River, North Carolina, USA

Camera: Tachihara 5x4in
Lens: Super Angulon 150mm (Standard)
Filter: None
Film: Fuji Provia 100
Exposure: 1sec at f/22
Waiting for the light: Immediate

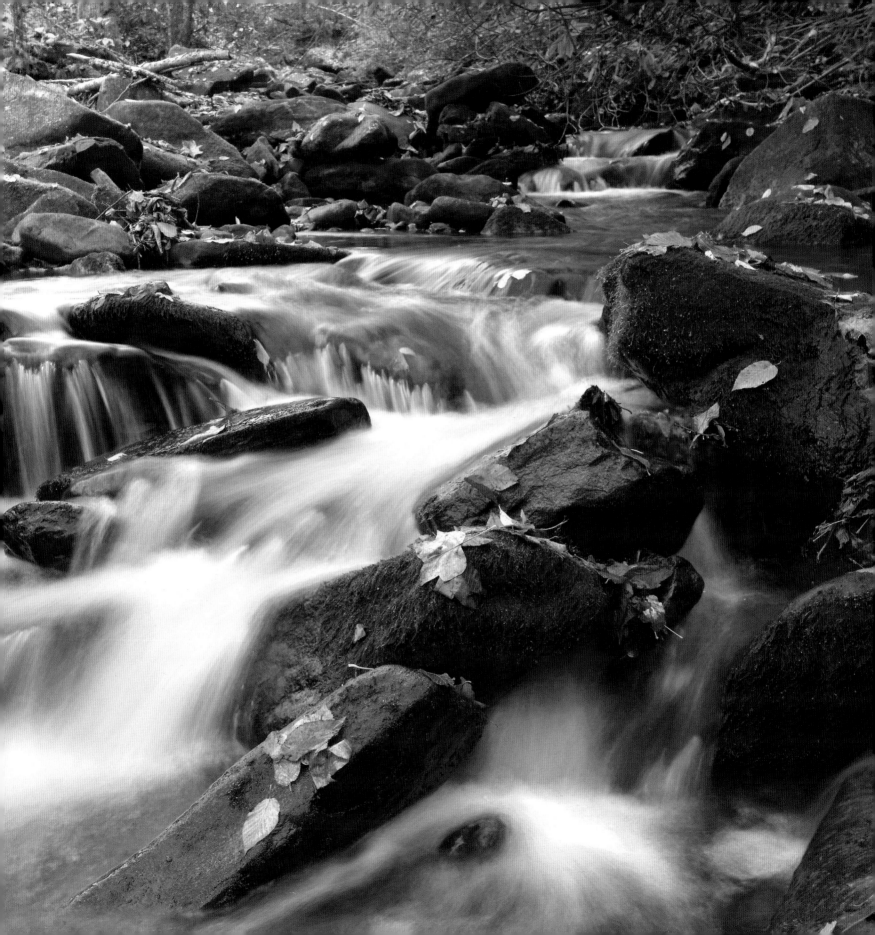

The Timeless Landscape

More than ten years separates the making of these two images but, by happy coincidence, both were taken in September. I revisited the scene simply because I happened to be in the area. It was by no means a work in progress and the thought of taking a second photograph hadn't crossed my mind. Having no idea what to expect it was both a surprise and a delight to see the apparently ramshackle shed not only standing but showing little evidence of further deterioration. This surprised me more than the flourishing landscape which, as you can see, has changed beyond all recognition over the years.

Not wishing to replicate the earlier picture below I changed camera position (and also the camera, because the later photograph, right, was taken digitally), fitted a telephoto lens and concentrated on the shed and surrounding trees and bushes. The result is two quite different images, the only common link being the shed. This illustrates the transient nature of the landscape (a decade does, admittedly, provide ample opportunity for change) and repeat visits can often be rewarding.

Unlike the earlier image, hazy sunlight suits the arrangement here. The tone of the colours is now softer. Strong sunshine would have created too much contrast.

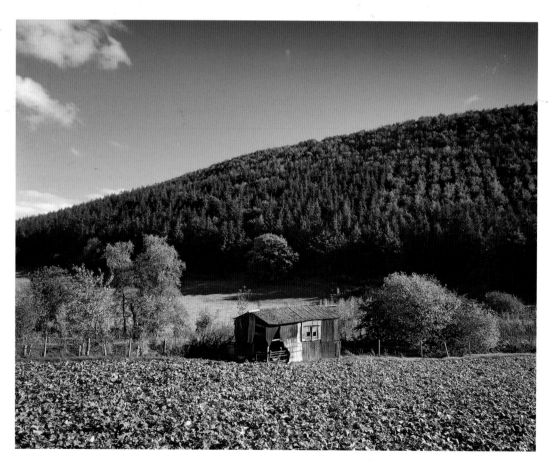

Mainstone, Shropshire, England

Camera: Tachihara 5x4in
Lens: Super Angulon 90mm (Standard)
Filter: Polarizer (half polarized), 0.3ND grad
Film: Fuji Provia 100
Exposure: 1/4sec at f/22.5
Waiting for the light: 2 hours

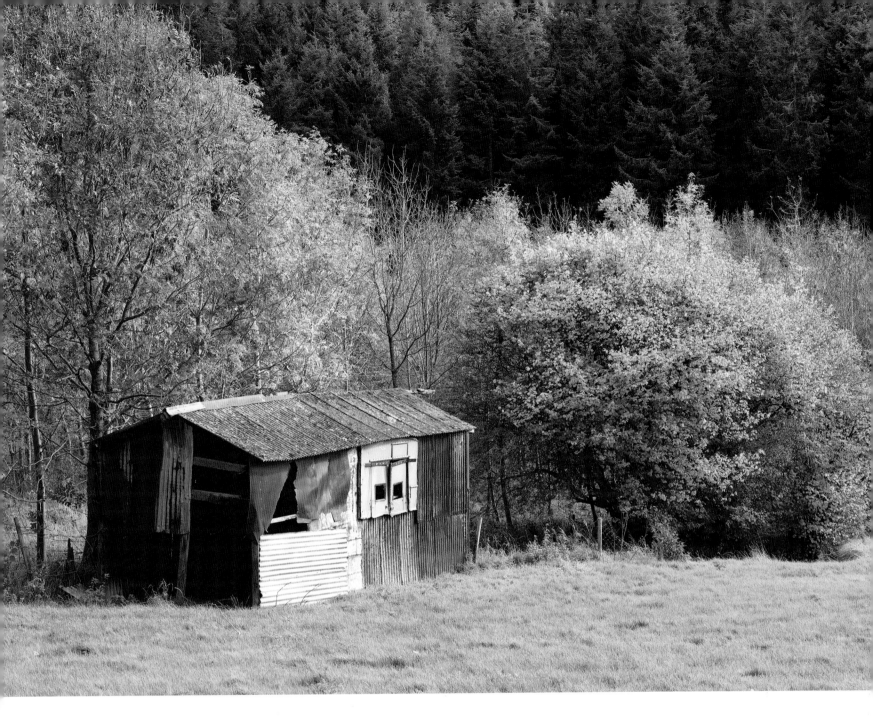

Mainstone, Shropshire, England

Camera: Mamiya 645ZD
Lens: Mamiya 150mm (Telephoto)
Filter: None
Film: Dalsa CCD sensor ISO 100
Exposure: 1/8sec at f/18
Waiting for the light: 45 minutes

Controlling Highlights and Shadows

Like many landscape photographers I regularly use a graduated neutral-density filter to reduce the brightness of the sky. This is its more common application but there are also occasions when other parts of a scene may require darkening in order to retain detail in both the highlights and shadows.

Even on cloudy days shaded areas can look underexposed and the way to avoid this is to darken the lighter parts of a scene with an ND graduated filter. This brings together the light values of the highlights and shadows and, by basing your exposure on the shaded areas, you will then have a correctly exposed image with no parts either under- or overexposed.

For example, in this picture taken deep in a dense forest, the colourful ferns were in the open and lit by an overcast sky. Behind them the thickly wooded area was in deep shade and there was a difference of two stops in the exposure values of foreground and background. By positioning a two-stop ND graduated filter across the ferns in the foreground I was able to expose for the darker parts and, because the lighter foreground had now been darkened by two stops, it too was correctly exposed. The result is that detail now appears in both highlights and shadows with the ferns displaying rich, saturated colour.

To take exposure readings of specific parts of a scene a spot meter is useful, because it enables you to take several pinpoint measurements across a number of different areas. It is not essential though, particularly if you have a zoom lens. By zooming in on small areas you can effectively use your built-in camera meter as a spot meter and this will enable you to determine the strength of filter required.

TIP: In addition to the ND filter a polarizer was used to enrich the colourful ferns. A warm 81B has also helped to balance the colour by compensating for a cool, blue cast which is often present in woodlands on overcast days.

Langlee Crags, Northumberland, England

Camera: Tachihara 5x4in

Lens: Super Angulon 90mm (Wide Angle)

Filter: Polarizer (fully polarized), 81B, 0.6ND grad

Film: Fuji Provia 100

Exposure: 3sec at f/22.5

Waiting for the light: Immediate

Chapter Ten

▶ October

This is the golden month or, more accurately, the red, orange, yellow, amber and russet month – the colours are endless. To get the most from the autumn peak, plan your locations in advance. Use Ordnance Survey *Landranger* maps (or their equivalent) to research your journeys. Look for deciduous woods and forests, then monitor their appearance as the leaves begin to turn. The optimum moment can be short-lived, so remain vigilant. Beware, in particular, of frost and strong winds, as they can have a ruinous effect on fragile foliage.

When photographing colour soft light is normally preferable to bright sunshine, but backlit woodland scenes can also look quite magical.

▶ No Moonscapes, Thank You

One of the finest landscapes in Britain, the magnificent Yorkshire Dales is, truly, a photographer's paradise. There is nowhere else quite like it. This is a charismatic landscape, a landscape served up invitingly on a plate. It has a unique character and my only hope is that it will be preserved and protected from any form of future development.

Of significant importance are the stone barns which are scattered across the hills, valleys and flower-rich meadows. They alone give the landscape a special quality and provide perfect focal points in an expansive, rolling vista. These images were taken from the side of a rising, narrow road. It's a popular stopping point for photographers, which is no surprise given the plethora of barns dotted across the hillside – there are eighteen in the photograph below!

Near Thwaite, North Yorkshire, England

Camera: Tachihara 5x4in
Lens: Super Angulon 90mm (Wide Angle)
Filter: 0.6ND grad
Film: Fuji Provia 100
Exposure: 1/8sec at f/16.5
Waiting for the light: 1½ hours

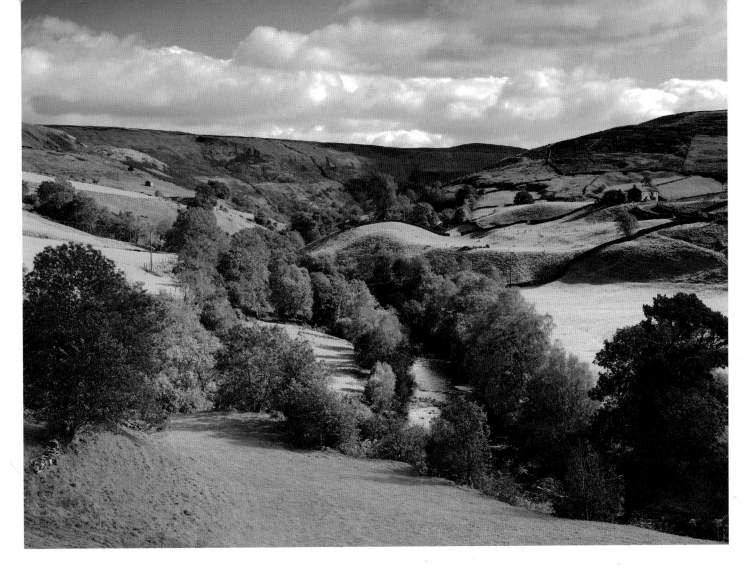

Near Keld, North Yorkshire, England

Camera: Tachihara 5x4in

Lens: Super Angulon 90mm (Wide Angle)

Filter: 0.6ND grad

Film: Fuji Provia 100

Exposure: 1/8sec at f/16

Waiting for the light: 1 hour

It was while I was waiting for the light that I was approached by another photographer who was keen to learn more about my large-format camera and I was more than happy to answer his questions. During our conversation he began to explain to me the workings of his feature-laden digital SLR. The whirring of his camera's motor drive was interrupted only by the beeping of the autofocus as I was given a firsthand account of the benefits of multi-autofocus points and mega-zone TTL metering.

It appeared to be technology NASA would be proud to own but I wasn't flying to the moon, I was just waiting for the right light so I could take my photograph! This seemed to be an undemanding task as far as technology was concerned and, our conversation having petered out, I was soon left to my own (old-fashioned) devices. I'm pleased to say that my wooden, lightproof large-format box coped admirably with the simple demands made of it and the image was safely captured.

▶ A Unified Blend

When photographing a distant view, the three key requirements are: light, sky and composition. If you have the first two, i.e. good light and a well-structured sky, then the composition should emphasize these two qualities in order to realize the potential of the attractive conditions. Often there will be one obvious choice of arrangement, particularly if there are no unsightly or unwanted elements spoiling the view. In these happy situations it should be a relatively straightforward task to bring together landscape, sky and light in an engaging and harmonious composition.

During a week's stay one autumn in the Yorkshire Dales I was, therefore, confident that, given the right conditions, it would be possible to make a successful image of the small town, Hawes. It lies deep in the heart of the strikingly beautiful Dales and, surrounded by sprawling hills and fells, it is the location which is part of the town's appeal. I therefore wanted to include as much as possible of the rural environment and climbed to the summit of a nearby hill to search for a commanding view.

In theory this should not have been difficult; in practice, however, it was. While the views were certainly sweeping, Hawes itself – which after all was the main subject – was hidden away deep in a valley. This was frustrating because the sky and early evening light were beginning to excel themselves. It was therefore with increasing desperation that I searched and searched and eventually found a viewpoint which, although a compromise, has proved to be quite acceptable. The only disappointment is the group of trees near the centre of the picture and, to a lesser degree, the presence of the smoke. They obscure the town a little more than I would have preferred but, apart from this, the landscape, sky and light are a unified, cohesive blend and portray the beauty and character of this part of northern Yorkshire.

Hawes, North Yorkshire, England

Camera: Mamiya 645ZD
Lens: Mamiya 35mm (Wide Angle)
Filter: 0.6 ND grad
Film: Dalsa CCD sensor ISO 100
Exposure: 1/2sec at f/32
Waiting for the light: 10 minutes

Near Dahlonega, Georgia, USA

Camera: Mamiya 645ZD
Lens: Mamiya 35mm (Wide Angle)
Filter: Polarizer (half polarized)
Film: Dalsa CCD sensor ISO 100
Exposure: 1/15sec at f/14
Waiting for the light: Immediate

Altogether much easier was this photograph of the magnificent trees deep in the heart of northern Georgia. Luckily they were at their peak and my task was to simply mount my camera on its tripod, attach a polarizing filter and make the exposure. Undemanding as it was, it was still very rewarding.

▶ Autumnal Tones

It was the colours of the rocks which attracted me to a shallow stretch of the winding Kimsey Creek. This was one of the slower parts of the river but the boulders and fallen leaves (such a perfect match for each other) more than compensated for the lack of dynamism in the water. The beauty of a Georgia fall seemed to be lying permanently along the river bed and the unusually low water level allowed the rocks to reveal their rich autumnal tones. There was a photograph here and I was more than happy to take it despite the muted appearance of the river.

Wet rocks are very efficient light reflectors and a polarizer will usually help, by suppressing these reflections, to enrich their colour. The only disadvantage is a resulting increase in exposure time because the filter absorbs approximately two stops of light. In a densely wooded area light can be at a premium and exposures longer than 2sec can soften the flowing water to such a degree that it begins to resemble cotton wool. If maximum depth of field is also required this will prevent you using a larger aperture, so the solution is to increase the ISO speed of your film or sensor. I therefore based my exposure on a film speed of ISO 200 and adjusted the E6 processing time in order to achieve the appropriate increase in speed.

It will also, in all probability, be beneficial to add an 81B or C filter. This will compensate for any blue cast in the daylight and will enhance warm colours. This is not, of course, necessary when shooting digitally because the fine balancing of colour (and it should be just fine balancing, overdoing it can look false) can be undertaken after exposure.

Kimsey Creek, North Carolina, USA

Camera: Tachihara 5x4in
Lens: Rodenstock 120mm
(Semi-Wide Angle)
Filter: Polarizer (fully polarized), 81C
Film: Fuji Provia 100 (pushed to ISO 200)
Exposure: 2sec at f/32
Waiting for the light: Immediate

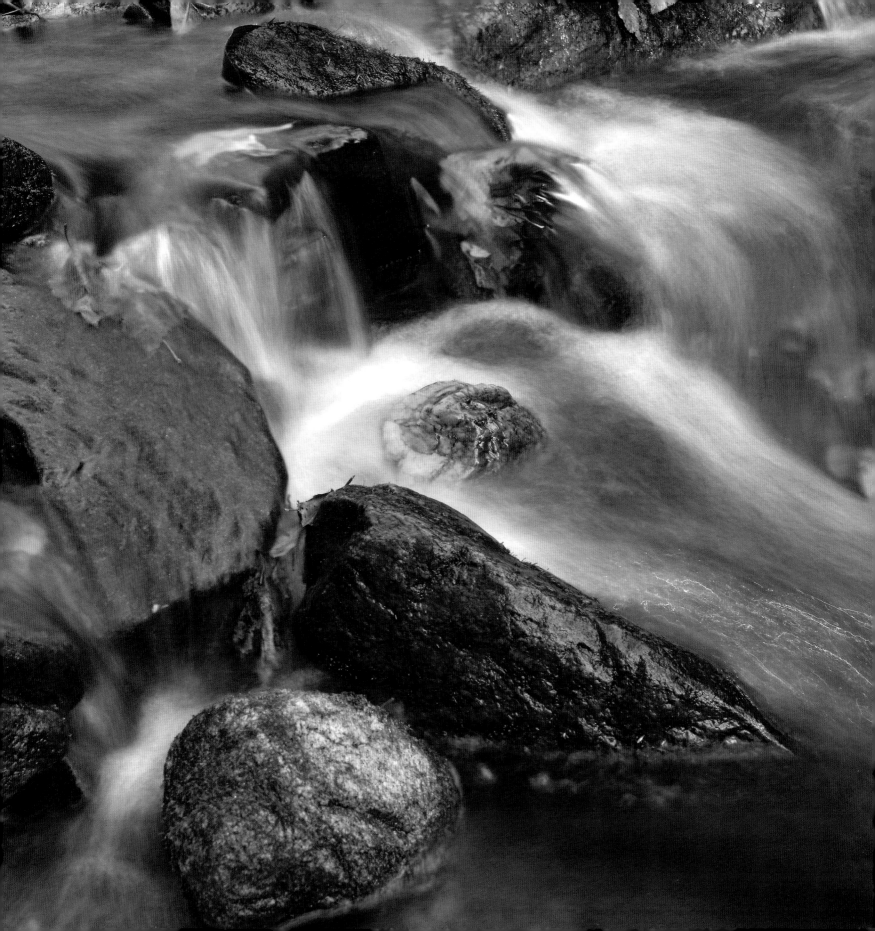

▶ Textured Foreground

The clear sky and bright sunlight were a welcome sight as I photographed the backlit tree along the banks of the Little Tennessee River (below). Colourful foliage can look quite stunning when lit from behind, but when the light source originates from any other direction then soft, hazy sunshine is preferable. Sadly, in the picture on the facing page, the blue skies continued to prevail. Day after day the sun would rise and the floodlight would be switched on – all day and every day.

I was staying for a week in a cabin along the riverside and each day I would rise at dawn and head down to the river. It was always misty but it was a thick impenetrable mist which would linger until mid-morning. By the time it cleared the sun was high in the sky and there was no golden period when sunlight and mist were favourably combined. The prospect of allowing the river to go unphotographed was rather unappealing (those trees are such glorious autumn colours) so the only solution was to accept the conditions and minimize the effect of the strong light

The picture on the facing page was taken from a position which enabled the frame to be filled with a variegated and rugged foreground. Because the surface is rough and stony the sunlight has created tiny shadows and this has given the expanse of rocks a coarse, textured appearance. This suits the foreground and breaks up the blanket of sunlight into a scattered myriad of highlights and shadows. It doesn't help the trees, unfortunately; they are still too bright for my liking and the cloudless sky is also not really for me. Fortunately the low river level has prevented the image from being a total failure. Had the rocks been submerged, which they often are, then there would have been no picture to take.

TIP: In harsh sunlight a roughly textured foreground will create shadows and provide a degree of visual interest.

Little Tennessee River, North Carolina, USA

Camera: Tachihara 5x4in
Lens: Super Angulon 90mm (Wide Angle)
Filter: 81B
Film: Fuji Provia 100
Exposure: 1/2sec at f/32
Waiting for the light: Immediate

Little Tennessee River, North Carolina, USA

Camera: Tachihara 5x4in
Lens: Super Angulon 90mm (Wide Angle)
Filter: Polarizer (fully polarized)
Film: Fuji Provia 100
Exposure: 1sec at f32
Waiting for the light: 30 minutes

▶ Filtered Sunlight

At the time of capturing this image there was a layer of thin, patchy cloud overhead which I always find unattractive, but it didn't matter because the sky had no role to play. Woodland images always benefit from the omission of the sky and on this occasion all that was needed were splashes of sidelighting with no brightly lit areas. Strong sunlight was filtering through the trees and after waiting for a couple of hours (well, to be precise, I sat on the nearby beach with a book and an ice cream, the weather was that mild) the light was at the desired angle.

In addition to the light, the composition was also of critical importance. The interior of woods and forests often have no specific focal point and to compensate for this there must appear to be a strong sense of symmetry, something the eye can wander over and immediately comprehend. This is important because, in the absence of a cohesive arrangement a woodland scene can, when photographed, appear to be little more than a random confusion of trees and bushes and it will fail to engage the viewer.

I would have preferred to have had a denser canopy of trees in the distance. They are not as solid as, ideally, they should be. The sparsity of leaf cover has created highlights which are slightly distracting. The only bright spots should be those formed by the filtered sunlight.

TIP: Take care when choosing your viewpoint – the success of your woodland image can hinge on you finding the right composition.

Newborough Forest, Anglesey, Wales

Camera: Mamiya 645ZD
Lens: Mamiya 35mm (Wide Angle)
Filter: None
Film: Dalsa image sensor ISO 100
Exposure: 1sec at f/22
Waiting for the light: 2 hours

▶ Colour Comes in all Sizes

Colour can always be guaranteed in the American fall season and the scale of it has to be seen to be believed. Image-making opportunities abound as sprawling, gargantuan forests glow with a rainbow of warm hues. This is the time of year when colour becomes the main theme and, as the peak of the season is so short-lived, those opportunities should be grabbed with both hands.

I certainly didn't want to let the view of the magnificent forest at Leatherman Gap go unphotographed. The sky was poor but that was of no concern because a panoramic crop perfectly suited the subject. This is a big view but it is the presence of the house and surrounding trees that has given the picture scale and depth, as has the combination of side- and backlighting and the hint of mist in the background.

Leatherman Gap, North Carolina, USA

Camera: Tachihara 5x4in (12x6cm roll film back)
Lens: Super Angulon 90mm (Wide Angle)
Filter: None
Film: Fuji Provia 100
Exposure: 1/8sec at f/16
Waiting for the light: Immediate

Near Bridgton, Maine, USA

Camera: Tachihara 5x4in

Lens: Super Angulon 150mm (Standard)

Filter: 81B, Polarizer (fully polarized)

Film: Fuji Provia 100

Exposure: 1sec at f/22

Waiting for the light: Immediate

Conveying a sense of depth and distance was not, of course, a requirement in the making of the second image. Although it can be tempting to concentrate on scenic views, particularly when you're surrounded by forests and tree-clad mountains, small, close-up images can be just as rewarding. The beauty of autumn comes in all sizes and it is a mistake to think only of sweeping vistas. By concentrating on small details, the essence of autumn can be just as effectively portrayed.

TIP: The smooth surface of the tree bark was creating an unwelcome highlight which the polarizing filter has helped to suppress.

▶ The Dawn of a New Age

This photograph was taken several years ago, long before digital imaging was considered a serious alternative to film. I remember thinking at the time how fortunate I was to be a landscape photographer, to be able to seek out the beauty in the landscape and then capture and preserve it in all its glorious detail. I also recall marvelling at the miraculous ability of film to soak up every shade and every nuance of colour and reproduce it faithfully in the minutest detail. There seems to be something deeply satisfying about the creation of a photograph, particularly a 5x4 or panoramic colour transparency which can be viewed and pored over on a lightbox. The photograph you have lovingly made comes alive as it positively radiates with colour, and sitting in a darkened room with a landscape image glowing before your eyes is like reliving the moment. Sadly, peering at an image on a computer monitor is, by comparison, a distinctly lacklustre experience.

The lack of a tangible, original archive of images is the one aspect of digital photography that I have had difficulty coming to terms with; there are many photographers who feel the same way but, regrettably, at the time of writing there is no solution. A digital version of a transparency is an unlikely development (I would be delighted to be proved wrong); however, the improvement in the quality of both digital images and monitors will continue apace. We can look forward to finer pixels and higher-definition screens followed by, at some point in the future, three-dimensional imaging. So, the coming years are certainly promising, but I fear it will be an increasingly transparency-free age and that is something which should be deeply regretted.

TIP: Don't hesitate to exclude the sky if you think your subject suits a panoramic format. If you don't have a panoramic camera simply crop the image after exposure.

Betws-Y-Coed, Snowdonia, Wales

Camera: Fuji GX617
Lens: Fujinon 105mm (Standard)
Filter: 81B
Film: Fuji Provia 100
Exposure: 1/2sec at f/22
Waiting for the light: Immediate

Chapter Eleven

▶ November

Autumn can be unpredictable and forests can still be alive with colour, particularly during the early part of this month. As winter encroaches fallen leaves carpet the ground so look down as well as up when searching for pictures. Tree roots and colourful leaves can make interesting images.

Forests and woodland are not, however, the only subjects deserving of attention. Warmer colours now tinge the landscape and although days are rapidly shortening good-quality light extends from dawn until dusk. Open views therefore photograph well at this time of year. If shooting on film an 81B or C filter will enhance the warm quality.

▶ Close Encounters

Grey skies and drizzle ruled out open views on the days these images were made. Fortunately in landscapes of the quality of the Lake District and the Yorkshire Dales there is always something to photograph in virtually any type of weather. Close-up subjects and waterfalls suit flat light and there is no shortage of either in the forests and fells of northern England.

This fine example of flourishing fungi was, in reality, much smaller than it now appears. The minimum focusing distance of the lens wasn't sufficient to allow the frame to be filled, so the solution was to crop the image after exposure. This has enabled the subject to occupy the entire image and the photograph has become an intricate study of finely detailed, repetitive shapes. A more distant photograph would have been unable to portray the elaborate structure of the fungi and would have failed to engage the eye.

TIP: When photographing repetitive shapes and patterns, avoid other distracting elements. If necessary crop the image to maintain the repetitive quality across the entire picture.

Near Hardraw, North Yorkshire, England

Camera: Mamiya 645ZD
Lens: Mamiya 35mm (Wide Angle)
Filter: None
Film: Dalsa CCD sensor ISO 100
Exposure: 1/2sec at f/32
Waiting for the light: Immediate

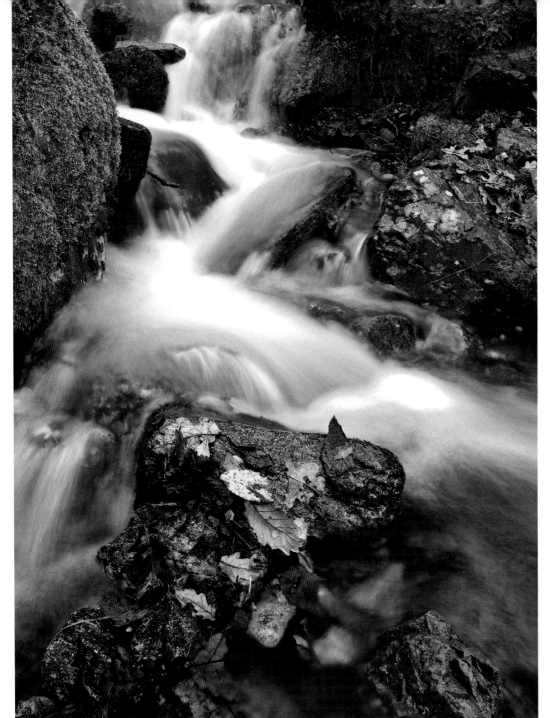

Borrowdale, Cumbria, England

Camera: Mamiya 645ZD
Lens: Mamiya 35mm (Wide Angle)
Filter: Polarizer (fully polarized)
Film: Dalsa CCD sensor ISO 200
Exposure: 2sec at f/32
Waiting for the light: Immediate

Similarly, when photographing the tiny stream at Borrowdale, I had to adopt a close (and wet!) position in the middle of the flowing water. This enabled the image to be built around the fallen leaves to give them due prominence. The wet rocks were reflecting unwanted highlights and to reduce them a polarizing filter was used.

This increased the required exposure and, not wishing to use shutter speed longer than 2sec, I adjusted the sensor rating to ISO 200. Having this capability is a tremendous advantage when shooting digitally and is my preferred option when photographing in low light.

▶ Lower Sun, Higher Quality

These pictures were both taken after several days of sky-watching and weather-watching. The photograph on the facing page was captured one hour before the smaller image below (which appears in my earlier book, *Reading the Landscape*) and I took it as a precaution, in case the weather closed in (as it had done for the previous five days). It was therefore an insurance policy against leaving the location empty handed.

The bigger picture, taken while the sun was still relatively high in the sky, is the inferior of the two. It hasn't been a total failure but it demonstrates not only the importance of light but the improvement a lower sun can bring to a photograph. Even the most outstanding landscape must be properly lit if its grandeur is to be successfully captured.

Sweeping vistas require late morning or early evening sidelighting because they need long shadows falling across the landscape in order to create depth; therefore the simple rule to bear in mind is: the bigger the view, the lower the sun should be.

TIP: Don't leave a location you have just photographed if the sun is still drifting towards the horizon. There might still be room for improvement. Watch and wait a while longer.

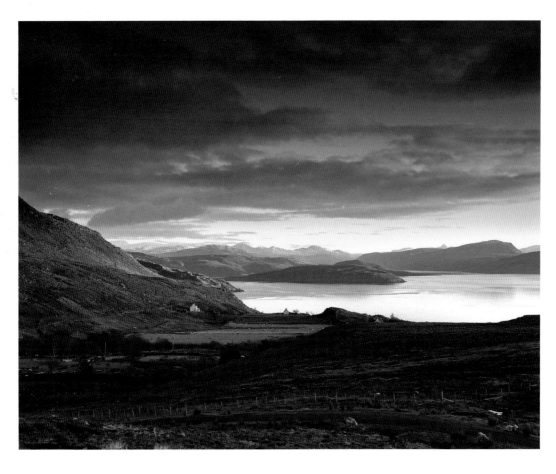

Culnacraig, Wester Ross, Scotland

Camera: Tachihara 5x4in
Lens: Super Angulon 90mm (Wide Angle)
Filter: 0.6ND grad, 81C
Film: Fuji Provia 100
Exposure: 1/2sec at f/32
Waiting for the light: 5 days

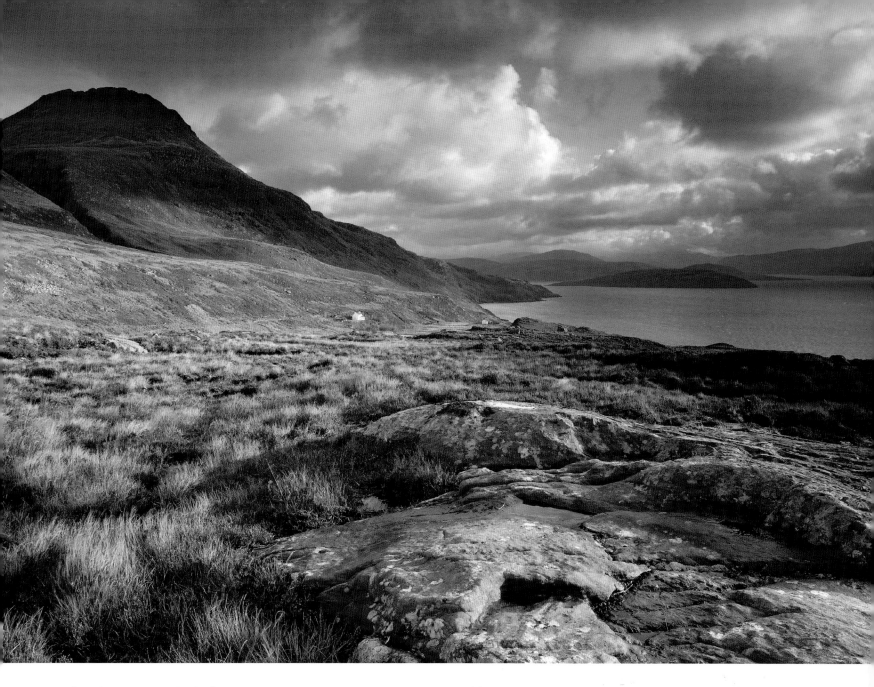

Culnacraig, Wester Ross, Scotland

Camera: Tachihara 5x4in

Lens: Super Angulon 90mm (Wide Angle)

Filter: 0.6ND grad, 81C

Film: Fuji Provia 100

Exposure: 1/4sec at f32

Waiting for the light: 5 days

▶ Seeing the Landscape

Despite the recent technological leaps in digital imaging, there is one aspect of photography that remains beyond the reach of even the wealthiest Research and Development organizations. It is of course the seeing eye, more specifically it is the photographer's seeing eye, because what matters most is observation. Images are conceived by the photographer, not the camera, and without the photographer's creative input and scrutiny of the landscape, photography as an art form would not exist.

Keen observation lies at the heart of successful photography because every landscape contains images – more than many people imagine – but the challenge is, of course, seeing them. It is easy for photographs to remain hidden away as the eye, distracted by the wider environment, skims over the potential and misses the opportunity for creative image making. Often it is the simple picture which goes unnoticed. What might appear to be unspectacular can become transformed when seen as a photograph. The key to success, therefore, is learning to take a detached view of what you observe, analyze it and imagine it as a picture.

Simplicity in an image is to be admired but in the real world it is usually ignored. For example, this photograph of a small part of a lengthy bank of trees could be easily missed – it almost was, in fact, because I was distracted by a nearby waterfall – as it doesn't stand out as being anything particularly remarkable. But as a photograph the simple colour palette, the repetitive rounded shapes, the contrast between the subdued background and the more brightly coloured tree combine together to produce an image which, in my opinion, engages the eye and, isolated from its surrounding environment, this little piece of forest now invites close scrutiny.

Note also how the telephoto lens has compressed distance and has isolated the trees from the surrounding landscape. It has also enabled the sky to be excluded.

Grange Fell, Cumbria, England

Camera: Tachihara 5x4in
Lens: Fujinon 300mm (Telephoto)
Filter: None
Film: Fuji Provia 100
Exposure: 1sec at f/22
Waiting for the light: Immediate

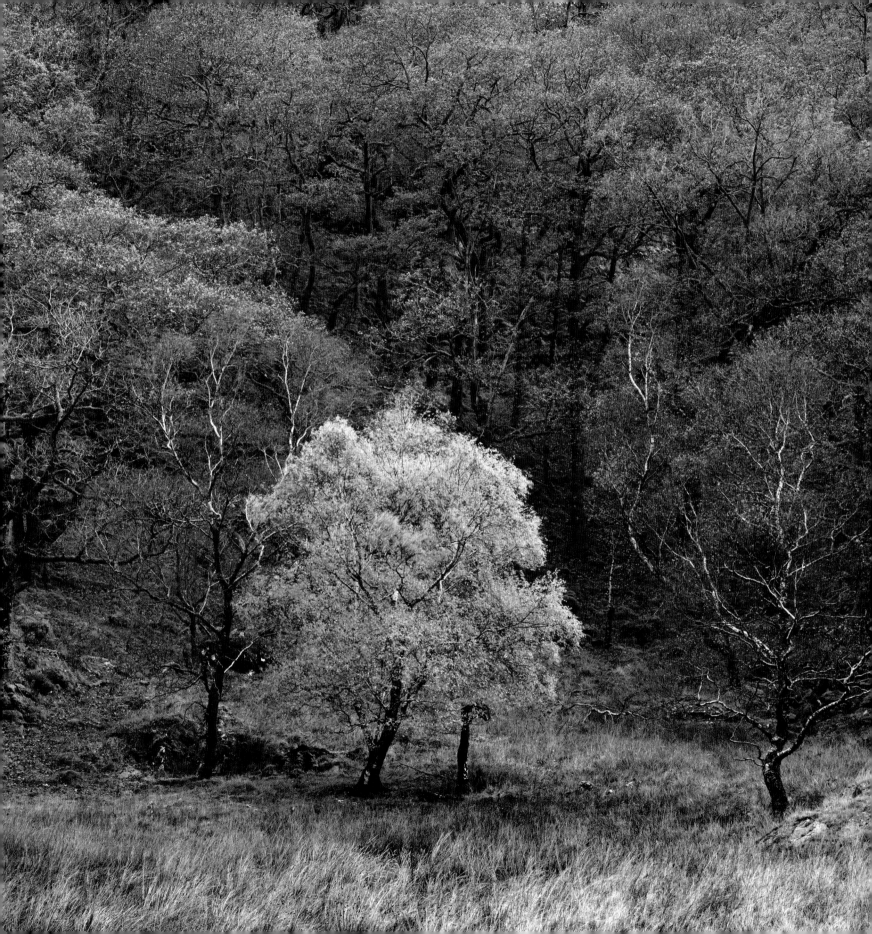

▶ Fleeting Light, Lasting Curves

At low tide the coastal Loch nan Ceall reveals a seabed rich in variegated detail. On the grey day I visited the loch, the colourful marine tapestry brightened up the entire landscape and provided an opportunity to embark on a search for an image around the rugged coastline. The search itself took little time but what did require a degree of patience was the wait for the sun to make an appearance. Two days later it eventually obliged. The light was fleeting but I was able to make three exposures in rapid succession as a beam of sunlight briefly illuminated the small cottage.

It would have been wrong to photograph this landscape in bright, evenly dispersed sunlight. A small splash of light falling on a key feature in the picture was all that was needed.

Loch nan Ceall, Arisaig, Scotland

Camera: Mamiya 645ZD
Lens: Mamiya 35mm (Wide Angle)
Filter: 0.6ND grad
Film: Dalsa CCD sensor ISO 100
Exposure: 1/2sec at f/22
Waiting for the light: 2 days

Morroch, Arisaig, Scotland

Camera: Mamiya 645ZD
Lens: Mamiya 150mm (Telephoto)
Filter: None
Film: Dalsa CCD sensor ISO 100
Exposure: 2sec at f/25
Waiting for the light: Immediate

According to the eighteenth-century painter William Hogarth, the 'S' curve is a line of beauty and is the basis of many acclaimed works of art. Looking at this photograph of the tree-clad lane I am inclined to agree with him (I make no comparison with acclaimed art, of course). The curve in the lane certainly brings an added quality to the picture and provides a visual avenue which beckons the eye to follow. This has been helped by the telephoto lens which has again compressed perspective and has emphasized the curve.

TIP: When searching for pictures look for 'S' curves or similar softly flowing lines. Their presence can provide an aesthetically pleasing focal point around which an image can be built.

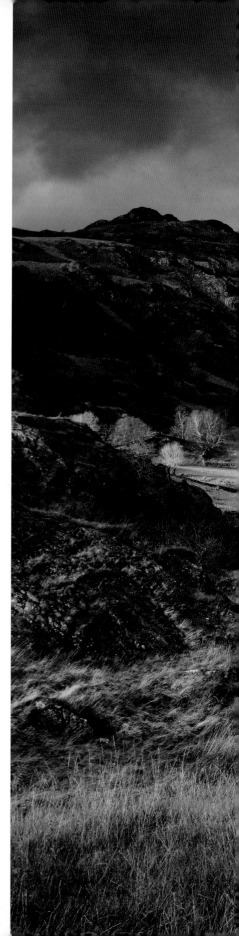

▶ An Important Lesson

Looking at this picture brings to mind an incident which I hope to never experience again. At the time of making the first attempt to capture this photograph the weather was challenging. Apart from frequent showers it was windy, so windy in fact that I had considered abandoning my plans for the day. A gale was blowing and there was no possibility of using my large-format film camera. But, not wishing to waste the day, I decided to take my new, expensive Mamiya equipment. This would prove to be a deeply regrettable decision.

Having found an elevated viewpoint, mounted the camera onto its tripod, covered everything in polythene in case of a sudden shower and, as a final precaution, adding extra weight by hanging a heavy rock from the tripod, I could see there was no prospect of making an exposure for at least 30 minutes so I decided to utilize the time by searching for other viewpoints. This was to be another decision I would regret.

Wandering slowly across the hilly landscape I would glance up every few minutes to check that all was well. Apart from one other photographer, the valley was deserted and I had no concerns for the safety of the equipment. The ferocity of the wind showed no sign of abating so a few minutes later I turned and began to head back, for one last time glancing up – and immediately stopped, blinked and looked again. No camera ... no tripod. Were my eyes deceiving me? What on earth had happened?

What had happened, of course, was that a gust of wind had blown the 'secure' tripod clean off its feet. There it lay, forlorn, legs sticking in the air like a decaying carcass. There was, as expected, some damage but it could have been worse. Tripod, lens and filter were all intact but the camera body required a new shutter release, a relatively minor repair.

One week later, repair complete, I was back. Same place, similar conditions, but a different approach. This time photographer and camera maintained a loving embrace throughout the entire picture-taking process. I had learned my lesson – the hard way. I say to you, please take heed and avoid making the same mistake.

Grange Fell, Cumbria, England

Camera: Mamiya 645ZD
Lens: Mamiya 35mm (Wide Angle)
Filter: 0.6ND grad
Film: Dalsa CCD sensor ISO 100
Exposure: 1/2sec at f/18
Waiting for the light: 1 hour

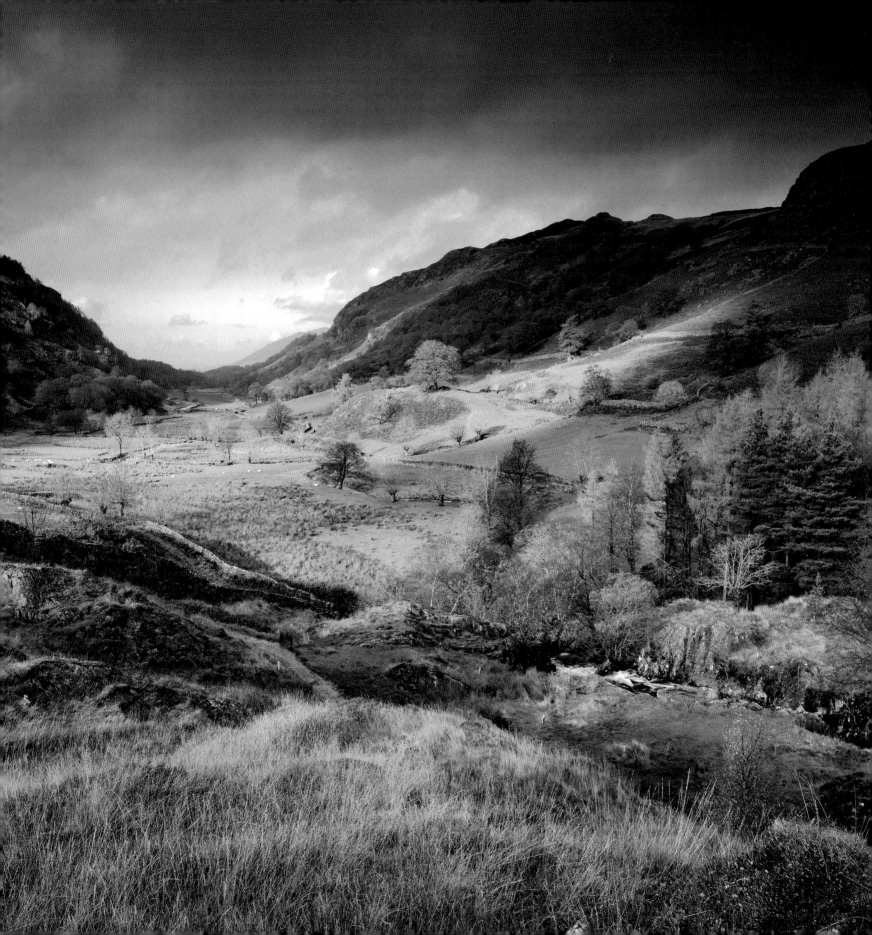

▶ A Landscape for All Seasons

The picture below was one of the first images I took on large-format film. Since those early years I have returned to the remote village of Martindale many times because it is one of those places I am drawn towards and I never tire of the view. The appearance changes with the passing of the seasons, sometimes it is subtle, sometimes dramatic, but always there is something different. It is the epitome of a timeless landscape because time itself has no lasting effect. Changes are transient as the months encircle the landscape in a constant cycle of seasonal transition.

If ever there was one, this is a landscape for all seasons and it is an unbridled joy to breathe it in and capture the nuances of transformation throughout the passing year.

Autumn is the time of rapid change across the landscape as can be seen in these photographs. The picture below was taken in September and the other one in November. Summer now seems to be a distant memory as winter threatens to bring the autumn season to an unwelcome end.

Martindale, Cumbria, England

Camera: Tachihara 5x4in

Lens: Super Angulon 150mm (Standard)

Filter: None

Film: Fuji Provia 100

Exposure: 1/8sec at f/22.5

Waiting for the light: Immediate

Martindale, Cumbria, England

Camera: Tachihara 5x4in

Lens: Super Angulon 150mm (Standard)

Filter: 0.6ND grad

Film: Fuji Provia 100

Exposure: 1sec at f/32

Waiting for the light: 1½ hours

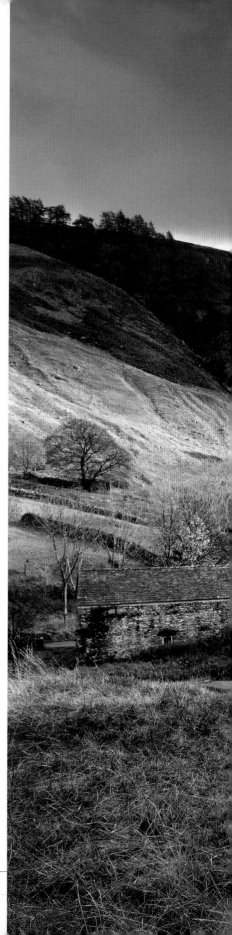

▶ Waiting for the Right Moment

The tiny hamlet of Watendlath lies at the end of a hanging valley along a winding, single-track road which passes one of the most photographed views in the Lake District, the iconic Ashness Bridge. Visitors arrive in their droves but many don't continue their journey, they simply admire the view and turn back. Unknowingly they are ignoring some of the region's finest, rugged scenery. If they continued along the road they would eventually reach Watendlath and discover a landscape oozing with character and picture-taking opportunities.

Although spectacular this landscape can, from the photographer's point of view, be somewhat inaccessible. It is light which presents the challenge. Here it is a precious commodity, particularly during the winter months when the height of the surrounding mountains shortens the winter days still further. It can be frustrating but there is no alternative to being prepared to spend inordinate amounts of time watching and waiting for the right moment because a good-quality landscape deserves good-quality light. It will arrive eventually, it might take several days but at some point all the elements will fall into place and you will get your picture.

In a rugged landscape splashes of light are always preferable to dispersed lighting. Often you don't need much, particularly if the scene is colourful. Strategically placed highlights will bring the image alive and will be sufficient to portray the grandeur of a mountainous location.

TIP: When you are surrounded by a magnificent landscape take time to choose a viewpoint. It all might look enticing but 'anywhere will do' is not the right approach. Look for an elevated position with a sloping foreground that leads into the picture and provides the viewer with a visual pathway which the eye can follow.

Watendlath, Cumbria, England

Camera: Tachihara 5x4in
Lens: Super Angulon 90mm (Wide Angle)
Filter: 0.6ND grad
Film: Fuji Provia 100
Exposure: 1/2sec at f/32
Waiting for the light: 3 days (I was lucky!)

▶ December

Light is at a premium this month but it is also of premium

quality. This is the time to photograph sweeping views

and sprawling vistas. Don't be deterred by poor weather.

You only need a few seconds of sunlight to transform

a winter landscape. Be patient, watch and wait for

the moment when specific parts of your image are

illuminated. Strategically placed splashes of light are

all that are required.

Winter skies bring an added dimension to open views.

Use neutral-density graduated filters to prevent the

sky from being overexposed. A correctly exposed sky

with a strong cloud structure will complement the

landscape below.

▶ Be Prepared, Be Happy!

Photography wasn't on the agenda the day this image was made and it was therefore completely unplanned. I happened to be near the River Mersey and, as the day seemed to be drawing to a promising end, decided to make a return trip to a viewpoint opposite the Liverpool waterfront. By good fortune I had with me my Fuji panoramic camera so suddenly the exciting prospect of taking a new photograph seemed increasingly likely.

Not wishing to replicate an earlier photograph, there was nothing to be gained by waiting for dusk to descend. The clear evening sky was in any case beginning to glow in a seamless graduation of delicate pink and blue. This contrasted well with the warmly lit buildings and within minutes of arriving the image was captured.

This had been completely unexpected and it demonstrates the advantage of carrying a camera at all times. Opportunities can arise at any moment and a prepared photographer is a successful – and happy – photographer.

TIP: For best results, night photography shouldn't in fact be undertaken in total darkness. Make your exposures when there is still some light in the sky. This will enable a hint of colour to be retained which is preferable to a solid black, featureless mass.

Liverpool waterfront, England

Camera: Tachihara 5x4in

Lens: Super Angulon 150mm (Standard)

Filter: None

Film: Fuji Provia 100

Exposure: 1 minute at f/16

Waiting for the light: 40 minutes

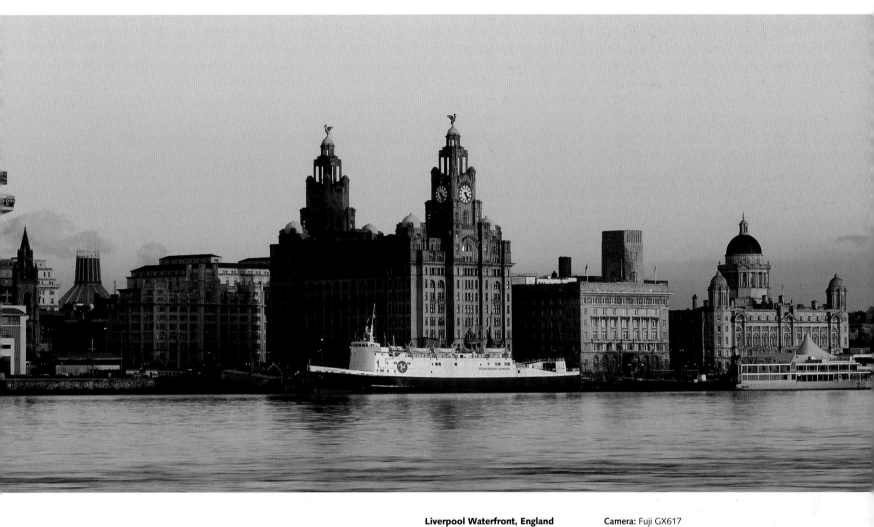

Liverpool Waterfront, England

Camera: Fuji GX617
Lens: Fujinon 105mm (Standard)
Filter: Polarizer (fully polarized)
Film: Fuji Provia 100
Exposure: 1/2sec at f/22
Waiting for the light: 10 minutes

TIP: In order to portray features and the three-dimensional shape of buildings, photograph them in oblique lighting.

▶ Appropriate Light

Rain was threatening but, having taken one image (the small picture below), I now felt a little more relaxed and contemplated alternative compositions. There were several possibilities and I eventually chose a lower viewpoint which was slightly closer to the castle. The bright sunlight continued and this suited the rugged landscape. The direction of the light was also a significant factor and this had to be taken into account when the various options were considered.

The scene is slightly backlit and this is an important detail. The shadows falling on the depth-enhancing foreground strengthen its presence as they do with the partially lit castle. The winter sun was also fairly low and this has helped to reveal the rough, textured finish of the long grasses in the mid-distance. Because of the quality of light visual interest is maintained throughout the photograph, from the near foreground to the distant mountains and sky. More general lighting would have flattened the image and weakened its impact.

TIP: The type of light used should be appropriate to the nature of the landscape. Generally, photograph rugged terrain with strong directional light to enhance drama in a scene.

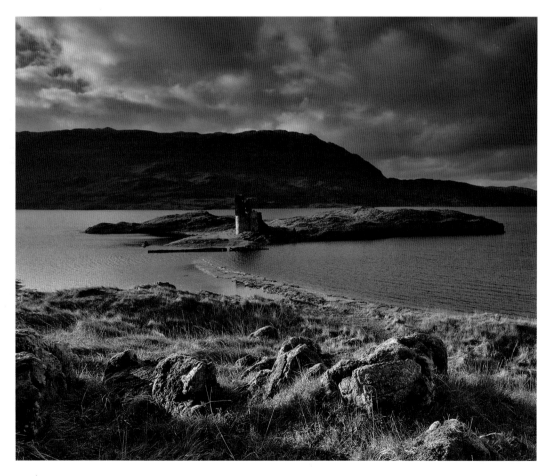

Ardvreck Castle, Sutherland, Scotland

Camera: Tachihara 5x4in
Lens: Super Angulon 90mm (Wide Angle)
Filter: 0.6ND grad, 81C
Film: Fuji Provia 100
Exposure: 1/4sec at f/22
Waiting for the light: Immediate

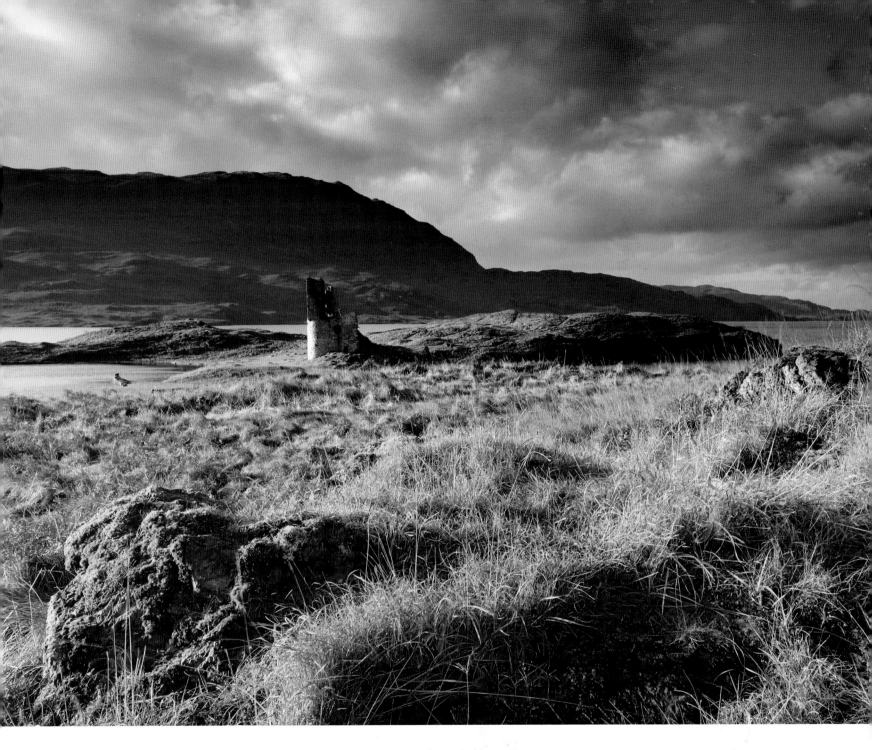

Ardvreck Castle, Sutherland, Scotland

Camera: Tachihara 5x4in
Lens: Super Angulon 90mm (Wide Angle)
Filter: 0.6ND grad, 81C
Film: Fuji Provia 100
Exposure: 1/2sec at f/32
Waiting for the light: Immediate

▶ The Perfect Combination

Digital was all the rage when I took up photography in the 1970s. But it was watches, not cameras, which suddenly were the must-have, in-vogue item. Digital photography was still two decades away; pixel development was in its infancy and the only hint of what was to come were autofocus and increasingly sophisticated in-camera TTL metering systems, neither of which appealed to me (and still don't). Inevitably the dawning of a new age of image making was beginning to approach but, as the sun eventually rose over the digital landscape, I, along with many photographers, ignored the new technology and continued to use film.

Change, though, is inevitable and, whilst preferring film for many images I have, as mentioned elsewhere, finally embraced the digital age. There are, as discussed at various points in this book, both advantages and disadvantages with the new methods. One distinct benefit is the opening up of what, in the past, would have been missed opportunities. Primarily this is because either the conditions or the environment are not conducive for large-format film photography. I therefore enjoy having the combination (and luxury) of film and digital and being able to select whichever method is most appropriate, or practical, for each individual situation.

It was certainly fortunate that the digital option was available at the time of capturing this image along the banks of Loch Morar. There was constant drizzle so, with camera in one hand and umbrella in the other, I made the exposure as quickly as conditions would allow. The smaller format of the digital sensor also provided greater depth of field (one of the drawbacks of large format is limited depth of field, particularly at close distance) and this was another factor in my decision to shoot digitally.

Similarly, the depth of field required for the picture of the rocky hills at Lochailort (opposite page) exceeded the capability of my large-format camera so again the digital option enabled the image to be taken.

Loch Morar, Lochaber, Scotland

Camera: Mamiya 645ZD
Lens: Mamiya 35mm (Wide Angle)
Filter: None
Film: Dalsa CCD sensor ISO 100
Exposure: 2sec at f/32
Waiting for the light: Immediate

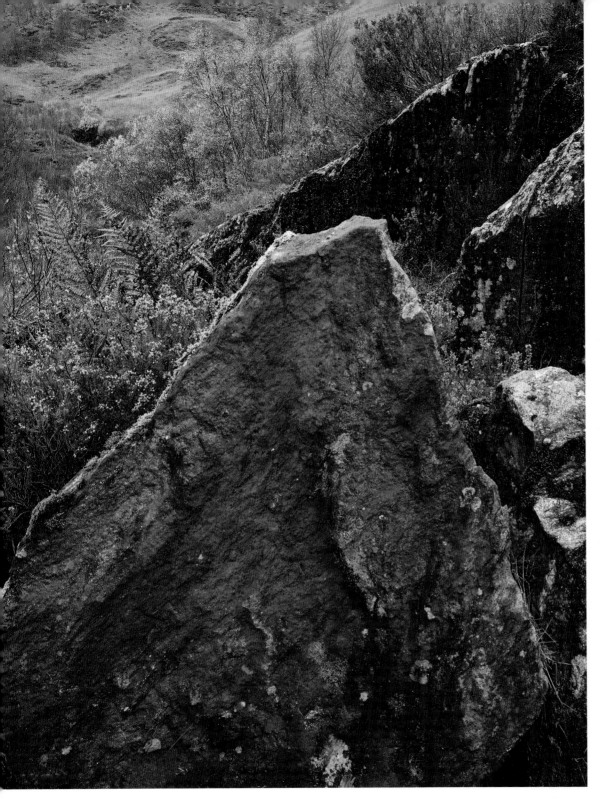

Lochailort, Lochaber, Scotland

Camera: Mamiya 645ZD
Lens: Mamiya 150mm (Telephoto)
Filter: None
Film: Dalsa CCD sensor ISO 100
Exposure: 1sec at f/32
Waiting for the light: Immediate

▶ A Perfect Partnership

Leafless trees are one of the few subjects that can be photographed successfully as silhouettes. The stark contrast against a background sky reveals every detail of their intricate structure and they can be a perfect accompaniment to a sunrise or sunset. If you have an attractively shaped tree and a strong sky you don't need anything else, the image will be complete with just these two elements.

They are relatively easy to photograph; simply base exposure on the sky and the tree will automatically be rendered as a silhouette. The sky is (or should be) the most eye-catching feature so keep large areas of solid black to the minimum by placing the horizon near the bottom of the picture.

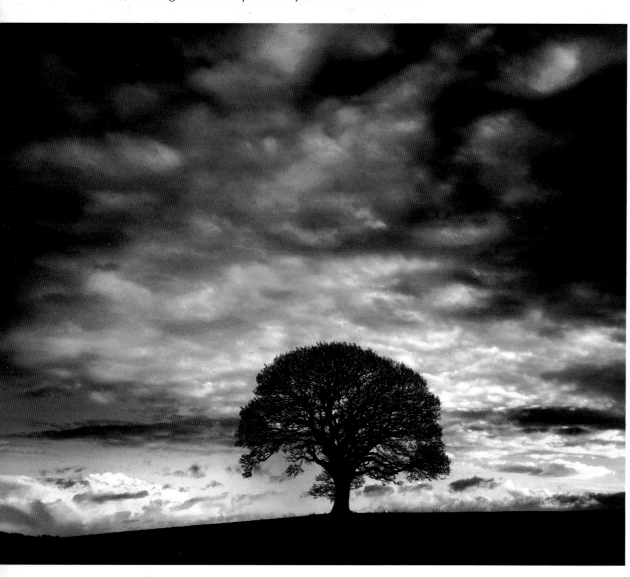

Near Bassenthwaite Lake, Cumbria, England

Camera: Tachihara 5x4in

Lens: Angulon 90mm (Wide Angle)

Filter: 81C

Film: Fuji Provia 100

Exposure: 1/2sec at f/16

Waiting for the light: 30 minutes

As a rule I exclude the sky when photographing woodland scenes, as I find that the presence of an area of sky distracts and weakens the theme of the image. As with any rule, however, there are exceptions and the sky can become an integral part of the composition, as with this picture (right). I was attracted by the tall, leafless trees and particularly liked their statuesque uniformity and flowing elegance. The clear blue background perfectly depicted their silhouetted form, therefore there was no doubt in my mind that this woodland scene would include the sky.

Initially there was little colour but as the mist dissipated a vivid blue began to emerge which contrasted well with the foreground of golden ferns and winter leaves. Timing was the critical factor in the making of this image because a presence of mist was still necessary in order to create atmosphere, but not to the extent that it diluted and weakened the colourful theme of the picture. It was a matter of waiting and watching as the fog gradually cleared and then making the exposure as the right balance of mist and sunlight developed.

Because the trees were in silhouette it was possible to position a grey graduated filter across the expanse of sky. This was important because, without the addition of the filter, the sky would have been overexposed and this should, of course, always be avoided.

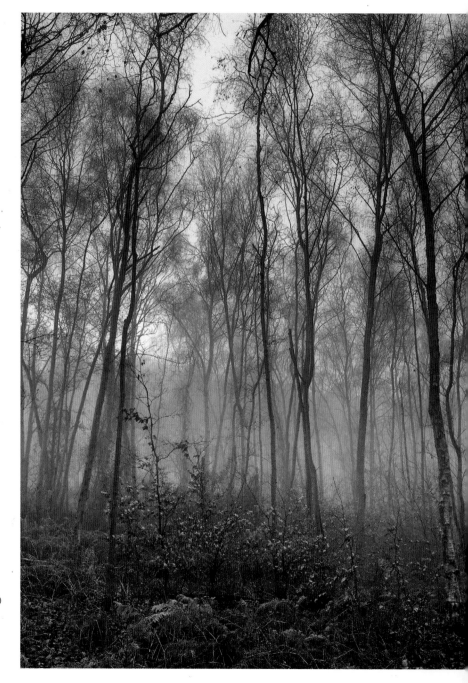

Storeton Woods, The Wirral Peninsula, England

Camera: Tachihara 5x4in
Lens: Super Angulon 90mm (Wide Angle)
Filter: 0.6ND grad
Film: Fuji Provia 100
Exposure: 1/2sec at f/22.5
Waiting for the light: 45 minutes

▶ Brooding Drama

The presence of mist and fog can have a profound and often dramatic effect on a woodland landscape. The transformation can be quite extraordinary as mood, mystery and atmosphere emerge from the trees and bushes to create powerful images which belie their humble origins. This is why, on foggy days, I ignore the open landscape and instead head for one of several forests which are, fortunately, within easy reach.

Dense fog had been forecast and dense it was, in fact visibility was so poor that driving even a relatively short distance was not an appealing prospect and I ventured no further than the local woods. Because of its proximity it is somewhere I have visited many times. I know its secrets and, having on many occasions subjected it to the closest scrutiny, it is always possible to predict its appearance – or so I thought.

On this particular day, although I knew what to expect, I was still taken aback by the extent of the otherworldly appearance that greeted me. It was of course a result of the density of the fog. Normally fog will not penetrate the deepest parts of thickly wooded areas, but on this occasion layers of mist enveloped every root, branch and trunk and this enabled me to choose a composition which made the most of the atmospheric conditions.

The picture captured that day is an improvement on another image which was taken in the same location but several years earlier (left). By comparison the smaller photograph lacks atmosphere and impact, this is partly due to the lighter mist but mainly it is a result of the shape and arrangement of the trees. They're a rather uninspiring group which is devoid of enigma whereas in the bigger picture there is, perhaps, a real sense of brooding drama which is appropriate to the theme of the image.

TIP: Depth and mood will be enhanced by using a dark foreground with progressively lighter tones which recede into the distance.

Storeton Woods, The Wirral Peninsula, England

Camera: Tachihara 5x4in
Lens: Super Angulon 90mm (Wide Angle)
Filter: None
Film: Fuji Provia 100
Exposure: 5sec at f/32
Waiting for the light: Immediate

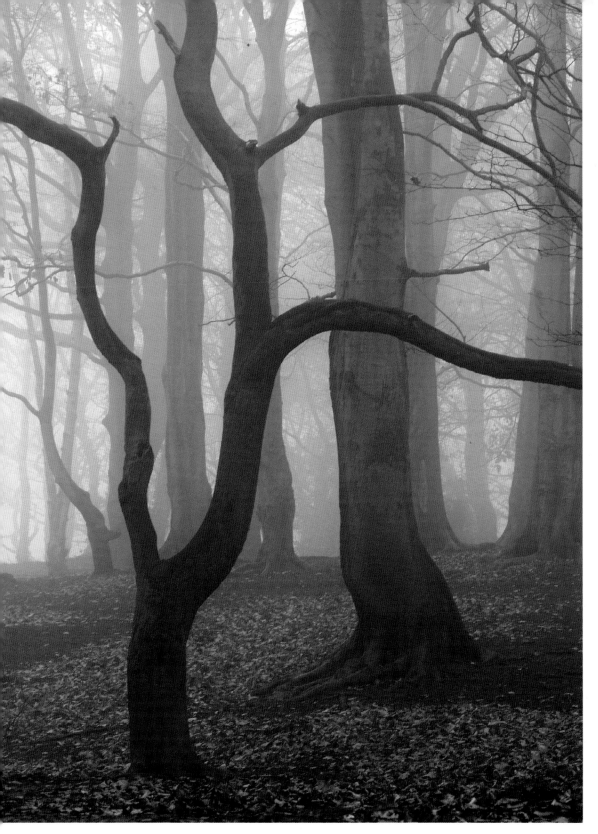

**Storeton Woods, The Wirral
Peninsula, England**

Camera: Tachihara 5x4in
Lens: Super Angulon 90mm (Wide Angle)
Filter: None
Film: Fuji Provia 100
Exposure: 2sec at f/32
Waiting for the light: Immediate

JANUARY

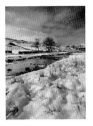

Page 18 **Langstrothdale,
North Yorkshire, England**

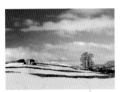

Page 19 **Near Burtersett,
North Yorkshire, England**

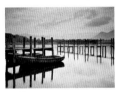

Page 20 **Derwent Water,
The Lake District, England**

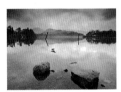

Page 21 **Derwent Water,
The Lake District, England**

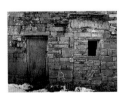

Page 22 **Near Bainbridge,
North Yorkshire, England**

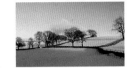

Page 23 **Near Countersett,
North Yorkshire, England**

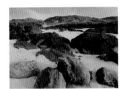

Pages 24–25 **Clachtoll Bay,
Sutherland, Scotland**

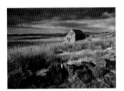

Page 26 **Brund Hill,
Staffordshire, England**

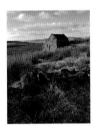

Page 27 **Brund Hill,
Staffordshire, England**

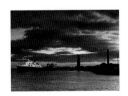

Pages 28–29 **Birkenhead
Docks, The Wirral Peninsula,
Merseyside, England**

FEBRUARY

Pages 32–33 **Near St Just,
Cornwall, England**

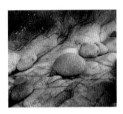

Page 34 **Porth Nanven,
Cornwall, England**

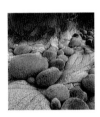

Page 35 **Porth Nanven,
Cornwall, England**

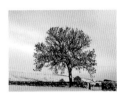

Pages 36–37 **Near Thornton
Rust, North Yorkshire, England**

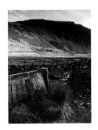

Page 38 **Nant Ffrancon,
Snowdonia, North Wales**

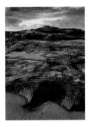

Page 39 **Nant Ffrancon,
Snowdonia, North Wales**

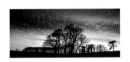

Page 40 **Near East Allington,
Devon, England**

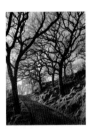

Page 41 **The Goyt Valley,
The Peak District, England**

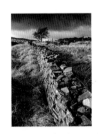

Page 42 **West Burton,
North Yorkshire, England**

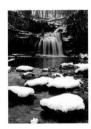

Page 43 **Fossdale Gill,
North Yorkshire, England**

MARCH

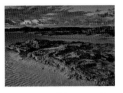

Page 46 **Hoylake, Wirral,
Merseyside, England**

Page 47 **Hoylake, Wirral,
Merseyside, England**

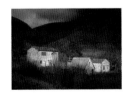

Page 48 **Near Cwm Bychan,
Snowdonia, Wales**

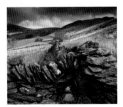

Page 49 **Montefegatesi,
Tuscany, Italy**

Pages 50–51 **Near Beddgelert,
Snowdonia, Wales**

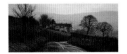

Page 52 **Higher Sutton,**
Cheshire, England

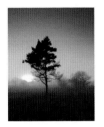

Page 53 **Royden Park Nature**
Reserve, Wirral, England

Page 54 **The Dee Estuary,**
Wirral, England

Page 55 **Sloan Gorge,**
New York State, USA

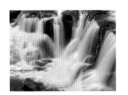

Pages 56–57 **Plattekill Creek,**
New York State, USA

APRIL

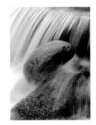

Pages 60–61 **Afon Goch,**
Llyn Dinas, Snowdonia

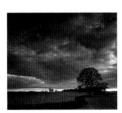

Page 62 **Near Ruabon,**
Clwyd, Wales

Page 63 **South of Shrewsbury,**
Shropshire, England

Pages 64–65 **Carbis Bay,**
Cornwall, England

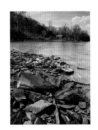

Page 66 **Warner Creek,**
New York State, USA

Page 67 **Panther Kill,**
New York State, USA

Pages 68–69 **Littondale,**
North Yorkshire, England

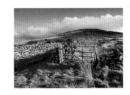

Page 70 **Near Barrytown,**
New York State, USA

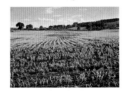

Page 71 **The River Hudson,**
New York State, USA

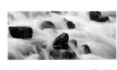

Pages 72–73 **The Hudson**
River, New York State, USA

MAY

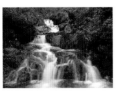

Page 77 **Near Church**
Stretton, Shropshire, England

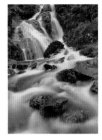

Page 78 **Cors y Llyn,**
Gwynedd, Wales

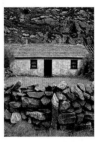

Page 79 **Near Delamere,**
Cheshire, England

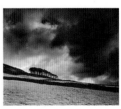

Pages 80–81 **Sour Milk Ghyll,**
Seathwaite, Cumbria, England

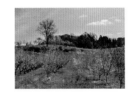

Page 82 **Y Garn Mountain,**
Snowdonia, Wales

Page 83 **Near Rhyd-Ddu,**
Snowdonia, Wales

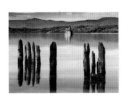

Pages 84–85 **Near Leyburn,**
North Yorkshire, England

JUNE

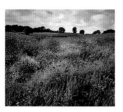

Pages 88–89 **Alvanley, Cheshire, England**

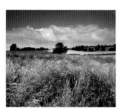

Page 90 **Alvanley, Cheshire, England**

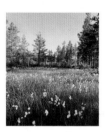

Page 91 **Near Aseral, Norway**

Pages 92–93 **Nordbo, Norway**

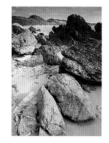

Page 94 **Freshwater West, Pembrokeshire, Wales**

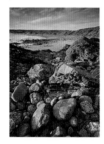

Page 95 **Freshwater West, Pembrokeshire, Wales**

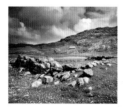

Page 96-97 **Near Borgh, The Isle of Barra, Scotland**

JULY

Page 100 **Hilbre Island, Wirral, England**

Page 101 **Port of Ness, The Isle of Lewis, Scotland**

Pages 102–103 **Near Dunvegan, The Isle of Skye, Scotland**

Page 104 **Near Ardroe, Sutherland, Scotland**

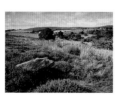

Page 105 **Commondale Moor, North Yorkshire, England**

Pages 106–107 **Near Llanberis, Snowdonia, Wales**

AUGUST

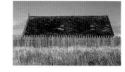

Page 110 **Souillac, The Dordogne, France**

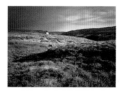

Page 111 **Souillac, The Dordogne, France**

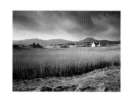

Page 112 **Near Nadaillac de Rouge, The Dordogne, France**

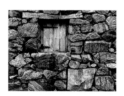

Page 113 **Near Pinsac, The Dordogne, France**

Pages 114–115 **Near Cazoules, The Dordogne, France**

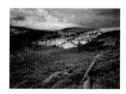

Page 116 **Llantysilio, Clwyd, Wales**

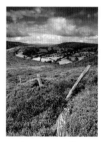

Page 117 **Llantysilio, Clwyd, Wales**

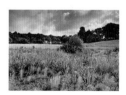

Pages 118–119 **Nevern, Pembrokeshire, Wales**

SEPTEMBER

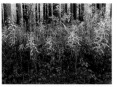
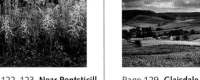

Pages 122–123 **Near Pontsticill, The Brecon Beacons, Wales**

Page 124 **Near Hawes, North Yorkshire, England**

Page 125 **Near Hawes, North Yorkshire, England**

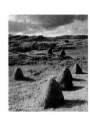

Pages 126–127 **Dyffryn Crawnon, The Brecon Beacons, Wales**

Page 128 **Great Fryup Dale, North Yorkshire, England**

Page 129 **Glaisdale Moor, North Yorkshire, England**

Page 130 **Near Madison, New Hampshire, USA**

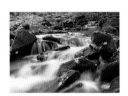

Page 131 **Near Lacasaigh, The Isle of Lewis, Scotland**

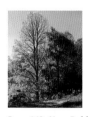

Pages 132–133 **Nantahala River, North Carolina, USA**

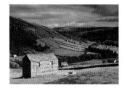

Page 134 **Mainstone, Shropshire, England**

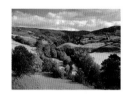

Page 135 **Mainstone, Shropshire, England**

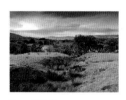

Pages 136–137 **Langlee Crags, Northumberland, England**

OCTOBER

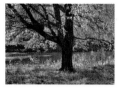

Page 140 **Near Thwaite, North Yorkshire, England**

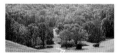

Page 141 **Near Keld, North Yorkshire, England**

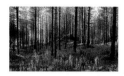

Page 142 **Hawes, North Yorkshire, England**

Page 143 **Near Dahlonega, Georgia, USA**

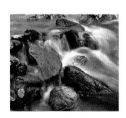

Pages 144–145 **Kimsey Creek, North Carolina, USA**

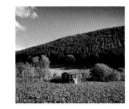

Page 146 **Little Tennessee River, North Carolina, USA**

Page 147 **Little Tennessee River, North Carolina, USA**

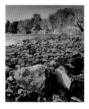

Pages 148–149 **Newborough Forest, Anglesey, Wales**

Page 150 **Leatherman Gap, North Carolina, USA**

Page 151 **Near Bridgton, Maine, USA**

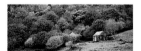

Pages 152–153 **Betws-Y-Coed, Snowdonia, Wales**

NOVEMBER

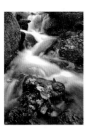

Page 156 **Near Hardraw,
North Yorkshire, England**

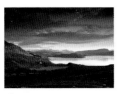

Page 157 **Borrowdale,
Cumbria, England**

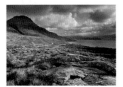

Page 158 **Culnacraig,
Wester Ross, Scotland**

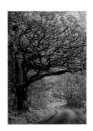

Page 159 **Culnacraig,
Wester Ross, Scotland**

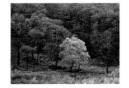

Pages 160–161 **Grange Fell,
Cumbria, England**

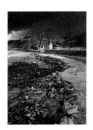

Page 162 **Loch nan Ceall,
Arisaig, Scotland**

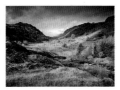

Page 163 **Morroch, Arisaig,
Scotland**

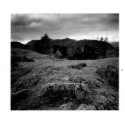

Pages 164–165 **Grange Fell,
Cumbria, England**

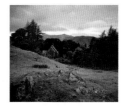

Page 166 **Martindale,
Cumbria, England**

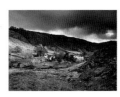

Page 167 **Martindale,
Cumbria, England**

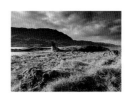

Pages 168–169 **Watendlath,
Cumbria, England**

DECEMBER

Page 172 **Liverpool
Waterfront, England**

Page 173 **Liverpool
Waterfront, England**

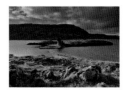

Page 174 **Ardvreck Castle,
Sutherland, Scotland**

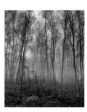

Page 175 **Ardvreck Castle,
Sutherland, Scotland**

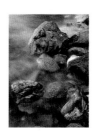

Page 176 **Loch Morar,
Lochaber, Scotland**

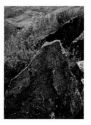

Page 177 **Lochailort,
Lochaber, Scotland**

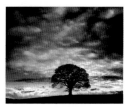

Page 178 **Near Bassenthwaite
Lake, Cumbria, England**

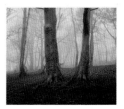

Page 179 **Storeton Woods,
The Wirral Peninsula, England**

Page 180 **Storeton Woods,
The Wirral Peninsula, England**

Page 181 **Storeton Woods,
The Wirral Peninsula, England**

Glossary

Angle of incidence The angle between the incident light falling on the subject and the reflected light entering the camera lens.

Angle of view The angle seen by a given lens. The shorter the focal length, the wider the angle of view. With the subject to camera distance this determines the field of view.

Aperture The hole or opening formed by the leaf diaphragm inside the lens through which light passes to expose the film or sensor. The size of the aperture relative to the focal length is denoted by f-numbers (f-stops).

Aperture priority Automatic in-camera metering of exposure based on a pre-selected aperture. Exposure is therefore adjusted by the shutter speed.

Aspect ratio The ratio of the width to the height of the frame.

Autoexposure (AE) The ability of a camera to recommend the correct exposure for a particular scene.

Autofocus (AF) An in-camera system for automatically focusing the image.

Backlighting Light coming from behind the subject shining towards the camera.

Bracketing Making a series of exposures of the same subject at different exposure settings, typically in steps of ½ or ⅓ stops.

Cable release A flexible cable, used to minimize the risk of camera shake, which is attached to the camera to enable remote release of the shutter.

Centre-weighted metering Type of metering system that takes the majority of its reading from the centre portion of the frame. Suitable for portraits or scenes where subjects fill the centre of the frame.

Chromatic aberration Colour-fringing caused by the camera lens not focusing different wavelengths (colours) of light on the same focal plane.

Colour cast A variation of the colour of light which causes a distortion in the colour in a photograph.

Colour correction filter A filter that is used to compensate for a colour cast, the most common example being the 81 series of warming filters. See Warm filter.

Colour temperature The colour of light has a colour temperature. This depends on a number of factors including its source and the time of day. It is measured on the Kelvin scale – lower temperatures produce warmer colours and vice versa.

Contrast The range between the highlight and shadow areas of a negative, print, transparency or digital image. Also refers to the difference in illumination between adjacent areas.

Converging parallels The distortion of parallel lines which appear as converging angled lines. This commonly occurs when a building is photographed with the camera pointing at an upwards angle.

Cropping Printing only part of the available image from the negative, transparency or digital image, usually to improve composition.

Definition The clarity of an image in terms of both its sharpness and contrast.

Depth of field (DOF) The zone of acceptable sharpness in front of and behind the point at which the lens is focused. This zone is controlled by three elements: aperture – the smaller the aperture, the greater the DOF; the camera-to-subject distance – the further away the subject the greater the DOF; the focal length of the lens, the shorter the focal length the longer the DOF.

Diffuse lighting Lighting that is low or moderate in contrast, such as the light on an overcast day.

DSLR (digtal single lens reflex) See SLR (single lens reflex)

Dynamic range See Tonal range

Exposure The amount of light reaching the film or sensor. This is controlled by a combination of aperture and shutter speed. Alternatively, the act of taking a photograph as in 'making an exposure'.

Exposure compensation A level of adjustment given to autoexposure settings. Generally used to compensate for known inadequacies in the way a meter will usually recommend a reading that may result in underexposure such as snow scenes.

Exposure latitude The extent to which exposure can be reduced or increased without causing an unacceptable under- or overexposure of the image.

Exposure meter A device, either built into the camera or separate, with a light-sensitive cell used for measuring light levels, used as an aid for selecting the exposure setting.

Exposure value A single value given for a measurement of light that indicates an overall value that can be reached by a combination of shutter speed and aperture for a particular ISO setting.

Field of view The actual dimensions of the scene that can be captured on film or sensor. This depends on the film/sensor format, the angle of the lens and the camera-to-subject distance.

Flare Non-image forming light reflected inside a lens or camera in an unwanted manner. It can create multicoloured circles or loss of contrast and can be reduced by multiple lens coatings, low-dispersion lens elements or a lens hood.

Focal length The distance between the film or sensor and optical centre of the lens when focused at infinity.

F-numbers A series of numbers on the lens aperture ring and/or the camera's LCD panel that indicate the size of the lens aperture relative to its focal length. The higher the number, the smaller the aperture.

Frontal lighting Light shining on the surface of the subject facing the camera.

Highlights The brightest part of an image.

Histogram A digital graph indicating the light values of an image.

Hyperfocal distance The closest distance at which a lens records details sharply when focused at infinity. Focusing on the hyperfocal distance produces maximum depth of field which extends from half the hyperfocal distance to infinity.

Image sensor The digital equivalent of film. The sensor converts an optical image to an electrical charge which is captured and stored.

Incident light Light falling on a surface as opposed to light reflected from that surface. An incident light meter measures the light before it reaches the surface. Compare with Reflected light.

ISO rating Measures the degree of sensitivity to light of a film or sensor as determined by the International Standards Organization. As the ISO number doubles, the amount of light required to correctly expose the film/sensor is halved.

Large format A camera which uses sheet film of 5x4in or larger.

Law of reciprocity A change in one exposure setting can be compensated for by an equal and opposite change in the other. For example, the exposure setting of 1/60sec at f/11 produces exactly the same exposure value as 1/30sec at f/16. See Reciprocity failure

Medium format Refers to cameras using rollfilm (normally 120 or 220 film), or a digital sensor of equivalent size, that measures approximately 2¼in (6cm) wide.

Neutral-density (ND) filter A filter that reduces the brightness of an image without affecting its colour.

Neutral density graduated (ND grad) filter A neutral-density filter that is graduated to allow different amounts of light to pass through it at different parts. These filters are used to balance naturally occurring bright and dark tones. In landscape photography they are commonly used to balance the exposure values of sky and landscape.

Panoramic camera A camera with a frame of which the aspect ratio of width to height is greater than 3:2.

Polarizing filter A filter that absorbs light vibrating in a single plane while transmitting light vibrating in multiple planes. When placed in front of a camera lens, it can eliminate undesirable reflections from a subject such as water, glass or other objects with a shiny surface, except metal. It is also used to saturate colour.

Prime lens A lens that has a fixed focal length.

Reciprocity failure At shutter speeds slower than 1second the law of reciprocity begins to fail because the sensitivity of film reduces as the length of exposure increases. This affects different films to different extents, but means that the exposure will need to be increased slightly to compensate.

Reflected light Light reflected from the surface of a subject. The type of light that is measured by through-the-lens meters and handheld reflected light meters such as spot meters.

Resolution The amount of detail in an image. The higher the resolution, the larger the potential maximum size of the printed image.

Shutter A mechanism that can be opened and closed to control the length of exposure.

Shutter speed The length of time light is allowed to pass through the open shutter of the camera. Together, the aperture and shutter speed determine the exposure.

Shutter release The button or lever on a camera that causes the shutter to open.

Sidelighting Light shining across the subject, illuminating one side of it. The preferred light of most photographers, it gives shape, depth and texture to a landscape, particularly when the sun is low in the sky.

SLR (single lens reflex) A type of camera that allows you to see the view through the camera's lens as you look in the viewfinder.

Soft focus filter A filter used to soften an image by introducing spherical aberration, it is not the same as out of focus and a sharp image is necessary in order for the effect to succeed.

Spot meter An exposure meter that measures a small, precise area. It enables a number of exposure readings to be taken of different parts of a subject and therefore provides a very accurate method of metering.

Standard lens A lens with a focal length approximately equal to the diagonal measurement of the film format. It produces an image approximately equivalent to that seen by the human eye, and equates to the following focal lengths: 35mm for digital APS-C cameras, 50mm for 35mm film or digital cameras, 80mm for 645, 90mm for 67 and 150mm for 5x4in cameras.

Telephoto lens A lens with a long length and narrow angle of view. When used at a long distance from the subject, a telephoto lens can help create the impression of compressed distance, with subjects appearing to be closer to the camera than they actually are.

Through-the-lens (TTL) metering A meter built into a camera that determines exposure for the scene by reading light that passes through the lens during picture taking.

Tonal range The range between the darkest and lightest areas of an image.

UV filter A filter that reduces UV interference in the final image. This is particularly useful for reducing haze in landscape photographs.

Vignetting The cropping or darkening of corners of an image. This can be caused by a lens hood, filter holder or the lens itself. Many lenses do vignette, but to a minor extent. This can be more of a problem with zoon lenses rather than prime lenses.

Warm filter A filter designed to bring a warm tone to an image to compensate for a blue cast which can sometimes be present in daylight, particularly with an overcast sky. The filters are known as the 81 series, 81A being the weakest and 81E the strongest.

White balance A function of a digital camera that allows the correct colour balance to be recorded for any given lighting situation.

Wide-angle lens A lens with a short focal length and a wide angle of view.

Zoom lens A lens with a focal length that can be varied.

About the Author

Peter Watson took up photography as a teenager, concentrating on black-and-white landscapes and developing and printing in a home-made darkroom. He sold his pictures in a local art shop and this early success encouraged him to pursue his hobby more seriously. He began to photograph in colour, still specializing in landscapes, and became a professional photographer in 1988, using large-format equipment (5x4in).

Peter is a contributing photographer to several leading picture libraries and his work is internationally published. In addition to his own landscapes Peter undertakes commissioned work for clients, primarily architectural and travel photography, in addition to studio work. He also runs his own picture library and holds practical photography workshops throughout the UK. He has previously written four books for Photographers' Institute Press: *Reading the Landscape*, *Capturing the Light*, *Light in the Landscape*: *A Photographer's Year* and *A Field Guide to Landscape Photography*.

www.peterwatson-photographer.com

Equipment Used

Cameras
Tachihara 5x4inch view camera
Fuji GX617 panoramic
Mamiya RB67
Mamiya 645ZD

Lenses
Super-Angulon 75mm, 90mm, 150mm, 210mm
Rodenstock 120mm
Fujinon 105mm, 300mm
Mamiya 35mm, 50mm, 80mm, 210mm

Filters
Lee ND graduated from 0.3 to 0.75, polarizer, warm 81B and 81C

Exposure meter
Sekonic spot meter

Tripods
Uni-Loc Major 2300 and 1600

Viewfinder
Linhof 4x5 Multifocus Viewfinder

Index

Page numbers in **bold** refer to illustrations

A
Anglesey, Isle of
　Newborough Forest **148–9**
Arisaig
　Loch nan Ceall **162**
　Morroch **163**

B
backlighting 48, 79, 101,
　106, 146
backpacks 14
Barra, Isle of
　Borgh **96–7**
beauty, preserving 90–1
blossom 70
Brecon Beacons
　Dyffryn Crawnon **126–7**
　Pontsticill **122–3**
buildings 24, 96, 111, 134,
　140, 173

C
cable releases 14
camera cases 14
Cheshire
　Alvanley **88–9, 90**
　Delamere **79**
　Delamere Forest **2**
　Harthill **8, 9**
　Higher Sutton **52**
close-ups 12, 39, 151, 156
clothing 14
clouds 82, 84, 96
Clwyd
　Llantysilio **116, 117**
　Ruabon **62**
colour(s)
　bold 33

large expanses 88
　as main theme 76, 150
　narrow range 34, 36
Cornwall
　Carbis Bay **64–5**
　Porth Nanven **34, 35**
　St Just **32–3**
Cumbria
　Bassenthwaite Lake **178**
　Borrowdale **157**
　Derwent Water 20, **20, 21**
　Grange Fell **160–1, 164–5**
　Martindale 166, **166, 167**
　Sour Milk Ghyll,
　　Seathwaite 80, **80–1**
　Thirlemere **15**
　Watendlath 168, **168–9**

D
dawn photography 68
depth of field, maximizing 94–5
digital photography
　digital enhancement 18, 126
　and film 10, 176
　memory cards 12
　pixel count 10
　sensor size 11
distance, compressing
　112–13, 160
Dordogne, France 110
　Cazoules **114–15**
　Nadaillac de Rouge **112**
　Pinsac **113**
　Souillac **110, 111**

E
England
　Alvanley, Cheshire **88–9, 90**
　Bainbridge, North Yorkshire **22**
　Bassenthwaite Lake,
　　Cumbria **178**

Birkenhead Docks, Wirral,
　Merseyside **28–9**
Borrowdale, Cumbria **157**
Brund Hill,
　Staffordshire **26, 27**
Burtersett, North
　Yorkshire **4–5, 19**
Carbis Bay, Cornwall **64–5**
Church Stretton,
　Shropshire **77**
Commondale Moor, North
　Yorkshire **105**
Countersett, North
　Yorkshire **23**
Dee Estuary, Wirral,
　Merseyside **54**
Delamere, Cheshire **79**
Delamere Forest, Cheshire **2**
Derwent Water, Lake District
　20, **20, 21**
East Allington, Devon **40**
Fossdale Gill, North
　Yorkshire **43**
Glaisdale Moor, North
　Yorkshire **129**
Goyt Valley, Peak District **41**
Grange Fell, Cumbria
　160–1, 164–5
Great Fryup Dale, North
　Yorkshire **128**
Hardraw, North Yorkshire **156**
Harthill, Cheshire **8, 9**
Hawes, North Yorkshire **124,
　125**, 142, **142**
Higher Sutton, Cheshire **52**
Hilbre Island, Wirral,
　Merseyside **100**
Hoylake, Wirral,
　Merseyside **46, 47**
Keld, North Yorkshire **141**
Langlee Crags,
　Northumberland **136–7**

Langstrothdale, North
　Yorkshire **18**
Leyburn, North
　Yorkshire **84–5**
Littondale, North
　Yorkshire **68–9**
Liverpool waterfront **172, 173**
Mainstone, Shropshire
　134, 135
Martindale, Cumbria 166,
　166, 167
Porth Nanven, Cornwall **34, 35**
Royden Park Nature Reserve,
　Wirral, Merseyside **53**
Shrewsbury, Shropshire **63**
Sour Milk Ghyll, Seathwaite,
　Cumbria 80, **80–1**
St Just, Cornwall **32–3**
Storeton Woods, Wirral,
　Merseyside **179, 180, 181**
Thirlemere, Cumbria **15**
Thornton Rust, North
　Yorkshire **36–7**
Thwaite, North Yorkshire **140**
Watendlath, Cumbria
　168, **168–9**
West Burton, North
　Yorkshire **42**
exposure meters 14

F
film 10, 176
filters
　ND grads (grey grads) 14, 42,
　　49, 62, 102, 136
　polarizers 14, 18, 76,
　　136, 144
　warm 14, 18, 46, 144
focal length 125
fog 20, 52, 180
foregrounds
　dominant 24, 50
　textured 146

forests *see* woodland and forests
formats, choosing 26, 46
France
 Cazoules, the Dordogne
 114–15
 Nadaillac de Rouge, the
 Dordogne **112**
 Pinsac, the Dordogne **113**
 Souillac, the Dordogne
 110, 111
fungi 130, 15

G
Georgia, USA
 Dahlonega **143**
 Young Harris **13**
Gwynedd: Cors y Llyn **78**

H
hilly landscapes 128

I
industrial landscapes 28
ISO speed, increasing 118
Italy: Montefegatesi, Tuscany **49**

K
Kinlochleven
 Mamore Forest **1**

L
lenses 12, 92
 telephoto 112–13
Lewis, Isle of
 Lacasaigh 130, **131**
 Port of Ness **101**
Lochaber
 Loch Morar **176**
 Lochailort **177**

M
Maine: Bridgton **151**
maps 14, 122
memory cards 12
Merseyside
 Birkenhead Docks,
 Wirral **28–9**
 Dee Estuary, Wirral **54**
 Hilbre Island, Wirral **100**
 Hoylake, Wirral **46, 47**
 Liverpool waterfront **172, 173**
 Royden Park Nature Reserve,
 Wirral **53**
 Storeton Woods, Wirral **179,**
 180, 181
mist 20, 52, 180

N
New Hampshire: Madison **130**
New York State
 Barrytown **70**
 Hudson River **71, 72–3**
 Panther Kill **67**
 Plattekill Creek **56–7**
 Sloan Gorge **55**
 Warner Creek **66**
night photography 172
noise 118
North Carolina
 Kinsey Creek **144–5**
 Leatherman Gap **150**
 Little Tennessee River
 146, 147
 Nantahala River **132–3**
North Yorkshire
 Bainbridge **22**
 Burtersett **4–5, 19**
 Commondale Moor **105**
 Countersett **23**
 Fossdale Gill **43**

Glaisdale Moor **129**
Great Fryup Dale **128**
Hardraw **156**
Hawes **124, 125**, 142, **142**
Keld **141**
Langstrothdale **18**
Leyburn **84–5**
Littondale **68–9**
Thornton Rust **36–7**
Thwaite **140**
West Burton **42**
Northumberland:
Langlee Crags **136–7**
Norway
 Aseral **91**
 Nordbo **92–3**

P
panoramic photography 32,
 150, 152
Peak District: Goyt Valley **41**
Pembrokeshire
 Freshwater West **94, 95**
 Nevern **118–19**
people in photographs 63
pixel count 10
Powys: Machynlleth
 Furnace Falls **11**

R
reflections, suppressing 64, 144
regional characteristics 38
revisiting locations 26, 116, 124,
 134, 166
rivers 71, 72, 144, 146
rugged landscapes 168, 174

S
'S' curves 163
sand 46
Scotland 24
 Ardroe, Sutherland **104**
 Ardvreck Castle,
 Sutherland **174, 175**
 Borgh, Isle of Barra **96–7**
 Clachtoll Bay, Sutherland **24–5**
 Culnacraig, Wester Ross
 158, 159
 Dunvegan, Isle of Skye **102–3**
 Lacasaigh, Isle of Lewis
 130, **131**
 Loch Morar, Lochaber **176**
 Loch nan Ceall, Arisaig **162**
 Lochailort, Lochaber **177**
 Mamore Forest, Kinlochleven,
 Scottish Highlands **1**
 Morroch, Arisaig **163**
 Port of Ness, Isle of Lewis **101**
sensor size 11
Shropshire
 Church Stretton **77**
 Mainstone **134, 135**
 south of Shrewsbury **63**
skies
 blue 18, 76
 darkening technique 14, 102
 grey 49, 83, 104–5
Skye, Isle of: Dunvegan **102–3**
Sloan Gorge, New York State **55**
snow 18, 36, 42

Snowdonia 38, 106
 Afon Goch, Llyn Dinas **60–1**
 Beddgelert **50–1**
 Betws-Y-Coed **152–3**
 Cwm Bychan **48**
 Llanberis **106–7**
 Nant Ffrancon **38**, **39**
 Rhyd-Ddu **83**
 Y Garn Mountain **82**
spirit levels 14, 111
spot meters 14, 136
Staffordshire: Brund Hill **26**, **27**
sunlight, harsh 100–1, 146
Sutherland
 Ardroe **104**
 Ardvreck Castle **174**, **175**
 Clachtoll Bay **24–5**

T
trees
 backlighting 146
 fallen 130
 leafless 40–1, 48, 178
 see also woodland and forests
tripods 12
Tuscany: Montefegatesi **49**
twilight 28

U
USA
 Barrytown, New York State **70**
 Bridgton, Maine **151**
 Dahlonega, Georgia **143**
 Hudson River, New York State **71, 72–3**
 Kinsey Creek, North Carolina **144–5**
 Leatherman Gap, North Carolina **150**
 Little Tennessee River, North Carolina **146, 147**
 Madison, New Hampshire **130**
 Nantahala River, North Carolina **132–3**
 Panther Kill, New York State **67**
 Plattekill Creek, New York State **56–7**
 Sloan Gorge, New York State **55**
 Warner Creek, New York State **66**
 Young Harris, Georgia **13**

W
Wales
 Afon Goch, Llyn Dinas, Snowdonia **60–1**
 Beddgelert, Snowdonia **50–1**
 Betws-Y-Coed, Snowdonia **152–3**
 Cors y Llyn, Gwynedd **78**
 Cwm Bychan, Snowdonia **48**
 Dyffryn Crawnon, the Brecon Beacons **126–7**
 Freshwater West, Pembrokeshire **94, 95**
 Furnace Falls, Machynlleth, Powys **11**
 Llanberis, Snowdonia **106–7**
 Llantysilio, Clwyd **116, 117**
 Nant Ffrancon, Snowdonia **38, 39**
 Nevern, Pembrokeshire **118–19**
 Newborough Forest, Anglesey **148–9**
 Pontsticill, the Brecon Beacons **122–3**
 Rhyd-Ddu, Snowdonia **83**
 Ruabon, Clwyd **62**
 Y Garn Mountain, Snowdonia **82**
water
 moving 56, 60, 66–7, 80, 82, 132, 144, 157
 rivers 71, 72, 144, 146
Wester Ross:
 Culnacraig **158, 159**
wind 88, 118, 164
Wirral
 Birkenhead Docks **28–9**
 Dee Estuary **54**
 Hilbre Island **100**
 Hoylake **46, 47**
 Royden Park Nature Reserve **53**
 Storeton Woods **179, 180, 181**
woodland and forests 122, 136, 148, 179, 180

Y
Yorkshire *see* North Yorkshire

Photographers' Institute Press,
Castle Place, 166 High Street, Lewes, East Sussex BN7 1XU, United Kingdom
Tel: +44 (0)1273 488005 Fax: +44 (0)1273 402866
E-mail: pubs@thegmcgroup.com
www.pipress.com